Sounding the Depths

Sounding the Depths

Theology Through the Arts

edited by
Jeremy Begbie

scm press

© SCM Press 2002

British Library Cataloguing in Publication data

A catalogue record of this book is available
from the British Library

0 334 02870 1

First published in 2002 by SCM Press
9–17 St Albans Place, London N1 0NX

www.scm-canterburypress.co.uk

SCM Press is a division of
SCM-Canterbury Press Ltd

Typeset by Regent Typesetting, London
and printed in Great Britain by
Biddles Ltd, Guildford and King's Lynn

Contents

Figures

Acknowledgements

The editor and publisher are grateful to the following:

Boosey and Hawkes Music Publishers Ltd for permission to reproduce the *Parthenogenesis* libretto, in Chapter 5.

Jonathan Clarke for Figures 1–5, in Chapter 11.

The copyright holders for the photographs between pages 144 and 145.

Contributors

Jeremy Begbie

Jeremy Begbie is Associate Principal of Ridley Hall, Cambridge, and Reader in Theology at the University of St Andrews, where he currently directs *Theology Through the Arts* at the Institute for Theology, Imagination and the Arts. He teaches systematic theology at Ridley Hall, and in the University of Cambridge. A professionally trained musician, he has performed extensively as a pianist, oboist and conductor. He is author of *Music in God's Purposes* (1989), *Voicing Creation's Praise* (1991) and *Theology, Music and Time* (2000). He also serves on the Doctrine Commission of the Church of England.

Lorraine Cavanagh

Lorraine Cavanagh is currently pursuing doctoral studies at the University of Cambridge. She is the author of *The Really Useful Meditation Book* (1995). Trained in drama and fine art, her work has been exhibited at the Living Art Gallery in London. She is currently a Church of England curate at St Andrew's, Chesterton, Cambridge.

Jonathan Clarke

An elected member of the Royal Society of British Sculptors, Jonathan Clarke is one of the leading artists of his generation. Venues for his exhibits have included the Strand Gallery in Aldeburgh, the Open Eye Gallery, Edinburgh and the Metropolitan Art Museum, Tokyo. He is a regular exhibitor at the

Royal Academy Summer Exhibition, and his commissioned work includes 'Stations of the Cross' at Southwell Minster.

David Ford

David Ford is Regius Professor of Divinity in the University of Cambridge, where he is also a Fellow of Selwyn College. Educated at Trinity College, Dublin, St John's College, Cambridge, Yale University and Tübingen University, he has taught previously at the University of Birmingham. His publications include *Barth and God's Story: Biblical Narrative and the Theological Method of Karl Barth in the Church Dogmatics* (1981), *Jubilate: Theology in Praise* (with Daniel W. Hardy, 1984), *Meaning and Truth in 2 Corinthians* (with Frances M. Young, 1988), *The Modern Theologians* (editor, second edition 1997), *The Shape of Living* (second edition 2001), *Theology: A Very Short Introduction* (1999) and *Self and Salvation: Being Transformed* (1999).

Nigel Forde

Nigel Forde is a freelance writer and contributor to many programmes on BBC radio. He is best known for presenting Radio 4's 'Bookshelf'. He has won several poetry prizes, and a musical written with Arnold Wesker was premiered this summer in Japan. He wrote the screenplay for three of BBC 2's animated series 'Testament', one of which won an EMMY award; and two short films for Claire Bloom and Jonathan Pryce. He scripted Channel 4's recent experimental 'Play in a Week'. His seven books to date include three of poetry and a critical anthology of G. K. Chesterton. His latest is a study of literature and belief: *The Lantern and the Looking-Glass* (1997). He is researching two anthologies, writing a novel and working on a play entitled *Stone, Paper, Scissors*.

Vanessa Herrick

Vanessa Herrick is Chaplain at Fitzwilliam College, Cambridge and seconded to Ridley Hall as Tutor in Pastoral Theology. She

was ordained in 1996 (having previously trained as a musician), and was curate at St Edmundsbury Cathedral, where she was responsible for developing the adult education programme, and was also able to explore further the relationship between the arts and theology. She is co-author of *Jesus Wept: Reflections on Vulnerability in Leadership* (1998), and is currently working on a book which explores the transfiguration of Jesus as a paradigm for encounter.

John Inge

John Inge is a Canon Residentiary and Vice-Dean at Ely Cathedral. He has responsibility there for education and mission. He trained and worked as a scientist before ordination. Prior to moving to Ely he was a parish priest on inner-city Tyneside, and before that Chaplain at Harrow School. Since his arrival in Ely he has developed an interest in the theology of place, and has recently completed a doctoral thesis on the subject. He has published a number of journal articles. He is married to Denise, an American, who is a writer and an authority on Thomas Traherne, the seventeenth-century poet and priest.

James MacMillan

One of Britain's most distinguished composers, James MacMillan studied music at the Universities of Edinburgh and Durham. In 1990, he became Affiliate Composer of the Scottish Chamber Orchestra. He is also Artistic Director of the Philharmonia's 'Music of Today' series, and in 2000 became Composer/ Conductor of the BBC Philharmonic Orchestra. His major works include: *The Confession of Isobel Gowdie* and *Tryst*, both of which premiered in 1990; *Veni, Veni, Emmanuel*, commissioned for Evelyn Glennie and first performed in 1992; *Seven Last Words from the Cross* in 1994; *The World's Ransoming*, a Cello Concerto for Msislav Rostropovich in 1997; and *The Birds of Rhiannon* for the BBC Philharmonic, premiered at the BBC Proms in 2001.

Alistair McFadyen

Alistair McFadyen is Senior Lecturer in Theology at the University of Leeds. A lay Anglican who worships at his local parish church, he is currently a member of the Church of England's Doctrine Commission and was previously a member of the Archbishop's Urban Theology Group and the Bishops' Advisory Group on Urban Priority Areas. He is author of *The Call to Personhood: A Christian Theory of the Individual in Social Relationships* (1990) and *Bound to Sin: Abuse, Holocaust and the Christian Doctrine of Sin* (2000). He is co-editor, with Marcel Sarot, of *Forgiveness and Truth* (2001) and, with Peter Sedgwick, of the SCM Press series, Society and Church.

Michael and Megan O'Connor

Michael O'Connor, a theologian and musician, is Warden of the Royal School of Church Music. He has contributed articles on music and liturgy to *Church Music Quarterly* and is currently working on a monograph on renaissance humanism and biblical exegesis. Megan O'Connor, a freelance editor and writer, has carried out research particularly in the area of English literature and is the author of *Metaphors of Change in the Language of Nineteenth Century Fiction* (1998). She also has extensive experience as a naturalist and environmental researcher.

Ben Quash

Ben Quash is Dean and Fellow of Peterhouse in the University of Cambridge. He teaches widely in the area of Christian theology, with a particular interest in the nineteenth-century background to modern theology, twentieth-century Catholic and Protestant thought, philosophical theology, and Christian ethics. His doctoral work was on the theological dramatic theory of Hans Urs von Balthasar, and combined his literary and theological interests. *Balthasar at the End of Modernity* (written with Lucy Gardner, David Moss and Graham Ward) was published in 1999. He is currently completing a longer book on Balthasar's

concept of 'Theodramatics' and the theology of history, and is book reviews editor for the international journal, *Studies in Christian Ethics*.

Paul Spicer

Paul Spicer is principally known as a choral director and composer. He studied at the Royal College of Music, and taught music before becoming a Producer for BBC Radio 3. From 1990 to 2001, he was Artistic Director of the International Arts Festival at Lichfield. He is the conductor of the Birmingham Bach Choir, the founder and conductor of the professional chamber choir, the Finzi Singers, and the principal conductor of the RCM Chamber Choir and Chorus. He is also Professor of Choral Conducting at the Royal College of Music in London. He has written numerous choral and orchestral works, including recent commissions for the Birmingham Bach Choir and New College, Oxford. Books published include a biography of Herbert Howells, and an Anthology of English Pastoral Part-Songs.

Michael Symmons Roberts

Born in Lancashire, Michael Symmons Roberts read Philosophy and Theology at Oxford. In 1988 he received the Society of Authors Gregory Award for poetry. He has produced three books of poems: *Soft Keys* (1993), *Raising Sparks* (1999), and *Burning Babylon* (2001). His poems have been widely published in the UK – in, among others, the *Observer*, the *Guardian*, the *Independent*, the *Times Literary Supplement*, the *London Review of Books*; and in America and Australia. His collaboration with composer James MacMillan has led to two London Proms commissions (*Quickening*, 1999, and *Birds of Rhiannon*, 2001), as well as songs and music theatre. A regular broadcast writer, his 2000 commission *A Fearful Symmetry* (BBC Radio 4 and World Service) won the Sandford St Martin Award. Alongside writing, he also makes documentary films for the BBC.

Jo Bailey Wells

Jo Bailey Wells is lecturer and tutor at Ridley Hall in Cambridge, where she teaches Old Testament and Biblical Theology. She was formerly Dean of Clare College, Cambridge. She has published *God's Holy People: A Theme in Biblical Theology* (2000), co-authored *Using the Ten Commandments* (2000) and contributed to *The New Lion Handbook to the Bible* (1999). She is currently working on a devotional commentary on Isaiah for the Bible Reading Fellowship.

Rowan Williams

Elected to be the eleventh Archbishop of Wales in December 1999, Rowan Williams was formerly Bishop of Monmouth, University Lecturer in Divinity at the University of Cambridge, Dean of Clare College, Cambridge, and Lady Margaret Professor of Divinity at the University of Oxford. His many books include *The Wound of Knowledge* (1979), *Resurrection* (1982), *The Truce of God* (1983), *Arius: Heresy and Tradition* (1987, second edition 2001), *Teresa of Avila* (1991), *Open to Judgement* and *After Silent Centuries* (both 1994), *Sergei Bulgakov: Towards a Russian Political Theology* (1998), and *Lost Icons* (2000).

Nicholas Wolterstorff

Nicholas Wolterstorff has a BA from Calvin College and a PhD in philosophy from Harvard University. After spending a year in Europe, he taught philosophy for two years at Yale University. He then returned to Calvin College, where he taught philosophy for 30 years. In 1989 he took up his current position at Yale, as Noah Porter Professor of Philosophical Theology, and adjunct professor in the philosophy department and the religious studies department.

After concentrating on metaphysics in his early career (*On Universals*, 1970), he spent many years working on aesthetics and philosophy of art (*Works and Worlds of Art* and *Art in*

Action, both 1980). In recent years, he has concentrated on epistemology (*John Locke and the Ethics of Belief*, 1996 and *Thomas Reid and the Story of Epistemology*, 2001), philosophy of religion (*Divine Discourse*, 1995), and political philosophy (*Until Justice and Peace Embrace*, 1983, and *Religion in the Public Square*, 1997).

Tom Wright

After taking a 'double first' from Oxford, Tom Wright held fellowships at both Oxford and Cambridge, wrote his doctorate on the Apostle Paul and worked as a College Chaplain. He taught New Testament Studies at McGill University, Montreal before returning to Oxford as University Lecturer in New Testament and Fellow and Chaplain of Worcester College. From 1994 to 1999 he was Dean of Lichfield, working closely with the Lichfield International Arts Festival. He is currently Canon Theologian of Westminster Abbey. He has published over thirty books, including *The New Testament and the People of God* (1992, second edition 1996); *Jesus and the Victory of God* (1996); *What Saint Paul Really Said* (1997); and *The Challenge of Jesus* (2000). He is married with four children.

I

Introduction

JEREMY BEGBIE

If all theology, all sermons, had to be set to music, our teaching and preaching would not only be more mellifluous; it might also approximate more closely to God's truth, the truth revealed in and as the Word made flesh, crucified and risen.[1]

Tom Wright's words go to the heart of what this volume is about. In modern times, the arts have commonly been relegated to the realm of decoration, entertainment, or self-expression. Without denigrating any of these for a moment, it needs to be asked whether we have too easily overlooked other perspectives on the arts, some of which are much older and far more pervasive. In particular, we are inclined to forget that the arts – even when they are decorative, entertaining or self-expressive – can be vehicles of *discovery*, not just of ourselves, but of other people and indeed of virtually anything with which we engage from day to day, from physical objects to grand ideas. Arguably, the most fascinating paradox of all about the arts is that through making things, we can find out more about what we have *not* made. When I struggle to articulate something in art, I learn more fully just what that 'something' is. In his essay in this book, the playwright Nigel Forde tells us: 'I write not *because* I see but *in order to see*.'[2] Essentially the point is taken up by Rowan Williams:

art, whether Christian or not, can't properly begin with a message and then seek for a vehicle. Its roots lie, rather, in the single story or metaphor or configuration of sound or shape which *requires* attention and development from the artist. In the process of that development, *we find meaning we had not*

suspected; but if we try to begin with the meanings, they will shrink to the scale of what we already understand: whereas the creative activity *opens up what we did not understand* and perhaps will not fully understand even when the actual work of creation is done.[3]

The same can be said of enjoying art. We find ourselves perceiving what we have never perceived – or only half-perceived – before. And this extends far beyond discovering the inner thoughts or feelings of the artist (if that is ever really necessary, or even possible). Realities hitherto unnoticed come to meet me through art, call forth my attention, shift my outlook. Can I ever look at a tree in quite the same way after painstakingly selecting the many shades of green necessary to paint one of them? Can the liberating rhythms of forgiveness ever be sensed in quite the same way after reading Hugo's *Les Misérables*?

It is this 'heuristic' capacity of the arts, their ability to 'open up' and disclose in unique ways which is the focused interest of the essays which follow. In particular, we are concerned with their capacity to open up what Tom Wright calls 'God's truth', and thus to contribute to *theology*.

Theology is, of course, a much contested word. Here, very broadly, it means 'Christian faith seeking deeper wisdom'. It is the disciplined thinking and re-thinking of that good news or gospel from which Christian faith arises: the reconciling self-communication of the triune God, climaxing in Jesus Christ, crucified and risen. The phrase 'thinking and re-thinking' here could easily be misunderstood as narrowly intellectualist – as if theology were ideally performed by pure minds, disembodied and detached from all practical interests, passions and commitments. But theology's immediate interest, we are suggesting, is wisdom, and in the ancient tradition of Proverbs and wisdom literature, attaining wisdom entails much more than the amassing information for the mind's scrutiny. Wisdom is evident in the making of appropriate judgements in particular practical contexts, and is ultimately aimed towards the cultivation of a whole lifestyle 'in tune' with God. Being theologically wise

means being able to discern what is right to say and do in a specific situation, in a manner that is true to 'God's wisdom', a wisdom embodied in Christ crucified and generated through the Spirit (1 Cor. 1.18—2.16). Accordingly, theology, as the pursuit of this wisdom, though undoubtedly intellectual, is integrally related to action, and indeed to every aspect of our humanity.[4]

What can the arts give to this kind of theology, this quest for deeper wisdom? More fully (linking up with my earlier comments), what can the arts give *as vehicles of discovery* to this kind of theology – not simply confirming what we already understand of God and God's ways, or adding a 'mellifluous' coating to what we have already expressed, but eliciting (as Williams puts it) 'meaning we had not suspected'?

Theology Through the Arts

It was with this question in mind that a research project, *Theology Through the Arts* (TTA), was set up in 1997, at the Centre for Advanced Religious and Theological Studies in the Faculty of Divinity of the University of Cambridge. The primary aim was 'to discover and to demonstrate ways in which the arts can contribute towards the renewal of Christian theology in the contemporary world'. An advisory board was established, a steering group gathered. We initiated a diverse programme which included lectures, seminars, courses and publications. Phase 1 (1997–2000) reached its climax in an international arts festival in Cambridge in September 2000, 'Sounding the Depths', which involved performances, seminars, exhibitions, a broadcast service, a day on film and theology, and two book launches. Literally thousands of visitors from many parts of the world – including the USA, Canada, Japan, India, Malaysia, South Africa, Australia, New Zealand, as well as from all over the UK – contributed to a remarkable week.

In 2000, TTA embarked on a second phase, running until 2005. Church-based activities are based at Ridley Hall, Cambridge, and its academic work is undertaken at the Institute

of Theology, Imagination and the Arts at the University of St Andrews, with a programme of postgraduate research, courses, lectures, publications, performances and conferences.

The 'pod' groups

From the beginning of the first phase, we were convinced that the project must involve practising artists at every level – art is first and foremost not a theory or an 'aesthetics', but something done. We were also convinced that some of the best fruit would be borne through intensive conversation and collaboration between artists and Christian thinkers. Hence four working groups were set up – 'pod' groups, as they came to be known – each comprising leading theologians and artists of various kinds. Each group met at least four times. Each was commissioned to produce an art work for the 'Sounding the Depths' festival. The groups were also asked to provide written material for publication, which would recount the process of collaboration and outline what the group members believed could be learned from their experiences about the future of theology. That written material forms this book.

It would be foolish to try to summarize their findings. There is a richness here which eludes any attempt at neat synopsis. A whole variety of ways in which the arts can enrich the theological enterprise appeared. For example, it was found that the arts could expose some of the more destructive anti-theological myths of modernity (*Parthenogenesis*); elicit conceptual tools – ways of thinking, models, frameworks, metaphors – for exploring, clarifying and re-conceiving the dynamics of God (see Ben Quash's reflections on *Till Kingdom Come*); overtly engage and open up foundational texts and doctrines (*Easter Oratorio, The Way of Life*); plunge us into the fierce dilemmas of living the Christian life (*Till Kingdom Come*); and expose truth by presenting its 'negative' or reverse image (*Parthenogenesis*).

Nevertheless, amidst the variety, it is perhaps worth highlighting some of the more significant broad strands of thinking which emerge and re-emerge in the pages which follow, especially with

a view to what they might signal about the way theology goes about its work in the new Millennium.

The collaborative dynamic

First, the collaborative dynamic itself seems to have been a major part of what the group members valued. In many circles it has become fashionable to favour 'process' over 'product', and 'corporate' over 'individual'. This can undoubtedly be over-played, especially when it is suggested that a concern for a 'result' or an artist's desire to work solo are somehow reprehensible. All the groups were acutely aware that something had to be pro-duced by a deadline, and the artists understandably wanted to do much of their work on their own; none of the writers seem to treat these as major drawbacks. (Indeed, the pressure to produce on time appears to have been a major spur to some very fine work, and, to pick up Alistair McFadyen's phrase, the notion of 'design by committee', where every artistic decision is put to a group, is most likely to lead to second-rate art.) But having said this, it is strikingly clear from these essays that the very activity of meeting together – praying, listening, responding, agreeing, disagreeing, exploring blind alleys, arguing at rehearsals, and so on – was not only intrinsic to the final result ('the play behind the play', as Ben Quash puts it), but also the means through which a vast amount of the most important theology was actually done. (No one ever treated another group member simply as a 'resource'. In Nigel Forde's words, here was 'Research material that answers back! That can suggest and explain with the utmost patience!'[5]) And, we should note, much of this interplay between people happened through the artistic media themselves – the collaboration during rehearsals of the drama group is a case in point, my own engagement through music with Paul Spicer and Tom Wright is another. The arts were the materials, not simply the channels, of learning.

The arts as required

Second, there is the conviction that theology not only benefits from the arts, but actually *needs* them. This is never far below the surface, and often breaks through quite explicitly. To cite one example, David Ford, pondering his own conversation with artists over many years, comments: '[It] has not been so much a matter of illustrating theological points with artistic examples; rather it is as if a satisfactory theological inquiry has *required* the arts.'[6]

There are a number of reasons, I would suggest, why theology will find itself pressed towards the arts in this way. Some arise simply because of the culture we live in. It is common, for instance, to point to the saturation of many parts of Western society with art of one sort or another, and to the explosion of electronic media which not only disseminate art with unprecedented power but have also generated many new forms of it. Arguably, a disillusionment about some of the grand claims once made for the natural sciences and an unease with direct and unambiguous styles of representation have led many to seek fresh meaning in the world of the arts and the imagination. Many would also allude to the ways in which matters of 'spirituality' are increasingly explored through artistic forms, even if such 'spirituality' is often diffuse and inchoate.[7] If part of theology's calling is to engage the main currencies of the cultures in which it finds itself, and if the late- or post-modern ethos is in many respects an artistic or aesthetic one (especially when broadly religious concerns are in view), then it is clear that theologians cannot afford to turn their backs on the arts.

Another reason why theology might find itself pushed into engagement with the arts today is because of a certain kind of damaging intellectualism in some theology, especially in the modern Western academy. It is a common lament that theology has often been captive to a Cartesian or quasi-Cartesian exclusive concentration on the mind. Theology becomes a certain kind of thinking which is supposedly prior to, superior to and

essentially separate from 'action' – the embodied commitments and activities which make up our lives from day to day. Liberation theologians, among others, have quite properly complained about this arid and self-serving vision of a supposedly 'pure' theology. It is just here that the arts can play one of their most crucial roles, for their immense *integrative* power is unquestionable: their ability to reunite the intellect with the other facets of our makeup – our bodies, wills, emotional life, and so on. In this way they can do much to offset the kind of dichotomies which have plagued so much Christian thought and nourish the kind of 'wise' theology I alluded to above.

A further reason why theologians might find themselves turning very naturally to the arts is that in many places theology has become unduly 'professionalized', restricted to full-time academics, such that people are denied many of the treasures, gifts and mysteries of the Christian tradition. One of the most encouraging features of today's Church is the flourishing of what is sometimes (unhappily) called 'lay' theology: theology for those who have had little or no contact with formal or institutional theological education. As many educators are telling us, very often the arts will be the natural language of such theologizing. The sculptor Henry Moore was once asked by a vicar about the process of sculpting a Madonna and Child. Moore said: 'I think it is [only] through art that we artists can come to understand your theology.'[8] What was true of Moore is doubtless true of growing numbers today.

But there are deeper reasons why theology cannot afford to neglect the arts. More than the particular challenges facing theology in this or that culture, as the 'pod' group writers make clear, it is the *subject-matter of theology* itself which invites close contact with the artist. A useful parallel here can be found in Martha Nussbaum's remarkable study *Love's Knowledge*. Her focus is on the inclusion of narrative literature in philosophical enquiry, particularly in the pursuit of ethical wisdom. She argues that when a writer chooses one style or form rather than another, the substance of what is said is inevitably affected, and that this applies to philosophical writing as much as anything else (even

though philosophers may be slow to admit it). 'Style itself makes its claims, expresses its own sense of what matters. Literary form is not separable from philosophical content but is, itself, part of content – an integral part, then, of the search for and the statement of truth.'[9] More than this, she claims that 'certain truths about human life can *only* be fittingly and accurately stated in the language and forms characteristic of the narrative artist.'[10] In other words – and she demonstrates this at some length – matters of ethics, or at least some fundamental ethical issues and concerns, *compel* the inclusion of narrative literature. Tellingly, she reflects on her early experience of teaching philosophy in an academic context:

> the conventional style of Anglo-American philosophical prose usually prevailed: a style correct, scientific, abstract, hygienically pallid, a style that seemed to be regarded as a kind of all-purpose solvent in which philosophical issues of any kind at all could be efficiently disentangled, and all conclusions neatly disengaged. That there might be *other* ways of being precise, *other* conceptions of lucidity and completeness that might be held to be *more* appropriate for ethical thought – this was, on the whole, neither asserted nor even denied.[11]

Those with ears to hear, we are tempted to comment, let them hear. Turning to theology, we might say something along these lines: given that God has chosen to interact with humanity through a form of 'dramatic' action (as Ben Quash argues below); given that this interaction has involved writings which include a very large measure of parable, myth, allegory, extended metaphor, and so forth; given that Christians celebrate a future hope whose description requires the imaginative 'stretching' of language in a way typical of the literary arts; and, not least, given that it seems ingrained in our God-created humanity, assumed and affirmed in Christ, to combine and juxtapose the materials of creation in ways that we call 'artistic' – given all this (and very much more), we are pushed to ask whether *theological enquiry which claims to be responsible* – response-ible, able-to-respond – to the God of the Christian Scriptures, to the particular

realities which this God has brought into being, and to the particular manner in which God has engaged with these realities, *is actually obliged to engage with the arts in order to be theology.* Of course, Christian history shows that time and time again, this has been acknowledged, even if sometimes quite tacitly. And, as a recent visit to South Africa reminded me, in many parts of the world, the arts have never left the theological arena. But history also shows that, for a variety of reasons, many Christian theologians have shrunk from engagement with the arts, and still do. (The paucity of courses on the arts in the contemporary theology departments and seminaries of Europe and North America is a sad testimony to this.) The witness of our 'pod' groups would seem to be that a re-engagement is not only profitable but, just because of what the Christian faith is, indispensable.

Is this to devalue or marginalize what we might call the more well-tried contemporary theological methods and disciplines? Not at all. These essayists show that a mutually enriching conversation is possible between what might be called more 'traditional' modes of enquiry on the one hand and the arts and their associated disciplines on the other. And the traditional methods can be greatly enriched in the process. What needs questioning is the assumption that only one intellectual avenue, or one set of intellectual tools is fitting for all serious theological endeavour. Sadly, this assumption is anything but absent today. Nussbaum's words could be all too easily applied to many a theology department: 'That there might be *other* ways of being precise, *other* conceptions of lucidity and completeness that might be held to be *more* appropriate for [theological] thought – this [is], on the whole, neither asserted nor even denied.'

To press the point further, in response to the oft-heard objection that to allow the arts a substantial place in theology inevitably means that theology becomes less rigorous, less precise, we need to insist that the very opposite can be true: the arts can generate greater rigour and precision, and thus help theology to be more appropriate, more faithful to its subject-matter – in Wright's words, 'approximate more closely to God's truth'.

Responsible respect

Third, there is one other prominent theme in these writings, all too rare in the history of the artist's encounter with the Church: the belief that one can be at one and the same time *theologically responsible* and *respectful of the integrity of the arts*.

In using the phrase 'theology through the arts', I have often met with anxiety from both theologians and artists. From the theologians' side, I have been warned that the phrase at best encourages theological confusion and at worst opens the way to art becoming an ultimate measure of theological truth. The primary orientation from which Christian faith receives its identity – towards the reconciling work of the triune God in Jesus Christ, as testified in Scripture and known by the Church in the power of the Spirit – is in danger of being forgotten. The anxiety is hardly surprising and needs to be heard. History is replete with examples of the arts over-determining theology: among the most extreme forms, the exaltation of art to quasi-divine status by some nineteenth-century Romantic philosophers; among the subtler forms, the keenness in much contemporary writing to identify the immense psychological power of music, film, painting or whatever as 'spiritual' or 'religious', and then cultivate some strain of 'theology' accordingly.

On the artistic side, the commonest worry is about artistic integrity. To speak of the arts serving theology – I have been told – inevitably means they will be dragooned into some kind of slavery, condemned to being mere carriers of predetermined theological 'messages'. Even worse, artistic freedom will likely be choked by some inflexible ecclesiastical orthodoxy. Either way, the arts don't get the 'room' they need. With these misgivings in mind, some Christians have joined a steady stream of writers who want to pull the arts apart from all questions of practical or 'extra-artistic' 'use' altogether, fearing (to pick up Nussbaum's metaphor) 'that the pressure of a practical question would, rather like a sweaty hand on an exquisite leather binding, sully the [artwork's] purity of finish'.[12] Again, the disquiet is under-

standable. Even if we dismiss the dubious view of the arts as 'autonomous' (for they are, and always have been, part of networks of 'use'), it is still true that all too often they have been treated by theologians as little more than attractive gloss for conceptual 'truths', secondary and colourful wrapping to be tossed away once an 'idea' has been grasped. David Ford rightly observes that 'There is often a suspicion that theology in the form of doctrine and argument fails to honour the integrity of [different] genres, tending to reduce them to an abstractable didactic content.'[13]

The writers of this volume, however, do not seem to be paralysed by either of these anxieties. A theological orientation is clear throughout, but they do not seem to find that the particularities of artistic making and enjoyment are thereby effaced or distorted. Indeed, the arts seems to flourish. One might go further – and these are my words rather than the 'pod' writers – and suggest that it is just *because* of a joint orientation to the triune God of Jesus Christ, who is committed to the flourishing of the world in all its manifold particularity and diversity, that they were able to honour the integrity of the arts with which they were dealing, and the integrity of the artists in each group.

Such, then, are some of the trajectories opened up for the future of theology in the pieces that follow. But there are many more, and it is hoped that the book will provoke readers to consider a wide range of ways in which the arts can 'sound the depths' and advance theology, wherever it is done and by whomever it is done. The writers do not formulate a neat agenda. But they provide materials from which many agendas could emerge, which in turn could have a considerable, perhaps sizeable impact on theology in the years to come.

The book is arranged in four sections, each devoted to a 'pod' group and its piece of art, and each prefaced with some explanatory comments of my own. Each section includes an essay by a person outside the group who records their own reaction to the piece of art produced. The genres and styles are very varied – ranging from academic article to poem, joint essay to interview – a diversity which, I believe, is significant in itself.

I would like to record my gratitude to all those who made the work of the 'pod' groups, and these essays, possible. Special mention should be made of the British and Foreign Bible Society, who were quick to grasp the vision at the heart of TTA and were the principal funders of the project's first phase. My thanks also extend to TTA's steering group, its advisory board, and numerous members of Ridley Hall, Cambridge and the Faculty of Divinity at the University of Cambridge – in particular, David Ford, Graham Cray, Daniel Hardy, Janet Martin Soskice, Ben Quash, Rosalind Paul and Sirscha Nichol. The huge organizational effort necessary to establish these groups, and the considerable workload entailed in setting up the events at which their work was presented to the public were borne principally by TTA's project managers, Fiona Bond and Ally Barrett, to whom I and countless others are deeply indebted. My colleague in Cambridge, Vanessa Herrick, has read through the entire script and offered numerous invaluable comments. I also want to thank Alex Wright of SCM Press, for his wisdom and support at every stage of the production, and Rebecca Jenkins and Katy King for their hard labour in collating material, arranging illustrations, formatting, proof-reading, and much else besides. My wife, Rachel and our four children bore a huge cost, for whom my appreciation and admiration are, as ever, limitless.

Jeremy Begbie
October, 2001

Notes

1 Below, pp. 210–11.
2 P. 64.
3 P. 28; my emphases.
4 I develop this more fully in *Music, Word, and the Future of Theology* (forthcoming).
5 P. 69.
6 P. 87.

7 See, for example, Robert Wuthnow, *Creative Spirituality: The Way of the Artist*, Berkeley: University of California Press, 2001.

8 As quoted in *Walter Hussey, Patron of Art*, London: Weidenfeld & Nicholson, 1985, p. 24.

9 Martha Nussbaum, *Love's Knowledge: Essays on Philosophy and Literature*, Oxford: Oxford University Press, 1990, p. 3.

10 Nussbaum, *Love's Knowledge*, p. 5. My emphasis.

11 Nussbaum, *Love's Knowledge*, p. 19. My emphases.

12 Nussbaum, *Love's Knowledge*, p. 29.

13 P. 88.

PARTHENOGENESIS

Parthenogenesis

The first 'pod' group to be established comprised the composer James MacMillan, poet Michael Symmons Roberts and the theologian Rowan Williams. The result of their collaboration was Parthenogenesis – a highly dramatic piece of musical theatre, scored for a small instrumental ensemble, soprano, baritone and actress. It was inspired by the World War II myth of a young woman, who, nine months after having been injured during an air raid, gave birth to a daughter whose genetic 'profile' was exactly that of her own.

The part of the clone-child's mother-to-be, Kristel, is sung by a soprano. Bruno (a baritone) is a flawed, failing, ambiguous angel; in love with Kristel and with the world. The spoken female voice is that of Anna, the imagined voice of the future clone-child.

Parthenogenesis received its premiere as part of the TTA 'Sounding the Depths' festival, on 12 September 2000 in the Cambridge Corn Exchange. James MacMillan conducted; the event was recorded and later broadcast on BBC Radio 3. There was a second performance at the Edinburgh International Festival, in the Queen's Hall, Edinburgh on 19 August 2001. At the time of going to press, a CD recording of the piece is being planned.

The three 'pod' group members reflect on their collaboration. Michael Symmons Roberts writes in the form of a poem, and his libretto is printed here in full. Michael O'Connor, Warden of the Royal School of Church Music, and his wife Megan, a freelance writer and editor, offer their impressions of the first performance.

Roberts has spoken of Parthenogenesis *as a kind of 'negative-print' or 'shadow side' of the incarnation: a virgin birth in opposites, with not God but human evil as the 'father', throwing theological truth into relief in an unexpected, paradoxical way. As such, the piece serves to highlight a range of tendencies in our culture today and their extreme contrast with the ways of God: destructive forms of control, the cult of sameness and repetition, the desire to replicate and repeat ourselves. But, as Rowan Williams suggests, the significance of* Parthenogenesis *may reach much further than the 'issues' of its subject-matter and their relation to God. Perhaps most significantly, it provokes the question: are theologians prepared to allow the arts to press them into engaging with doctrine in this way, through an imaginative exploration of the 'reverse' side of Christian truth, and in so doing, to rediscover something of the immense power of theology's own central commitments?*

2

Making it Strange: Theology in Other(s') Words

ROWAN WILLIAMS

The later months of 2000 saw the publication of new recommendations about the legal recognition and control of experimentation with human embryos, recommendations that revived the usually rather muddled debate about the moral implications of cloning human genetic material – and also the unexpectedly rapid legalization of cloning human embryonic material for research purposes. The less reflective responses to this issue often concentrate on what cloning is supposed to imply for the supposed absolute uniqueness of each human individual – responses that take for granted the popular science-fiction/cartoon version of cloning, in which exact replicas of individuals are produced in such a way as to be functionally indistinguishable: they look the same, they say the same, they can be relied on to behave in identical ways. It can be matter for comedy or tragedy, or simply melodrama (villains attempting to clone the genetic material of Hitler or whatever). There is little recognition of the rather substantial question of how our material *history* might constitute moral or personal identity; because it seems odd (to say the least) to talk as though genetic identity between human subjects dictated identical histories, an identical self-awareness, an identical memory.

But what might be called the mythology of cloning itself still shows the same fascination with the idea of being able to produce another *me*. It is a modern version of the powerful pre-modern urge to guarantee and perpetuate a bloodline, to live in one's descendants – one of the great themes of patriarchal

societies in various times and places. And some popular rhetoric about cloning from the scientific community can go along with this: do we not all dream, we are asked, of immortalizing ourselves? Or of making sure that our children will continue precisely who and what we are? Do we not long to get away from the risks of a history that will make things different?

It is a striking admission of our hunger for control. And in the context of current debate about genetic experimentation, it is not all that easy to draw the line between the sort of control we should regard as uncontroversially a good thing – the avoidance of pain and impairment where they *can* be avoided – and the desire for a totally secure environment at any cost. But perhaps before we try to settle any such issue in the abstract, it is important simply to register the nature of the problem. For ourselves and for each other, we desire freedom from suffering; we are, or we should be, aware that the desire to avoid suffering can at times bring about suffering of its own; that in the passion to reduce risks we begin to narrow the scope of our lives. What is frightening for us is precisely the fact that our identities are shaped as time passes by relation and circumstance, that they are not settled in all respects either by individual choice or by genetic determination. So we are always becoming ourselves in relation to what is not ourselves – other agents, circumstances, sheer accident. The difficulty is discerning where our desire to avoid suffering turns into the desire to avoid the other – the other person, the experience of a different kind of human life, the uncontrollability of circumstances, and so on. At least one of the questions we might be asking about the rhetoric around cloning is to do with the alleged attractiveness of reproducing myself; if what I want is to safeguard the self that exists at *this* moment, in these conditions, I am saying in effect that I'd rather not face the challenge of growing, of myself becoming different.

When people become 'messianic' about higher levels of genetic control, there is often a not-too-deeply buried agenda that has to do with just such a fear of otherness or difference – sometimes at the level of very crude assumptions about the tolerability of human life lived with one or another sort of impairment, which

is why in the discussion about genetic control, it is important to listen to the voices of those who actually experience what we call impairment. As most commentators agree, the subject is clouded by the undoubted fact that the highest levels of enthusiasm for genetic improvement or purification in the first half of the twentieth century were associated with anxieties about racial purity, fear and disgust directed towards certain kinds of difference. No one would suggest that contemporary concerns about genetic therapy can be reduced to this; but we need to hold this memory in mind if we are to avoid treating our hopes about therapy as hopes for the elimination simply of what happens to make us feel uncomfortable because it is humanly strange.

Cloning means reproducing precisely the same genetic 'script' in a distinct physical form. If cloning occurred in the natural order, it would be by means of literal single parenthood – a new individual brought into existence out of one and only one genetic carrier. Parthenogenesis, virginal conception, would be necessary for this, the division of a single cell within the parent body without the intervention of another genetic 'donor'. At the simplest biological level, this is how reproduction happens, by the division of single-celled organisms. There are examples in the plant world, and some (very few) in more complex animal organisms, which have been the subject of rather inconclusive experimental investigation. There appear to be no scientifically authenticated cases in the human world, though there is a certain amount of anecdotal material. One story that surfaces in a couple of surveys has a particular interest because of its setting, and it is that setting that prompted Michael Symmons Roberts and James MacMillan to the collaboration that issued in *Parthenogenesis* as performed in Cambridge in the autumn of 2000. It is the story of a young woman in Hanover in 1944, caught out on the streets during an Allied bombing raid; although her superficial injuries were not serious, she gave birth nine months later to a child whose genetic profile was identical to hers. She insisted that she had not had intercourse before conceiving. The only explanation that could be offered was that

the impact of the explosion somehow triggered the process of fertilization, so that a separated fragment of cellular tissue implanted itself as would a sperm.

Confirmation of this bizarre story is lacking; it may be a kind of urban myth, or it may be a true story the records of which vanished in the chaos of the period. No one seems to have recorded whether the child survived (or the mother). The child was, of course, a daughter, there being no source for the divergent chromosome that would determine maleness. But the truth of the story is irrelevant. It stands as an extraordinary symbol of what the world of the Third Reich was obsessed with. Here is precisely an identical, a 'pure', self-reproduction, such as the ideologues of Germany dreamed of: the ultimate guarantee of racial 'integrity'. What might such an occurrence have meant to a German of 1944? The child would have been 'messianic' in a pretty literal sense, a promise of the possibility of preserving untouched the present purity of German identity . . .

But at once the ambiguities flood in. The self-identity promised is not only a perfect genetic continuity; it also abolishes that fundamental presence of difference in the human condition embodied in sexual differentiation. The pure race could only be a succession of women. How would the passionate Third Reich cult of masculine heroism and feminine domesticity cope with the idea of purity at the expense of masculinity? And the conception is the fruit of violent action by a committed enemy; what does it mean to have purity and identity created out of violence that is aimed at destruction? Is it only in the ecstasy of destructive energy that the 'gift' is given which can secure the future? What sort of gift is it that arises from something like a rape without sex and that (in the terms of the ideology of the context) produces a defenceless 'feminized' humanity? It is as if the cost of purity is both rape and castration.

Seen in this light, the story of the Hanover parthenogenesis reads almost as a myth of *hubris* or a fairy-tale about how wishes are granted in a way that destroys what is loved and valued. Reflecting further on it, one might imagine what it might be to be the 'child' of an act of apocalyptic violence, an absence that is

also an invasion of terror; and the child only of a mother with whom one is genetically identical. What would a human identity be that knew no 'ordinary' difference – only genetic sameness and the explosive intrusion of technological violence as its genesis? Such a question suggests that the story is more than a fable about Nazi Germany; it may be a tool for thinking about what our fascination with genetic control could ultimately imply for human self-awareness. We are properly sensitive about what it might mean to be a child of rape. There seems to be an issue somewhere here to do with what it means to be a *child* at all – the product of a certain process and a certain relationship. That suggests some further questions arising from our current hopes and fantasies: what does it actually mean to be the product of an artificially engineered process (an anonymous 'donation' of genetic material)? In what sense does our awareness of human identity as traditionally imagined involve the awareness of being 'parented' in more than a purely technical way? Developmental psychology might suggest that the growing process of a human individual conceived and born under controlled and impersonal conditions might be significantly different from what we commonly take for granted.

Rapid answers to these issues are, in the nature of the case, not available. But the two basic matters raised do need more than casual reflection: what does our interest in genetic sameness and 'stability' mean for our self-understanding? And what sort of personal self-awareness results from artificial generation of various kinds? Theology does not give a solution to these riddles, but offers some tools for the more-than-casual reflection that is called for.

The parthenogenesis narrated in the Christian story becomes, in this context, a good deal more than an embarrassing mytho-logical adjunct to the doctrine of the incarnation. Mary con-ceives by an agency more 'other' than sexual differentiation, yet not other in the sense of another participant in the world's process. She conceives by free response to the gift declared by God's messenger; she is perfectly prepared for this gift, it seems, yet it is not something that emerges from her own will or

foresight (she is both surprised at the angel's greeting and ready to respond). Her child is a son, not a daughter; not a genetic repetition of her own physical identity. In short, the divine gift as it supremely appears in the incarnation, affirms as clearly as could be that God's action for human liberation and change is involved with otherness at every level. The virginal conception anchors the events of salvation in an encounter with something immeasurably more strange than sexual otherness; Mary's freedom is realized in being wholly seized by God's freedom – which instead of appearing as the successful rival will that overcomes her liberty is shown as precisely what makes her liberty infinitely fruitful. The pattern of divine action in the incarnation echoes but does not repeat what has been done before. And the angel of the annunciation proclaims, literally, a new creation that both is and is not the world we know: the saviour who is utterly intimate with humanity and utterly intimate with its maker.

How is this vision to be connected with the world of scientific 'messianism' with which we began? For the group working on *Parthenogenesis*, the way of realizing the implicit critique in the annunciation story of so much of our contemporary fantasy was in exploring further the 'myth' of what you might call a secular virginal conception. What could imaginably be 'incarnate' in such an event? What is 'announced' to the world? There were many directions in which the myth could be taken, and the Cambridge composition opened only a few. But fundamental to the enterprise were considerations about what the cult of sameness and repetition does to love, and thus, ultimately, to growth, movement in real history. The ambiguous figure of Bruno in the work (a falling angel? a pseudo-angel?) is constructed around this issue. He loves the world, loves the virgin mother, yet his love coincides with the traumatic violence of the bomb. Ultimately he needs to be loved, and is helpless to change the world he longs to embrace. He has something to do with what St Augustine says about our failure to 'love human beings humanly' – that is, to love them in their diversity, incompleteness and frailty.

In his essay in this volume, Michael O'Connor suggests that it was 'a play of absences': there is an absent *relation* at the centre of the story, the human relation that should be the source of new life. The Christian narrative is about an absence too, but it is that uniquely inviting absence that is effectively and functionally the presence of the unimaginable God; relation to this God is the ground of Mary's conceiving. But for our story, there is also an absence of God that is sheer emptiness, an emptiness filled by the dark angel of violence. We hadn't thought of it at the time, but there are parallels here with the theme of Iris Murdoch's chilling novel, *The Time of the Angels*:[1] her point is that the absence of God is not, as optimists might think, a liberating clearing of the skies, but condemnation to a world ruled by 'angels', spiritual powers that are uncoordinated, ungoverned, destructive. There is nothing for them of which to be messengers. Bruno belongs in just such a world. And within the same ambience of ideas, we have a daughter who cannot be other than her mother, a daughter who is absent *as* child, and whose bitterness turns on her identity as a kind of splitting or mirroring of another identity. She has no 'ground' of difference, so is importantly not there: we had many discussions as to how her 'not being there' could be represented visually, verbally and musically.

All this begins to point to an insight about method that emerged in our work together. If it is really as hard as it seems to speak with integrity about God in our current cultural climate, some things can only be said by parody, by 'near-misses' of religious utterance – the kind of strategy you might identify in, say, the religious poetry of Geoffrey Hill. Don't be didactic; imagine the translation of a religious narrative into the frame- work of secularity; then prompt the question of what has changed. The secular myth veers decisively away from the valuation of contingency and difference; what might that say about secularity itself? If we were 'in control', would we be shaping a utopia or a hell? And would we be emancipated from a tyrannical deity or enslaved to the angels? Would we be shaping a real future or freezing for ever the present in which we stand? Only by putting the parody together in some such way, it

seems, can we understand the original narrative in a way that is not stale or merely pious.

The possibilities of a parodic religious art are intriguing and very rich these days. Look at successive numbers of the excellent American journal of religion and the arts, *Image*, and you'll see a whole series of studies of visual artists (Gregory Gillespie, Richard Kenton Webb, Jim Morphesis, Robert Gober and others) whose idiom is essentially parodic in this way: dependent upon a half-remembered repertoire of Christian symbolism, and provoking questions about that symbolism by reworking it, sometimes in disturbingly subversive forms. It is almost a visual translation of the method of Flannery O'Connor's novellas and short stories. These set out to show what grace is by imagining a world without it – not a secular world in the usual sense, but a world perhaps ruled by the ungoverned angels, in which obsession, hurt, frustrated love and fantastically misdirected prayer and devotion take the place of God. But it is as we see this worked out in O'Connor's often grotesque narratives that we begin to grasp what might be the proper focus of these extreme, wounded, passionate interactions. Without God, there is nowhere for some parts of the human constitution to go, so to speak, except into violence and madness.

This is not to construct an apologetic by covert threat (without God, we are doomed), but to recognize that religious language and practice is something that belongs in a dangerous region of the human self, and that the danger is at risk of being unleashed if the attachments are wrong. It doesn't need saying that *within* religious language and practice the danger is still there; and that some of what is supposed to be directed towards God is in fact directed towards the 'angels', towards a God who is less than God. But this is precisely why an imagination like Flannery O'Connor's works on the margins of orthodox or conventional religion, in the area where faith and blasphemy mingle apparently indistinguishably. Only by laying out unsparingly what the world of the angels is like can we see something of the truth of faith.

If this is the method, there are some things you mustn't

do. You must not reach for the language of orthodoxy to fill imaginative gaps – that is, you must face the full implications of the premise that grace is absent or frustrated in the world you are constructing. You must not simply create a problem to which grace is the answer. You must keep close to the danger of the emotions and interactions you are tracing, and not give the impression that mere incorporation in the orthodox Christian fold will neutralize the danger. It is not an easy line to tread: O'Connor negotiates it with extraordinary skill, some other novelists less so. To take one example, John Updike's *Roger's Version*,[2] a novel about a libidinous theologian trying to come to terms with modern scientific cosmology and its possible implications for faith, is, like all Updike's work, written with elegance and delightfully felicitous verbal play; but its evocation of redemption as something sensed in the middle of a quite conscious moral degradation leaves a feeling of being imaginatively cheated. The narrator's 'Barthian' consciousness of grace abounding misses just that monumental awareness of risk and delusion in the world governed by angels that Flannery O'Connor so relentlessly presses upon us. A more honest (and formidably complex) exploration than Updike's of a similar cultural agenda is E. L. Doctorow's recent *City of God*,[3] although here the resolution is a drastic break with any orthodox language at all.

But to return to the *Parthenogenesis* project: I have been trying to suggest some analogies between what was there attempted and the method of someone like O'Connor in order to bring out our own sense of the virtual impossibility, in an age hostile to 'orthodoxies', of representing our faith commitments in imaginative form by using a direct and unambiguous style of representation. Some of our collaboration had to be about a kind of mutual 'holding-back' on the part of artist and theologian, to ensure that it was indeed the negative print that would appear. We were concerned, ultimately, with a mindset in modernity that is intensely involved in the dangerous areas of feeling and hope that I have been trying to identify: the messianism around genetic technology, the sense of the sacredness of the individual

self, whose primary task is to secure its exact reproduction, the passionate struggle to overcome time and matter and biology. By using an 'annunciation' story to make concrete this realm of displaced religiosity, what I have been calling the world ruled by angels, we were seeking to open up the question of how modernity meets its judgement, spelling out the sense in which our cultural messianisms conceal a myth of sterility.

This probably makes the process of the composition of *Parthenogenesis* sound a great deal more self-conscious than it actually was. Of course we did not sit down and decide to expose the myths of modernity by discovering a suitable narrative vehicle. It took time to sort out why the story of 'Kristel' and her child had struck each of us so deeply; why and how it suggested complex and ramifying connections with aspects of the world we inhabited. And this needs saying as well: art, whether Christian or not, can't properly begin with a message and then seek for a vehicle. Its roots lie, rather, in the single story or metaphor or configuration of sound or shape which *requires* attention and development from the artist. In the process of that development, we find meanings we had not suspected; but if we try to begin with the meanings, they will shrink to the scale of what we already understand; whereas creative activity opens up what we did not understand and perhaps will not fully understand even when the actual work of creation is done. That is why the artist is never the sole or even the best judge of the work, which rightly and properly escapes into the interpretative field of its public. What I think we experienced was the process of finding resonances in a story that in turn forced us to re-imagine the story itself. I wonder, incidentally, if this is not something we ought to be seeing in the process of the composition of the Gospels: not a story repeated, nor a story invented to make a point, as the more mechanically minded critics might argue, but a set of narratives constantly being retold, and altered in the retelling because of what the very process of telling opens up, shows or makes possible. But that needs a bit more exposition than there is room for here, I suspect.

To emphasize in this way the indeterminate elements even in

a composition of some theological self-awareness is to make a point about how the manner of working is intrinsically connected with the subject worked upon. If the composition of this or any work were determined by the meanings independently agreed in advance, this would in fact be another version of just that perpetuation of the same, that repetition, which we identified as near the heart of our cultural malaise. Artistic work is always discovery, not illustration. Or, to put it slightly differently, but to connect it with the whole thesis of this essay, artistic work both engages with the real otherness of the environment and itself becomes 'other' to the original planning mind as it moves towards its final form. It is not an empty cliché to repeat that the artist genuinely doesn't know until the work is coming to its expression just what it is going to be.

And this does indeed take us back to where we began. For the perspective of faith, the formation of what is properly human is constantly being held back or distorted by the urge to *repeat*, to enshrine what exists already, the self I know and am confident of. We are persistently afraid of history. Faith regards history as essential to our integrity as humans, not only because we actually exist as changing physical organisms, but because God's own primordial act is the generation of what is truly other than God. Before the world is made, God generates a divine other, in a relation both more intimate and more differentiated than we can find words or ideas for; and, says classical theology, that act of generation is the eternal foundation for the act of God in making a world different from the divine life, and a world that is so made as to go on differentiating itself as time unfolds. Repetition is not, it seems, what God is interested in. And in the world of time, each reality becomes itself in two ways that reinforce this insight. Created things become themselves as they change, as they become 'other' to what they have been. And they become themselves in relation to other agents in the world. For this to be the way the world works, there has to be at a fundamental level an absence of control for any one isolated agent over the process of becoming. God's own creative act is not the imposition of a divine individual's plan on a set of subordinate and limited wills,

but the formation of a world of possibilities whose realization is genuinely indeterminate at any given point in the story. God does not repeat God (the relations in the Trinity are not a process of divine cloning); and the world would have no integrity in itself if it were a repetition of divine life (and so it must be subject to change and chance, and itself a process of more than repetition). The artist (Christian or not) is involved at a very deep level in trying to do justice to this divine principle of non-repetition.

And I find myself wondering, in the wake of the experience of working on *Parthenogenesis*, whether the process of finding a scheme of representation for doctrinal truth by way of inversion and even parody has something to do with the very same principle. Perhaps theology itself needs excursions into the mirror-world of what it is *not* saying in order to find what it *is* about. The tradition of negative or apophatic theology has always, of course, held this corner for the theological enterprise; but it seems that negative theology need not be only the prayerful denial that attributes ascribed to God cannot be understood in the sense they would have if applied to creatures. It can also be the imaginative process of exploring a world of absences, the absence of grace or the absence of newness or the absence of mercy, so as to begin to see where – in Wittgensteinian terms – the language of God would 'come in', not as a solution (because the world *can* be consistently imagined in important ways as without grace or whatever), but – how to put this? – as the 'what-comes-next', the turn of a situation towards change, that makes the chronicles of created time more than a record of imprisonment. More simply, if there were no God, what would this be saying about the world, what difference would it make? Perhaps not much or anything in a scheme of explanation; but what in a scheme of imaginative construction or human understanding?

This is one way, certainly, of reading the Christian poetry of George Herbert or R. S. Thomas or Geoffrey Hill, as the licensed experimentation with the 'dangerous edge of things' (to quote another Christian poet – Browning – who is a lot less comfortable than some readers have thought) that will in some way show what cannot be said 'straight' in a context in which the direct

utterance of faith has become embarrassed or stale, when it no longer (and it is Bonhoeffer I have in mind here) makes a difference. How theology sustains this kind of experiment is a searching question for those who practise the discipline; but I think that what is at issue is just what lies behind the traditional discourse of apophaticism: the sense that anything like direct and descriptive language for God must in some significant ways be inadequate – specially inadequate, perhaps, when even the best of that language is seen as the dialect of an eccentric cultural ghetto. Can this kind of apophaticism release us from such a ghetto? What I've been calling the parodic voice can do two things at least: it can pick up the residual memories of religious themes, narratives and pictures, the cultural echoes of a half-understood faith, and simply remind the culture that they are there, without insisting that they instantly be revived and highlighted; and it can make that half-memory, that vague familiarity, something strange (different) and therefore something of a question. The images and narratives that are regularly both garbled and patronized in our culture can emerge with novelty and oddity in the hands of an artist who can find a way of speaking that *begins* from the incomprehension and indifference of the general cultural milieu. Needless to say, this is something quite distinct from the revival of the motifs of unexamined religious folklore which has in recent years produced an intriguing crop of films about angels or devils or both. There is a difference between parody and pastiche.

The theological implications, then, of collaborating on *Parthenogenesis* are not so much to do with specific insights about an 'issue', though the issues around cloning with which this essay began are serious enough in all conscience. It is rather that the process of constructing a sort of post-Christian myth, a negative photographic image of the familiar narrative, uncovers something of the character of the God who is the subject of theological discourse, the God whose passion is for difference; and so too, something of – not exactly the character, but the potential of theological language itself to *be* itself, to speak its truth, in this process of retrieving itself through alienation and parody. That is

no news for a lot of serious Christian artists, as I have noted in the course of this essay, but it is a rather new way of understanding how Christian theology can contemplate the undermining of its own procedures. The *via negativa* isn't necessarily the austere dissolution of concepts in silence; it can also be the acceptance and exploration of the artist's search for a way around the one-dimensionality of unexamined doctrinal speech. If as believing theologians we have sufficient trust in the resilience and resourcefulness of the doctrinal tradition we inhabit, this ought not to be alarming. A poet like Herbert allows himself the dangerous emotional experiments of some of his poems (what does rejection of God *feel* like, what are the 'right' words in which to say 'No' to God?) because he wants the theology of assurance and absolution to be linguistically and imaginatively serious, and because he believes such seriousness is truly implicit in the doctrine, however blandly it can sometimes be presented. Something of that order is involved where we look for and look at the 'photographic negative'; and I can say with some feeling that the co-workers on the concept and fabric of *Parthenogenesis* recognized the business of composition precisely as an entry into the centre of the doctrinal commitments they shared.

Notes

1 Iris Murdoch, *The Time of the Angels*, London: Chatto & Windus, 1989.
2 John Updike, *Roger's Version*, Harmondsworth: Penguin, 1987.
3 E. L. Doctorow, *City of God*, New York: Random House, 2000.

3

Parthenogenesis

JAMES MACMILLAN

The poet Michael Symmons Roberts and I had collaborated on a couple of projects before the creation of *Parthenogenesis*. Our first work together was *Raising Sparks* – which sprung forth initially from Michael's reading of the eighteeenth-century Hasidic mystic and theologian Menahum Nahum. We then produced *Quickening*, for the 1999 BBC Proms – a large-scale work for various choral groups and orchestra – which celebrated the mysterious fragilities and ambiguous sanctities of human life. We share a wide range of theological, artistic and political concerns, and both of us have been delighted by the fruitfulness of the working relationship that has developed.

Ideas bounce back and forth with ease and good humour as well as deep thought, and we seemed to fit Jeremy Begbie's concept of the 'pod' group, where artists and theologians pooled their enthusiasms and expertise to spark off new avenues of artistic adventure. Michael studied theology at Oxford and was a great admirer of Rowan Williams. Through both Michael and Jeremy, I gradually began to acquaint myself with his work, and eventually we set up an official connection.

Jeremy brought us all together and attended the first of about a dozen regular meetings. It was not long before we fastened on to a common concept that provided the basis for much discussion and thought, bearing artistic fruit in due course. I have no proper theological training at all, and only in recent years have I been able to direct my amateur fascination in particular directions. The 'pod' group experience has proved invaluable and exciting for me but initially I was rather overawed. However, all of us have a wide range of experiences: Rowan is a poet

as well as a theologian, so was able to bring some of that poetic presence and insight into our discussions at an early stage. He is also a lover of music, and with Michael's wider concerns as well as my composerly sympathy with poetry and extra-musical stimulus, there was an easy confluence of contributions. We were able to proceed to finding common ground, out of which the piece grew.

The idea for *Parthenogenesis* originally came from Michael. Through his work at the BBC he had researched the vexed topic of genetic experimentation and had produced a documentary on it. He had interviewed many geneticists and had explored some of the ground already. During his researches he came across the astounding Hanover case-study on the internet, and discovered that it had been documented by doctors and scientists at the time, and discussed by geneticists ever since.

The chosen story motivated our discussion in a number of directions, impinging on ethics, on the concept of human individuality, on the sanctity of life, and on the very nature of human creativity. All art is a kind of mirror image or a response to divine creation, to the first gesture of creation by the Creator. In many ways, artists have a tiny glimpse into the pathos with which God, at the dawn of creation, looked upon the work of his hands. John Paul II, in his Letter to Artists in the Holy Year of 2000, talks of 'a glimmer of that feeling (which) has shone so often in your eyes when – like the artists of every age – captivated by the hidden power of sounds and words, colours and shapes, you have admired the work of your inspiration, sensing in it some echo of the mystery of creation with which God, the sole creator of all things, has wished in some way to associate you'.

In *Parthenogenesis* I suppose we were tracing around similar territory. The 'pod' group experience was an exploration of human creativity from the artist's perspective, but also of what it means to create human life. And throughout this exploration there emerged a range of different interconnecting threads, and all before a note was written!

Many of my works begin with an extra-musical starting-point. The pre-musical inspiration is an important factor on the specific

nature and character of the music itself. It is important that this connectiveness between the pre-musical and the musical is always palpable and audible in the final creation. Important in many works is the crucifixion narrative. I have traced its territory literally in works like *The Seven Last Words from the Cross; Visitatio Sepulchri* and *Triduum*, but also obliquely in the theatre works, *Busqueda* and *Ines de Castro*, where the emblem of the cross is made manifest in the lives of ordinary people. In all these pieces, the theological pre-echoes the musical. In the case of *Busqueda* the connections between the extra-musical and musical are complicated and multi-layered. It is a music-theatre work which sets poems of the Mothers of the Disappeared from Argentina, interlaced with the Latin text of the Mass. In *Busqueda* the political comes together with the religious, the sacred with the secular, the timeless and the contemporary progressing in parallel lines which sometimes bend towards each other and intersect.

For me, finding inspiration in something that is not immediately musical in the abstract sense is an entirely natural phenomenon. This can sometimes seem incongruous in a form that is the most abstract of the arts. At a fundamental level music does not need any justification or explanation other than its own substance, its own musical parameters. Music speaks and communicates strongly without words, beyond words, and in its purest sense, represents nothing other than itself.

However, people who love music talk genuinely about the 'language' of music and of that language not only 'speaking' to them in the depths of their souls but also about how music transforms their lives. On this basis music cannot be totally abstract and has profound implications for the whole self. Music cannot be separated away from the completeness of our everyday lives and boxed off into one little aesthetic corner of our existence. Whether they are religious or not, people can and do speak in religious terms about the life-enhancing, life-changing, life-giving transformative power of music. This quasi-sacramental aspect of the form proves that music has a power and depth to touch something in our deepest secret selves, for music cannot be

contained in its abstract parameters. It bleeds out into other aspects of our existences and experiences. In a very palpable sense music can justifiably be described as the most spiritual of the arts.

Poetry has a parallel theology and a similar expanse of aesthetic debate. Because of this I found much common ground in my discussions with Michael and Rowan. As with every other piece I write, *Parthenogenesis* also required much pre-compositional meditation. But in this case ideas were bounced around and between three individuals rather than in a solitary reflection.

Writing music and writing poetry can be very lonely and isolating activities. These are necessary solitudes because in that separation and silence art is created. But sometimes there can be an arid solitude. There is a very thin dividing line between that which is fertile and that which is dessicated and artists need to keep their minds and souls active. We need to be inspired through our reading, our relationships and our many interfaces with society. External influences plant the seeds of growth.

Divine inspiration is an external influence but it can be present in the minds and words of one's fellows. To explore common threads, common ideas and common enthusiasms such as we did in this 'pod' experience was a heightened, focused way of bringing the extra-musical, pre-compositional instincts to bear on the music itself.

Many might think that the story we tackled is a subject that sits uneasily within a Christian context. It touches on areas that are uncomfortable, messy and disturbing, but I feel that theologians need to engage in these areas and be involved in debates pertaining to the nature of human life which are currently raging in our culture. It is tempting to retreat from this engagement, to hoist the white flag and to ease effortlessly into positions which correspond to new secular orthodoxies. But to do so would leave a huge gap in the wider understanding of these issues. Western, post-modern, post-Christian society will continue to be enriched by our experience, our traditions and our perspective on the sanctity of life, for example. We must continue to bring a unique and precious contribution to the discussion.

Some might think that *Parthenogenesis* is blasphemous. There is a dark annunciation at the heart of this work. The father of the child is not God but human evil in the shape of a bomb, the explosion of which dislodged the cell in the woman that led to parthenogenesis. To cast human evil as the progenitor in our story throws a negative mirror image on the Annunciation. We have presented it like a mock annunciation where the woman is visited by an angel, a fallen angel. Their dialogue is not chronological or historical, but rather an imagined philosophical engagement between an ordinary woman and this dark, fallen angelic presence who is like a wounded prowling animal. In another dimension is a child (the clone) who comments separately and bitterly.

Although the implications of this scenario are discomfiting, there is a long tradition of Christian artists feeling the necessity to confront and embrace the harrowing central presence of the crucifixion in the great narrative of sacrifice and redemption. One does not have the resurrection without the crucifixion. By confronting the darkness of this tale one takes the cross into the abyss and redeems it. To retreat from the abyss and focus solely on the transcendent would be to conform with the post-Christian spiritual narcissism of our predominant capitalist culture. We are artists formed in the Christian tradition, and precisely because of this, we bring a radical confrontation and challenge to all that is fashionable and accepted. If our radicalism has a transcendent potential it is because it is rooted in a knowledge of the death of Jesus.

From this position the depths of the human spirit can be probed and plumbed, but not in a spirit of glitzy nihilism that is now so sanctioned by the official arts establishments. The crucifixion is to be found in the here and now, in the turbulence of society's culture wars, in the provocation of its politics, in the dirt and in the mire of the world's dispossessed and in the sorrows as well as the joys of ordinary people. That is where Christ's Church should be, that is where one finds Rowan Williams, and that is where artists like Michael and I need to be.

The 'pod' group experience led to more than the composition

of *Parthenogenesis*. It led to a significant reflection on our positions as artists of religious faith in the modern age. In that sense the reflection was invaluable – vital even for the way we approach each new artistic endeavour in the years to come.

4

Study for the World's Body

[after a painting by R. B. Kitaj]

MICHAEL SYMMONS ROBERTS

The poem relates more to the TTA aims and the 'pod' process than specifically to Parthenogenesis. *In part it is about the inter-relatedness of the arts – it is a poem about a painting about a dance – but also about the open-endedness and risk involved in making any worthwhile art, and any worthwhile theology (author's note).*

It only looks like an embrace
when frozen. In truth it is

a dance; unaccompanied and slow.
This house feels abandoned. How

a couple came to be here in an upstairs
room (nothing through the glass

but open sky), is immaterial.
The point is, they cannot tell

what has interrupted them,
some sound outside their room

has made him jump and swivel:
perhaps a weightless footfall,

a ventriloquist's trick, a voice
thrown, a voice cut loose

and trapped in its own simple
utterance. The stripped walls

40

of this house have made an aural
hall of mirrors, so a single

board creak is a possible epiphany,
each draught is a litany

of hopes and fears. What is it
he is so afraid of? She is not:

her white owl face is lineless,
eyes calm, lips apart but silent.

Her hand, on his shoulder still,
pulls him gently back, pulls

him back into the real world
of bodies in motion, the weight

and measure of a dance.
Here is a story of love, loss, chance,

not in the blank sky, sanded
boards, the coatless hanger

on a nail, the empty hanging
socket in each ceiling;

but among the perfect geometry
of unfurnished rooms, an intimacy

takes two people by surprise.
It may be, in the world's eyes

they should not be here,
but without their risk the house is bare.

5
Libretto for *Parthenogenesis*

MICHAEL SYMMONS ROBERTS

*Anna, a grown-up clone-child. Individually spotlit in a place
away from the stage, she wears a crimson dress.
Kristel, mother of Anna. Her dress is similar to Anna's, but a
deeper, darker red, closer to purple.
Bruno, an angel, dressed in a black shirt and suit.
Bruno and Kristel are on stage together, facing each other but
with some distance between them.*

ANNA

I am. I am my mother's twin,
her spirit-duplicate, her flesh-ghost.

There was a time, when I had lost
my milk teeth, before her mouth turned black,

there was a time when I was often
taken for her. Good friends, cousins

mistook me for my mother, so I took
to vivid lipsticks,

bleached and grew my hair,
painted nails, hemmed-up skirts.

Then it was her lovers, old flames
reignited by a flicker of the past.

'It's incredible,' they said. 'You are her
perfect match, her doppelganger.'

BRUNO

If I had wings, one glimpse
of them would burn you blind,

their radiance would stagger you,
but you would have to look.

If I came with a gift
it would be a flawless lily

or a thornless rose with no scent,
without the sweet-sick smell of rot,

without a black fringe to its leaves,
and what would be the sense of that?

So I stand before you grounded, earthed;
at home now in this wounded world.

KRISTEL

Now for the first time I see you,
set late summer sun, clotted light,

Angel of the house, you have flickered
in the corners of my eyes, but here you stand,

coarse-suited, powerful with ease,
at home as if you owned the place,

although the place owns you.
Are you my Gabriel, my guardian, my Azazel?

ANNA

She lacks the usual accoutrements:
a lily or rose, a book of devotions,

crown, apple, mirror or moon.
No, this is no annunciation.

Her messenger is wingless, clipped
and I believe he is in love with her.

He envies her her body,
its openness to dissolution, death.

She is no seamstress either;
not spinning, weaving, the usual

symbols of gestation. This is no
annunciation, but he does have a message,

and before long I'll be stitched
inside her like a lost sibling,

like a twin taken into her sister's flesh,
absorbed and forgotten.

BRUNO

I have watched this house for long enough
to know why human kindness is called milk.

At first, you are so full and heavy,
longing to express it, fit to slake a thirst;

but as the rhythms of dependence come,
which call for richer hindmilk,

then those suckling lips feel waxy,
so you turn your milk to sand.

KRISTEL

Do not condemn our lack of love,
our hearts are choked with fear.

We never raise a shout. We keep a bed
made for the worst without expecting it.

In summer we hope, in winter trust.
We took this house for peace sake;

but our wars tear us to pieces. Our men
hear voices and our women will not speak.

ANNA

My sister-mother-stranger,
the building blocks of my life

were written deep inside you all along
like your real, your secret names

– Adenine, Cytosine,
Thymine, Guanine –

This angel gave you no choice,
just a warning. Barely a warning,

more a prophecy. Some prophet:
in love with the body of the world,

in love with your body, forgetful.
Witness an angel in free-fall.

BRUNO

I have lived in gardens, was born in the first,
but I have never had the taste, touch, sound, sight, smell.

If this feels like a house in which families have broken,
– windows painted shut, their sashes cut – if you see

no hope but to rip it to its boards and start again
because the atmosphere oppresses, that is me:

I have been here since the first threshold was crossed;
all that was done was done to me, all that was lost I lost.

KRISTEL

You are bleeding. Your hair is matted where it heals.
You crossed worlds to meet me, and you bear the scars,

If I kissed your wound, like a mother does a child's,
would the order of creation break apart?

would all the noseless statues that pyramid
up faces of cathedrals crash to pieces on the flagstones?

would the sleeping dead wake up to find
no maps and no known landmarks?

ANNA

Parthenogenesis: fatherless conception,
growth of an egg without fertilisation.

It requires a shock, a bolt of lightning
or a bomb, to trick the cells into dividing.

Any life that comes of it is female,
a bastard daughter; shadow of her mother.

No-one knows how long a clone-child lives;
until the first beats of her embryonic heart,

or into full maturity, old enough
to understand the doppelganger myth;

that she who meets her double
meets her death. One of us mother, one of us . . .

*(Towards the end of Anna's speech Kristel crosses the room and
kisses Bruno on his head, like a mother does a child. Then she
returns to her original position.)*

KRISTEL

Your hair has printed stone onto my lips;
sandalwood, iron and rain, tastes of this house,

but you smell of scented bark too,
a herb track underfoot, a bonfire of fruit.

Your eyes are wet and pinched
from years spent staring at our darkness,

BRUNO

A kiss. A kiss like chrism on my hair.
Now I understand the firm clasp of the sepals

round a new bud. When they burst in petals
I will make you attar from Damascus roses.

A girl will come to you, a daughter.
Her name is Anna. She will have no father.

ANNA

Forget the roses. Think of rood wood;
the tree that gave the cross. Bring her

that contorted ilex. Not the true cross,
which lies splintered in a thousand churches,

but a cutting of its mother, a cutting
of a cutting of a cutting of a cutting of a cutting . . .

6

A Play of Absences

MICHAEL AND
MEGAN O'CONNOR

When Charles Darwin married his own cousin, he feared that the tightness of the knot might harm their offspring. Although he lacked our modern imagery of DNA, Darwin knew that our choices can take on a new life, which we cannot control, but for which we are, in some shadowy way, responsible.

For us, the knowledge of genetics takes us even closer to questions of responsibility: of the extent to which we should try to control the means of reproduction, in order to limit the chance of disability or mutation. Cloning occurs as a matter of course among some species of plants and animals; it has been reported to have occurred in humans by accident. Through advances in modern medicine, it now seems possible to achieve it by design, and, in so doing, to take great strides towards the eradication of disease. But new technology cannot shake off older concerns. In other words, cloning is not just about cloning.

It is no surprise then, that *Parthenogenesis* is a demanding piece – ethically and theologically – as well as musically, textually and dramatically. Those looking for a simple 'message', an ethical manifesto, will be disappointed; instead, they will find a compelling story and powerfully drawn characters. *Parthenogenesis* forces us to consider issues of life, love and freedom, but without compromising the story it has to tell. The resulting tension – between narrative integrity and due consideration of the issues – makes the listener's participation far from straightforward.

The starting-point is the unintended, spontaneous cloning at

Hanover in 1944. Here is a first point of difficulty: the notion of choice. The spontaneous occurrence of cloning caused by the Allied bombing is quite different from the intentional cloning which beckons us today (rather as there is a world of difference ethically between a miscarriage and a termination – a 'spontaneous' and a 'procured' abortion). Although Allied bomber pilots and governments chose to drop bombs on Hanover, they did not choose to cause cloning; even if the bombing is evaluated as evil, the accidental cloning remains morally ambiguous. In the drama, the spontaneous and the intentional are held in momentary alignment through the agency of an angel in free-fall. The resulting plot is a tangle of accident and intention, freedom and seduction, coincidence and consequence. Although the act of cloning is foreseen by the angel, it is not presented as his direct aim; rather, it is a by-product of his longing to experience the world, to know touch and intimacy. This is the key point: the goal is not a new cloned person, but an increase in knowledge, the clone's existence almost an irrelevance.

A second difficulty arises from the way the tale proceeds. *Parthenogenesis* 'calls into question our genetic future', yet refuses to do this through a neat and tidy morality play. Our possible future could have been explored through the obvious contrast between cloning and nature's wonderful but 'normal' story of conception and birth. Instead, the 'pod' group chose to offer a negative or dark annunciation: a contrast is drawn between the strangeness of cloning and the strangeness of the incarnation – the human conception and birth of God's Son. As a consequence, the allegory is much richer. Although their presence is unannounced, we can discern the faces and words of Mary, Gabriel and Jesus himself. Theological and ethical questions are entwined.

Whilst not exhausting the rich allusiveness of the drama, comparisons with the narrative of the annunciation open up a fruitful avenue of exploration into *Parthenogenesis*.

Anna

The depiction of Anna is compelling. During the performance of
Parthenogenesis, four letters (A, C, T and G) were projected
in a continuous sequence on to a screen behind and above the
orchestra. These represent the four basic elements of DNA
(Adenine, Cytosine, Thymine, Guanine), the 'secret names',
'written deep inside you'. Digital recorded sounds, playing as the
audience took their seats, mirrored this genetic sequence with its
regular rhythms and complex mutations of four notes (A, C, D
flat, G). This musical genetic sequencing was to return later in the
piece, at the moment of cloning, corresponding to the bomb's
'impact'. A second digital recording was used, consisting of
very deep and resonant sounds, at once cosmic, oceanic and
amniotic.

Arising out of this opening soundscape, Anna, the cloned
child, presents herself: articulate and perceptive, but deeply
embittered and adrift. Whilst the other characters sing to one
another (usually accompanied by the orchestra), Anna simply
speaks – to herself, or to anyone who will listen (with nothing
but the deep, cavernous reverberations for context). Genetically
indistinguishable from her mother, and often mistaken for her
even by good friends and close relatives, she struggles to find the
word to describe herself: sibling, twin, doppelganger, duplicate,
ghost, bastard daughter, 'sister-mother-stranger'. In the end, it
seems that the most successful definition is a negative one: she is
not what her mother is.

Strong images prevent us from interpreting this as normal
teenage rebellion. Anna differs from her mother as the 'thornless
rose with no scent' differs from the mortal rose. This metaphor is
subtle but pervasive: on stage, the two women wear a similar red
dress, but whilst one is alive but ageing, the other is livid but life-
less. Anna is the scentless rose, all that Bruno can effect, despite
his promise to make 'attar from Damascus roses'. She is a 'clone
rose', not a 'true cross'; following through the parody of the
annunciation, she will not be called holy, the child of God (cf.

Luke 1.35). Christ alone, she seems to say, is the true cross, the ingenious hybrid of human and divine sought after by the divine cultivator. The staging and the performance of Anastasia Hille did not attempt to evoke sympathy, leaving only an impression of desolate isolation. How can Anna believe that she is chosen, wanted, that every hair on her head has been counted?

Kristel

Kristel is no Madonna to her clone-child. She is not accompanied by the usual symbols of the annunciation (lily, rose, mirror, book of devotions), or even those more universally associated with gestation (weaving, spinning). Motherhood finds her unprepared. There is a void in the drama which exposes the staggering question of the relationship between the 'cloned' and the 'clonee'. The relationship between Kristel and Anna is impossible: 'she who meets her double meets her death'. This impossibility is evoked in the drama by absences: Anna speaks of her mother in a bitter and distant tone. Kristel, meanwhile, does not relate to Anna at all; every one of her lines is addressed to the angel. In performance, Kristel's maternal tenderness is turned towards Bruno, overshadowing any trace of romantic or erotic attraction. Twice she shows motherly feeling towards her supposed lover; but she shows (or anticipates) nothing of the sort towards Anna.

Of course, a lack of maternal warmth, towards one's own child, is not unique to cloning. Nor is lack of preparation, of relationship, of intention. *Parthenogenesis* hints at some very ordinary human dynamics. The cloning motif does, however, intensify our sense of alienation – within a family, within a self – in contrast to the many portraits of the Virgin Mary in Christian art, where the mother is so patently full of love and tenderness for her child.

Lisa Milne's performance gave moving expression to the ambiguities in Kristel's character: her passionate longing for closeness, her self-doubt, and her deference to the angel who was either a guardian, or the demon Azazel.

Bruno

The dark resonances of Bruno's character are more allusive than those of Kristel and Anna. First of all, Bruno is no angel-messenger from God. The Angel Gabriel was sent to announce the coming of John the Baptist and of the Christ, to celebrate the fulfilment of age-old promises with a new divine intervention. The existence of the child is the centre of Gabriel's message. Bruno, meanwhile, announces Anna's coming into existence almost as an afterthought, a pointless repetition, an insignificant spin-off from his own adventures.

Secondly, Bruno names the child. In the beginning, Adam names the creatures in recognition of his dominion and responsibility under the Lord, and in search of a companion (Gen. 2.19–20). With authority, Gabriel names both John and Jesus (Luke 1.13, 31). Bruno, however, names Anna without a care. The most striking contrast is with Zechariah, John the Baptist's father: struck dumb for his lack of faith, Zechariah writes of his son, 'His name is John'(Luke 1.64); immediately he receives back the gift of speech and bursts into a song of praise. Bruno, by contrast, whose music is so often lyrical and passionate, names the child in a single moment of flat, spoken dialogue; his song ceases, he speaks, 'Her name is Anna. She will have no father', then falls silent.

Thirdly, and most surprisingly, there is something Christ-like about Bruno. He is a heavenly being who loves the world and is wounded on coming into the world. He is held and embraced by Kristel, sometimes a lover to him, sometimes a mother, in ways that call to mind the contrasting iconographies of the *Pietà* and the Magdalene. In the movie *City of Angels* – based on *Wings of Desire*, clearly something of a precursor to *Parthenogenesis* – there is nothing diabolical in Nicholas Cage's fallen angel, rather a tragic, romantic longing to know the taste of a pear. In Christopher Purves' performance, Bruno was vulnerable and yearning.

At first, this presentation seems anomalous and frustrating.

But on reflection it makes profound sense: Bruno is a new creature, an exultant heavenly-man. But he is by turns impotent and destructive, seeming to possess great power over the world, but in fact possessed by it, owned by 'this house'. His is no gracious incarnation and he is no mediator; he has no gift to bring and his promises are hollow. He has no wish to create, only to explore and indulge. Like a sullen, self-absorbed artist, he does not cherish his works, but immediately discards them. Although anointed by 'a kiss like chrism', he is an unwitting anti-Christ.

An absence of family

Parthenogenesis is a play of absences: Anna is the daughter who is not a daughter; Kristel is the mother who is not a mother to her child, but who mothers her seducer; Bruno is no angel-messenger from God, no father to the child he names and whose existence he causes, no lover to the woman he seduces. The moment of intimacy between the two brings about the existence of the third, but no lasting relationship is established. By the end of the piece, we are left observing three isolated individuals, unsure of who they are and where their roots lie; there is no family.

Governments and health and welfare agencies throughout the world have pledged to prevent cloning from bringing about such a situation. British politicians assert that public opinion in the UK is set against it. Recent legislation passed by the British parliament is clearly designed to rule out the use of cloning to produce babies. Its goal is exclusively to provide material for potentially life-saving scientific experimentation – hence the rhetorical distinction between 'reproductive cloning' (to remain illegal) and 'therapeutic cloning' (now permitted for research purposes only, under strictly controlled conditions). Cloned embryos will be destroyed after a matter of days, once testing is completed. But if they were allowed to grow old enough to speak, would their words be like Anna's?

Parthenogenesis does not give simple answers to topical questions in medical ethics. Indeed, as we have suggested, the

bridge from the narrative to the issues is not an easy one to cross. What it does do is explore anxieties about cloning through poetry and music of expressive and evocative power; it terrifies because it imagines a hellish future where human relationships – the real presence of persons to one another – have become impossible.

Although cloning has been the point of departure, many of the questions raised have a wider application: How do we honour human life? Is any human life a disposable means to an end, or a tangential by-product of another, more 'real', experience? What are our responsibilities to those whose lives we touch, especially those whose existence we cause? *Parthenogenesis* can put us in mind of a wide range of situations where communication has failed, relationships have broken down and love has grown cold. And here, perhaps, the underlying fear of the piece can be identified: that we now have the power to produce human individuals who will be unable to locate themselves in the most basic, primary way – within a family – and so lack an essential precondition for flourishing within the human community. This fear, of the absence of family, is as much the ethical burden of *Parthenogenesis* as the concern about what is done in labs with pipettes and petri dishes. Clearly the misery of human loneliness predates cloning. But it is an irony that attempts should now be made to reduce that misery precisely through cloning – the deliberate production of human individuals whose identity is intrinsically contradictory and unstable.

The final moments of *Parthenogenesis* are bleak and painful, but they do not constitute its last word. The creators of the piece have characterized it as a dark parody, a negative annunciation. Between the lines, present but inarticulate, we must discern the positive annunciation, and the members of the strange, but holy and loving family. By 'staring at our darkness', *Parthenogenesis* more than hints at where light may be found.

TILL KINGDOM COME

Till Kingdom Come

In 1998, over 800 bishops from the Anglican Communion converged in Canterbury for the Lambeth Conference. For the opening session of that huge gathering, the York-based theatre company Riding Lights *collaborated with five Cambridge academics to produce a short play,* Wrestling with Angels. *So fruitful was the collaboration that some of them responded warmly to an invitation from* Theology Through the Arts *to extend the process and form a 'pod' group and generate a play for the* Sounding the Depths *festival. The outcome was* Till Kingdom Come: The Story of God's Mutineer.

The playwright Nigel Forde recounts the process of dialogue which helped to form Till Kingdom Come. *The theologians, David Ford, Daniel Hardy and Ben Quash, met at various times with Nigel, as well as with the historian Robert Whiting, and the directors Paul Burbridge and Bridget Foreman. They were aided at any early stage by the scholarly expertise of John Morrill, Professor of British and Irish History at the University of Cambridge.*

England's seventeenth-century Civil War provides the setting, a period when theology was a matter of life and death. It centres on Robert Lockyer, a trooper who, although initially fervently loyal to Cromwell's cause, was eventually shot for mutiny on Cromwell's orders. The wide range of theological dilemmas, passions and concerns that arose in the collaborative process as well is in the final play are traced in these essays – among them: How can one do God's will in exceedingly complex and compromised circumstances? How are we to handle the tension

between the need to act 'in God's name' in fiercely urgent
situations, and the need to listen patiently to tradition (the
tension between the 'holy decisiveness' of Robert Lockyer and
the 'holy patience' of the clergyman, Isaac Bellerby)?

As with all the 'pod' groups, these questions were negotiated
in large part through the artistic medium itself, in this case,
drama. This is brought out especially by Ben Quash, who
comments on the disturbances and provocations which a
medium like drama brings to theology. In a similar vein, David
Ford concludes his essay by providing a telling account of the
way his involvement with the arts has shaped his own theologi-
cal career.

Till Kingdom Come *(later re-named* Friendly Fire) *was staged*
during Sounding the Depths *in Jesus College Chapel, Cambridge,*
on 13 September 2000. Lorraine Cavanagh, a doctoral student
at Cambridge, records her reactions to that performance. In total
it has been performed in over fifty venues around the UK.

In the play, the Lockyer household consists of the mother,
Margaret, *and her two children,* Kate *and* Robert, *along with an*
old family friend, Mary, *whose husband, like Margaret's, was a*
soldier killed in battle. Robert Lockyer *is a fervent Cromwellian*
trooper fighting in the Civil Wars. He is in love with Margaret
Bellerby *despite the fact that she is the daughter of the Royalist*
Isaac Bellerby. *Isaac is the village parson who educated both*
Robert and Margaret as they grew up together.

7

The Playwright's Tale

NIGEL FORDE

Theatre is by its very nature religious. This will not be easy to understand by those whose experience and understanding of drama has been formed by television executives and is exemplified by *Peak Practice*, *Casualty* and adaptations of classic novels, because substance in such cases has either been reduced to the bringing in of 'An Issue' or supplanted by mere plot. But the theatre that will be remembered in a hundred years' time, the plays that will constantly be performed and reinterpreted, are those which address humanity's deepest longings, anxieties and questions; those which explore the nature of the moral universe and our place within it: religious plays. Even though God is clearly absent from both of them, *The Winter's Tale* and *Waiting for Godot* are, in their different ways, profound and profoundly religious plays. What would have been the effect on them had a group of Cambridge theologians had a part in their construction? Call it, for the moment, a reservation, just a reservation.

But, since we have dared to use the word *religious*, it would be sensible before we go any further, to distinguish between the religious play and the *religiose*; that is, between honest stringency and superficial proselytizing. Plays, even plays about the life of Christ, can be written with a degree of sentimental humanitarianism which has no place in genuine religious exploration. In religiose plays the subject-matter seems to be religious but it is only superficially so: issues are fudged, the arguments are predictable and often biased and we can all go home at peace with our consciences and a step or two further back in our spiritual understanding. The right side has won, the message, which we all knew before we arrived, has been delivered. Some

sort of honour has been satisfied and any sort of intellectual and spiritual growth has been effectively avoided. It is on the whole the secular theatre that addresses with genuine passion the real, pressing, subversive and difficult issues. In the well-meaning religiose theatre what has usually happened is that the play has been so concerned with shouting loudly 'We are right and you would do well to listen!' that it has failed even to murmur anything about truth.

The question 'What is truth?' not only echoes through the Gospels but it echoes, or should echo, through backstage corridors in all our theatres. But let us not be content to accept a comfortable answer or an uninspected answer. To be told that in order to play the violin you have to put your fingers in the right place on the strings and co-ordinate their movements with those of the bow does not lead swiftly to an acceptable performance of the Sibelius Violin Concerto. In the same way, it is not enough to be told over two hours and three acts that socialism is the answer or that capitalism is the answer, or, indeed, that Jesus is the answer.

How, then, can theology be approached through the medium of theatre? That was the problem facing this particular 'pod' group. Theology, after all, is a rigorous, logical, intellectual discipline where, just as in medicine, a mistake can be fatal; its discourse is as opaque as that of quantum physics to the layman. How can it be transmitted through a form which relies on ordinary human feeling and behaviour; which, because it takes place in time – you can turn to a previous page in a book, not in the theatre – has to be immediately accessible on some level? Which must at least seem to be lived reality – loose, haphazard and quotidian: just the opposite of rigorous, logical and intellectual? Anything ending in -ology must be concerned with tabulating information and finding answers; theatre excels at asking questions. Theology tackles the ineffable; the theatre is full of the apparently effable.

The first thing that became apparent was that none of us in the 'pod' group was going to surround himself with the thickset hedge of his own particular discipline or expertise; none of us

was going to insist, to veto or to claim the last word. Had that been otherwise, it would have been impossible for any progress to have been made. We may have shaken hands – or, indeed, shaken fists – across a void, but there would have been no meeting of minds and no discernible mark would have been made by either discipline on the other. Perhaps it was important that the theologians in the group were far from ignorant about the methods by which theatre makes its meanings, just as the theatre practitioners had more than a smattering of theological expertise. But perhaps it was not. At the time, the process was of secondary importance to the result we were seeking in the same way as rehearsal is secondary to the final performance. Absolutely essential, in other words, but not concentrated on for its own sake. So recollections of the process may not be wholly reliable, but my overriding impression is that it was the personal qualities of the participants that made the whole venture such a rich and stimulating experience; it would be difficult to pay adequate tribute to the gentle wisdom, the good humour and the relentless drive towards identifying and refining the truth on the part of Dan Hardy, David Ford and Ben Quash. Paul Burbridge and I have had years to accustom ourselves to each other's methods and thought-processes, so I say nothing of that except to hope that similar qualities were not entirely lacking in our contribution to the 'pod' group discussions.

The first exploratory meeting was held in Ridley Hall, Cambridge with a group slightly larger than that which turned out to be the final 'pod' group. Many ideas were mooted but by the end of the meeting there was a consensus that the most interesting theme to have arisen was that of the Protectorate. Why?

'Axioms in philosophy', wrote Keats, 'are not axioms until they are proved upon our pulses.'[1] Perhaps there was never a time before or since the mid seventeenth century when pulses raced faster – or were stopped altogether – as a consequence of deeply-held beliefs. Theology was then, literally, a matter of life and death. Ideas about God, how and why he worked, what he wanted of his people, what Scripture said and how it should be

understood were of an importance that is scarcely credible to the twenty-first century, even to the twenty-first-century Christian.

Morality in government, however, has today become a topic of interested discussion following allegations of wrongdoing and sleaze and following the apparently cynical way in which politicians are only too ready to claim a Christian allegiance whenever it may attract more votes but to forget it when it comes to policies that reflect Christ's concern for the poor, the rejected, the unlovely. And there are other questions too, not unrelated. How do we live with people whose beliefs are sincere but different from our own? Is religiously motivated government automatically a good thing? How far should personal belief influence public action? Is compromise always wrong? May beliefs, however strong, be taken to the point of bloodshed? How can we best bring about the Kingdom of God on earth?

All these huge and difficult questions are raised by the events of the Civil Wars and all are still as pertinent today as they were then. This to me was the deciding factor. A playwright has to have a good reason for writing a particular play at a particular time. A perfectly competent and interesting piece of theatre can be written about almost any topic you care to name, but the best theatre is life-changing in that it forces an intellectual and emotional engagement with questions which are of more than academic or antiquarian interest. *De te fabula narratur*. Theatre that is merely documentary or didactic, or theatre that tries to hide the fact that it is little more than propaganda holds very little interest for me; fact-finding, even on the rare occasions when it is impartially carried out, makes for a kind of gridlock in the traffic of the stage. These things are better done in other disciplines. If it is rigorous analysis and accuracy that is needed, leave history to the historians, biography to the biographers and, indeed, sermons to the preachers. But to use an historical event or set of events in order obliquely to explore a modern concern seems to me an interesting and valuable process.

It is at this point – where the general theme has become apparent but no decisions have been taken about content or method – that the difficulties of committee work become

apparent. The starting-point of the process, for me at least, is not the gathering of ideas or the discussion of parliamentarian motives as opposed to royalist; it is not even a story, let alone anything that could be dignified with the title of *plot*. I start with an image, or an atmosphere; perhaps a character, perhaps just a kind of weather: sunlight in a barn, perhaps, or rain streaming down window-glass, a pond creaking in its winter coat. Something concrete rather than something abstract. From that point (which can always be changed later but which, if it is to be useful, must have a resonance in my own mind) other images, characters and situations begin to suggest themselves. I will admit that this primary image or character, or whatever it is, probably is not entirely random even though it feels so. Discussion has made my mind and my imagination begin to work in a certain way and, once nothing is being demanded of it, this is what has come up. 'Nothing will come of nothing,' said King Lear; and the converse is also true: anything may come of anything. This is both frightening and reassuring; frightening because there is nothing to fall back on, reassuring because the possibilities are endless. From here the play will grow by matching itself to the vision of itself.

One thing I know I must not do is have anything to 'say'. If the play does succeed in saying anything worth attending to, it will be because the audience have discovered it, not because I have cunningly inserted it and then covered it with leaves like a Pooh trap for Heffalumps. (Though even the Pooh trap for Heffalumps caught something quite unexpected.) To begin with a message is to write an illustration; to make a case, not a play.

From our discussions it was quite clear that there were no easy answers to the questions of religion and duty that exercised the seventeenth-century mind; to offer any, therefore, would be foolish and patronizing. We're back to Keats again: what was necessary was Negative Capability – the capacity to be in uncertainties, mysteries, doubts, without any irritable reaching after fact and reason. Only in this way would the play awaken and question the beliefs of the audience, challenge their prejudices, engage them with the questions that were perplexing

the characters. These questions were defined, discussed, explained, interpreted by and with the theologians, and it was during these sessions that the complexity of the human race's vexed relations with its Creator, all its longed-for certainties and all its consequent uncertainties became apparent. Not always with crystal clarity, not always, for me, in an easily capturable form but as an immensely stimulating environment for further exploration. Theology *could* be proved on our pulses if I could find characters of sufficient humanity, sympathy and conviction for us to feel their struggles, their passion and their pain. Without being simplistic, without sacrificing stringency, even the most abstract ideas might be brought through discourse and action back to the kitchen table, to the fireside, even to the rain-swept, hoof-mashed field where these questions come to the point; where the facts of history (because, however few I use, they must be right) are no longer imaginatively inert but become as passionately important as where the next meal or the next five pound note is coming from.

Like most writers, I don't know what I know until I start to write about it. The very process of writing becomes the process of revelation. I write not *because* I see but *in order* to see. I don't have a vision of the world which must with missionary fervour be passed on. The imagination – and, like Coleridge, one may with diffidence call it a fragment of the mind of God – offers treasures, mysteries, gifts. The writer must unwrap them and greet them with the time-honoured cry of 'Just what I wanted!' and then try to believe it; to arrange them objectively and unsentimentally. Conversely, facts have to be wrapped up in the paper that the gifts came in so that they look just as exciting and mysterious. They can then inhabit the same world and each be fed and sustained by the truth of the other. It may just be that I am a late learner, but what the 'pod' group discussions had generated in me was the consciousness that theology is, in its own way, as descriptive of our lives and the way they are focused as theatre is, and that to turn the one into the other needs no sleight of hand.

But it needs work and application. Where do we go from here?

I have in my mind a picture of a kindly, flawed, disappointed man sitting in his study and reading Latin poetry. I don't know where it came from, but there it is. I don't know what is going on outside, I am not sure who he is. It does not matter. I will listen to him later. I also have the feeling that this is the end of the play. I'm right, but I use it as the beginning so that we may concentrate not on *what* happened but on *how* it happened.

I have missed the first 'pod' meeting; while the others are being astonished and inspired by the intellectual passion of Professor John Morrill, I am supine listening to the doctor telling me that nothing can be done about backs and that I'll just have to wait. Some can wait, some can't. That will come into the play as well, though I don't know it at the time. But I am sent detailed minutes of the meeting and given an appointment to meet John Morrill, so I haven't missed out.

There was much talk in that first meeting about the actions and motivations of Cromwell himself. This is not surprising since, from whatever standpoint one views the period, he was the principal character. He cannot, however, be mine and there are good reasons for this. Most plays are written, then cast and then performed; you employ the cast you need in order to fit the play.

But my play had to be written for an existing company, for a company of four, moreover – three women and only one man, and all in their twenties. There was obviously no one among them who could convincingly play Cromwell, and even if there were, what would be the point since he could interact only with women and we could never see him in all the situations one would like to recreate? Furthermore, there are dangers about putting words into the mouth of a genuine historical figure, not the least of which is bathos.

Restrictions are freedoms if they are looked at in the right way. I am used to writing for a prescribed number and trying to make that limitation a strength rather than a weakness. I fought to have another man in the cast. It seemed to me impossible to write about such a male-dominated society and to entertain the questions we had identified as the most interesting unless we had at least two men. I didn't want to use women in 'breeches' roles

because it smacks too much of pantomime or opera buffa or else presupposes a style of storytelling that removes the action a notch towards an objective, patterned, see-through style; I wanted immediacy rather than style. It is probable that a fascinating play and a good play could be written about women in the Civil Wars, but that is not what the 'pod' group had discussed, not what I had been avidly reading up and, with only nine weeks before the first performance, it was too late for such a radical rethink.

Ghost stories and tales of the supernatural always supply much more of a frisson if the threat is never quite made clear, if the ghost never quite materializes. The power of the imagination again. I was fascinated by the idea, which I think came first from our designer, Sean Cavanagh, of writing a play dominated by, bestridden by a colossus who never actually appeared. How much more that would say about his strength and influence. One could then concentrate on where true history was happening, understand the *meaning* of civil war, the *meaning* of the choices that one made, rather than inspect yet again the policies and laws of that abstract entity 'the state' which, even if it made an appearance, did so in gold encrusted cloaks and ostrich plumes. This was to be a play about responsibility, about adequate behaviour before God. That is not to preclude the possibility, even the likelihood, of others thinking it is about something entirely different. I welcome that, but it won't happen if I try to include all the questions. I need to restrict myself; something which the 'pod' group seemed entirely to understand and approve.

By the time I met Professor Morrill I had made some more provisional decisions about the characters and their situation and had given myself the story of trooper Robert Lockyer as a possible framework. I discovered the story, if it can be called a story, in John Middleton Murry's 'Heaven and Earth' and John Morrill confirmed that there was little more to add. Lockyer was a young trooper, on fire for Cromwell's cause. He was shot for mutiny on Cromwell's orders. No one quite knows why so I was at liberty to make up his home background and suggest motives.

For me it was an enduring paradoxical image of waste and sadness mingled with honour and self-sacrifice. Now I had to discover why and how and what his connection was with the man reading Virgil in his study.

From John Morrill I received a brief but sparkling tutorial in social history which clarified a number of issues. We spoke of conditions in the army, wages, women's roles, weather – one forgets what a huge influence it could be on battles, crops and the availability of food and ale – and a hundred other things. I went on to talk, very constructively, to Ben Quash who found theological virtue in some of the characters I was considering; Mary, for instance, the quiet, sensible Fifth Monarchist who, despite holding firm beliefs that, today, would be seen as eccentric, was full of common sense, deep love, and made a still centre for the spinning world of the Lockyers and the Bellerbys – my Virgil reader had a name at last. He read to me from Balthasar, rationalized some of my instincts and agreed with me on the very practical point of the language that should be used. No pastiche of seventeenth-century prose; no gadzookery; no 'tis and 'twas and tush but a plain, neutral language in which the rhythms and the cadences of the seventeenth century might be replaced and suggested by careful imagery. All should be articulate and interesting; no excusing myself from stringent thought by pleading that my characters were uneducated or incapable of expressing themselves. Not entirely naturalistic, perhaps, but acceptable if the convention were sustained and much more honest.

The 'pod' group then left me to my own devices until the first draft was ready.

When that moment came, the cast, directors, writer, theologians and various Riding Lights staff met in Friargate Theatre in York for a first read-through. That was a very constructive time. Apart from any other consideration we had, at last, something tangible to discuss and we made the most of it. It was still work-in-progress so I was under no illusion that with the addition of a line or two and the excision of a semi-colon we would have a finished product. While there was a general warmth of approval there were also plenty of places where, it

was felt, opportunities had been missed, points could be made with more clarity, ideas could be explored more deeply. There were passages and characters that I too wanted to revisit. We decided what was good and *must* stay and what might beneficially be taken back to the drawing-board. This was necessary, not least because there were some passages that were disliked by some and yet heartily defended by others. It is not always easy or indeed sensible to apply democracy to a work of the imagination.

Rehearsals began and I provided rewrites within a day or two but the 'pod' group did not have a chance to assess the new script until they saw it in performance several weeks later. They made a written response and then, before the show was given its final form and sent out on tour, we had a final meeting in York. Many of the comments chimed with my own feelings. They picked out areas of the show that I was still not satisfied with. Two whole scenes went at a stroke, which gave me space to deepen others and to explore some ideas about radicalism and compromise from Bonhoeffer's *Ethics* which, David Ford and Ben Quash suggested, clarified and brought into focus aspects of the conflict between Robert Lockyer's philosophy and Isaac Bellerby's. The end and the beginning were both rewritten. The title was changed to *Friendly Fire* but for the Cambridge premiere the previous title *Till Kingdom Come* was kept since that is how it had been advertised. For better or worse, we had a play.

And was it for better or for worse? That is for others to judge. Randall Jarrell has defined the novel as an extended piece of prose which has something wrong with it; a description one could apply with the same degree of truth to a play . This one is too long; not much, but a little, and it has the Shavian vice of too much talk: it is not fully incarnated. All that is my fault. Other, smaller faults, might (only might) have been avoidable with an extra actor or two. There was one moment in the original draft which I am still desperately sorry to have lost, because it summed up in one shocking image – of little Kate shooting Isaac Bellerby – the sometimes dreadful consequences of political action on innocence; the absolute morality discussed throughout the whole play suddenly coming down to relative morality; good has

become bad, bad has become good. There were ways I could have gone but didn't; things I turned away from that I might have pursued. But that is true of anything anyone has ever written. It could always have been different.

What was certainly not at fault, in my opinion, was the process. The 'pod' group was an extraordinary resource. Research material that answers back! That can suggest and explain with the utmost patience! To be able to tap in to such knowledge, such enthusiasm, such wise and generous criticism and support was a privilege, and I can only wonder at and be grateful for the time and energy that the group gave so freely. Each meeting was a step forward. All my fears that the 'pod' group, however well-intentioned, would actually get in the way of the process turned out to be unfounded. There is no doubt that this was a huge benefit, and I felt, I still feel, that I was the sole beneficiary. I look forward to learning whether others too received or whether they only gave.

Perhaps the most important thing that *Theology Through the Arts* has done – and is doing – is to give authority and credence to what artists have understood for a long time and what the Church itself seems to have forgotten: that the imagination is capable. It can reveal truths that no other discipline has found a way to countenance. It is not a vestigial organ like the tonsils or the appendix that may be removed without harm. True understanding, as opposed to mere knowledge, is a work of the imagination and we neglect it at our peril. Nobody has yet been able to explain how the imagination works and you must not expect me to succeed where my betters have failed. I am content to let it remain a mystery. Like many a writer before me I have been asked of some passage or other 'How could you know that?' to which my answer has had to be 'I didn't: I made it up.' This has not always been believed, especially when the incident in question involved something that could be described as a trade secret or was an unlikely phenomenon familiar only to one or two privileged professions. 'You must have been told! That's precisely what happens in such situations! That's just how people . . .' and so on and so forth. How can one despise or,

worse, discard the imagination when it is able to jump the
synapses like that, to bypass the lack of knowledge and yet still
arrive at the truth? Forgive me if, to end with, I quote Keats one
last time:

> The Imagination may be compared to Adam's dream – he
> awoke and found it truth.[2]

Notes

1 Letter to J. H. Reynolds, 3 May (1818), in H. E. Rollins, (ed.), *Letters of
 John Keats*, Cambridge: Cambridge University Press, 1958, vol. 1.
2 Letter to Benjamin Bailey, Saturday 22 November (1817), in Rollins,
 (ed.), *Letters of John Keats*, vol. 1.

8

Dramatic Theology: York, Lambeth and Cambridge

DAVID F. FORD

The performance in September 2000 of *Till Kingdom Come* was the culmination of a collaboration that began in 1997. This pre-history is not only relevant to understanding the performance; it was also packed with learning about drama and theology. So I will begin there.

Wrestling with Angels at the *Lambeth Conference*

Every ten years the bishops of the Anglican Communion gather for the Lambeth Conference. In 1997 five Cambridge academics (Daniel Hardy, Mike Higton, Tim Jenkins, Ben Quash and myself) were invited to take responsibility for the opening and closing plenary sessions of the 1998 Lambeth Conference, when over 800 bishops and their spouses, advisors and representatives of other Churches (around 2000 people in all) were to gather in the University of Kent at Canterbury.

The brief was to use drama and video, as well as direct address, in order to focus the opening and the ending of the Conference through the Bible. We joined with Angela Tilby of the BBC and a team from Westcott House in Cambridge in order to plan videos for the two sessions. There is a story to be told about those videos, but here the concern is with the making of the drama. For that we worked with Riding Lights, supported by a substantial grant from the Bible Society.

The result was *Wrestling with Angels* by Nigel Forde and Paul Burbridge, performed in the opening plenary on 21 July 1998,

and based on Genesis 32—33 and Paul's Second Letter to the
Corinthians. Immediately after the performance came an address
which included the following:

'Give me time. I need a little time to be astonished,' says Jacob
to Esau.
'How long?' asks Esau.
And Jacob answers: 'Oh, a lifetime will do.'

There is a lot to be astonished at in that drama. What happens
in it?

We are plunged into the real world of fear, bad faith, past
actions that return to haunt us, and terrible violence. Jacob is
a leader with life and death responsibility for his wife and all
the people with them. In facing Esau he has to confront the
strands of himself, the tangled identities which shaped him and
Esau from the womb. The pressures are intense, and his fears
increase them. His whole identity is at stake.

Between Jacob and Esau there is a division about something
apparently non-negotiable, a legitimate birthright and succes-
sion. But there is no 'tidy map' to be consulted, either for who
God is in this situation, or how peace is to be found with Esau.
He is 'face downwards in his history'; he agonizes and
struggles.

The drama draws us into his wrestling in prayer at Jabbok
Ford: 'God of my father Abraham, of my father Isaac, you see
how the world piles up behind me . . . and still I fear to find
your face . . . Save us from the death that hangs in Esau's
hands. Save me from my own deserving.'

He grapples with the mysterious wrestler who knows him
only too well. He is wounded; he is given a new identity as
Israel, 'the one who strives with God'; and he is blessed by
being reconciled with God and his brother together. And it is
worth being astonished at Esau's act of forgiveness and peace-
making.

But even more astonishing is the mysterious complexity of
God's action: he both challenges Jacob's tangled, wrongly

complex identity and heals it, opening a way for him and all his people beyond Jabbok. God blesses through wrestling, wounding, naming and facing.

And when the drama moves on into the heart of the Gospel there is something more extreme: wounding that kills, and blessing that comes out of death on a cross. We saw all those sticks, including many texts taken from 2 Corinthians, that can be used for building or for violence.

That activity of God in blessing which takes upon itself conflict, suffering and death is utterly central to 2 Corinthians too.

2 Corinthians is a difficult text. But why?

In conversation with some of you before the Conference and since we gathered on Saturday, it has been striking how many of you, in your preparatory study of this letter, have found it both difficult and extraordinarily fruitful. So too did the group charged with preparing this Presentation today . . .

I suspect that this common experience of a fruitfulness that comes through much grappling and long-term study, discussion and prayer is crucial for the quality of this Conference's life and work.

But why is it such a difficult letter?

It is not primarily a matter of scholarly difficulties, although they are there in abundance and need to be faced. It is a hard text to translate, and there are many arguments about Paul's meaning. There are endless disputes about the situation in the Corinthian Church that it is written to, about the letter's unity, its theology and much else.

Those questions never go away, and as soon as you think you have settled them they crop up again. Yet still they are not at the heart of the difficulty. *Nearer to the heart of it is the sheer density, intensity and richness of what Paul is saying.*

The letter is about God, the world and the Church together: about suffering and encouragement together; about the pain and the joy of Christian community; about the new creation and the old order together; about treasure in earthen vessels, generosity in poverty, and strength made perfect in weakness;

about Jesus Christ 'made sin' for us; about crucifixion and resurrection, 'dying and behold we live' (6.9); and about perplexity without despair.

But even that does not quite reach the heart of it.

Right at the heart of it is what we also find centre stage at Jabbok Ford: God.

God is the deepest reason why the letter is unmanageable, constantly surprising, and overflowing with fresh meaning. The vitality of a rich and complex God finds us through these and other parts of the Bible. If that is so, then not only is it true that prayer and worship are the primary place for the Bible in the Church, as our Anglican tradition has always affirmed; but also the prayer has to be as serious as Jacob's prayer was when he wrestled on this coffin,[1] and the worship has to be as primary and embracing as it is in 2 Corinthians . . .

But who is the God of Jacob and Paul and ourselves?

The pivotal moment in the drama is when Jacob is in agony but still holding on, insisting on a blessing. He has his head slowly wrenched around to face his opponent, to face God. Then he is told: 'You have my blessing, Israel. Turn and receive it.' He turns and sees the face of Esau, the one he thought would kill him. The blessing received is both the face of God in the wrestler, and the face of Esau embracing him in peace. Jacob makes perhaps the most important theological statement of the play, taken from Gen. 33.10: 'To see your face is like seeing the face of God.'

Multiple performance

That was a 'performance of theology' conceived through an intensive process of collaboration. There had been intensive Bible studies over several months; a residential meeting with the Cambridge group, some of Riding Lights, and the Lambeth Conference organizers; and constant discussion. But the pressure of time was such that the Cambridge group was not able to attend any of the rehearsals in York before arriving in Canterbury. So we had only the script to work with in preparing the first

plenary address that followed the drama. Then in Canterbury we attended the hectic rehearsals in the two days before the Conference began.

The experience of the rehearsals was like a bombshell hitting our prepared text. The text may have done justice to the script. But faced with live rehearsal, listening for the first time to the music written specially for the play by David Kangas, seeing the actors shaping their roles under Paul Burbridge's direction, and this happening in the extraordinarily appropriate set of coffins and cross by Sean Cavanagh: the total effect was to show how inadequate was our address based only on the script. The reluctant decision was taken to rewrite the address overnight. The result, quoted above in part, still failed to do the play justice, but at least it was inspired by the play's performance.

This experience of the inadequacy of the script alone has generated many theological thoughts, but especially the following. In interpreting Scripture (perhaps especially its narratives, but by no means only them) we are involved in a multiple performance.

There is first the performance to which the text witnesses. That may invite us to imagine people, events, relationships or practices, whether historical or fictional (think of Jonah or the prodigal son). The biblical text itself is a new communicative performance which embraces fresh elements but still can only act as an indicator of the full richness to which it testifies. This very underdetermination of the text opens the way for generation after generation of interpretation in many modes, from commentary and liturgy to drama, ethics and systematic theology. These are new performances. *Wrestling with Angels* is now part of the tradition of interpretation surrounding Genesis 32—33 and 2 Corinthians – and its composition was fed by intensive discussion of those texts, with the participation of theologians who knew something of the history of their interpretation. Then there was the address following *Wrestling with Angels* – a performance of theology for an audience that knew Genesis and 2 Corinthians well and who had just seen the premiere of the play. This multiple performance, recapitulating

and improvising upon many others over the centuries, related to a range of performances already present in the memories of the Conference participants.

The plenary was an example of the interpenetration of theology, drama and video. The latter dimension was not just the opening video made by Angela Tilby in which bishops were interviewed about Scripture and its interpretation today. Because of the constraints of space in the main Conference hall, about 800 of the 2,000 in attendance were in an adjacent hall to which a video of the drama was transmitted. But in the main hall the video of the performance also was being shown on a large screen behind the stage. So there one could see the live performance from wherever one was seated and, at the same time, see it on screen from whatever angle one of several cameras was shooting. Many said how powerful this double viewpoint was.

Overall, the aim of the plenary was to offer a language to the Conference, a way of imagining reality, and an approach to some of the key questions facing the bishops. How could they face differences over an issue such as homosexuality on which many took positions which they considered non-negotiable? How could their struggles and divisions conceivably be related to the blessing of God? Could their interpretation of Scripture have anything like the richness and depth of the best in the tradition? The address concluded with a series of questions, which included:

- Will we wrestle long enough and profoundly enough to discern the truth of this world before God, and will we realistically face where that truth leads?
- Will we hold on to the Bible throughout the Conference and, like Jacob, gain a blessing through our wrestling? Will the Conference really inhabit Scripture? Will our language have something of the vitality and intensity of the Bible? Above all, will we find the authority of Scripture in the deepest reality that it testifies to: in God and the blessing of God as the deepest truth of our history and ourselves?
- At the end of the Conference will each participant be able to

say to each other: 'To see your face is like seeing the face of God'?

Those questions derived what power they had from the combination of video, drama and theology. As Nigel Forde says in his essay in this volume, drama is well suited to profound interrogation, resisting comfortable or uninspected answers. He tends to see theology as more about giving answers, and it is true that it has often been primarily concerned with affirmations, negations and imperatives. But there are other theological moods, especially the interrogative. Any theology that stays close to the Bible – its long timespan, varied genres, differing parallel accounts of the same events, ethical provocations, ambiguities, and sheer complexity – has to be radically interrogative, and this is intensified by modern scholarly methods and by interpretive strategies which take into account the questions we bring to the text today.

But affirmations, negations, imperatives and interrogatives are still not sufficient – or perhaps a better way to put it, on the analogy of the Jewish Passover liturgy is: those might have been enough, but in fact we have been given something even richer. There are also longings, desires, hopes, orientations to a better future; and there is the element of what might have been or what might be – experimenting with possibilities. Here we glimpse a realm where drama and theology might sensitively help each other to open up visions of the future and paths of receptivity and activity looking towards the Kingdom of God. *Wrestling with Angels* was above all a drama of yearning for reconciliation, blessing, and the face of God. Neither Jacob nor the Lambeth Conference had a 'tidy map' with authoritative directions that could be immediately translated into answers to their problems. But one of the impulses behind the next collaborative effort resulting in *Till Kingdom Come* was the experience of the Conference wrestling towards, and sometimes finding, a better way.

What was the effect of the opening plenary on the Conference? That is impossible to answer adequately. The immediate

aftermath was bizarre. The Bishop of Jerusalem complained passionately about the use in the drama of some Old Testament texts which were also being used by extreme Jewish groups against Palestinians. This made headlines in national newspapers, together with some fine photographs. There was no media discussion of the plenary as a whole or even of the drama as a performance.

Yet within the Conference there were many echoes of the drama's themes, and it made some contribution to the quality of discussion in the Bible studies and in the working sections into which the Conference was divided. The interviews recorded in the video produced by Angela Tilby and her team for the final plenary gave several testimonies to the power of Riding Lights' evocation of wrestling towards reconciliation. And that plenary also had at its heart a dialogue about Scripture between bishops from various traditions. Their performance of theological conversation was part of the process of finding fresh ways of inhabiting and interpreting Scripture in the Anglican Communion which grew out of the Conference, and which has been a special concern of the now-annual Primates' Meeting of the archbishops who head the provinces of the Communion.

Interlude: York, Canterbury and Cambridge Communities of Interpretation

Before moving from *Wrestling with Angels* to *Till Kingdom Come* I want to comment on the deeper prehistory of both dramas.

One thing that becomes very clear in working with Riding Lights is that this is a community as well as a theatre company. For 24 years it has contributed all sorts of theatrical works to churches (which have provided many venues for their tours), conferences and theatres, and now it is converting a warehouse in York into a fine theatre and drama centre. The three long-term members who took part in both processes were Paul Burbridge, Nigel Forde and Sean Cavanagh. How can one do justice to the breadth and richness of the experience they combine, both in

thinking and working together and in the dramatic embodiment of Christian faith? We tasted a little of the quality of their community, built up year after year through the pressures of artistic performance and economic survival.

Then there is what for convenience I call Canterbury, representing the church community. That is heir to a worshipping, scriptural community going back thousands of years to ancient Israel – the Genesis story of Jacob wrestling is itself the written deposit of long oral tradition and interpretation. In *Till Kingdom Come* the Cromwellian setting is part of the traumatic genesis of modern Britain, and the issues still evoked powerful gut reactions in audiences according to their denominational and political allegiance – Canterbury as one side in a tragic civil conflict.

Cambridge represents an academic community having strong historical links with both Canterbury and Cromwell, together with a tradition of studying theology and drama, and performing them in worship or on stage. It is also not only ecumenical in its Christian community – Professor John Morrill, whose role is described by Nigel Forde, is a Roman Catholic expert on Cromwell – but also has other religions. And its academic life is largely marked by the sort of practical atheism which pervades public life in Britain, and which is, as Professor Morrill showed, partly the result of the traumatic effects of religion in the public sphere that are associated with the Civil War.

So these three primary communities came together in both dramas. It is worth recognizing those communal and institutional conditions for the possibility of both events. The performances would not have been possible without the immense labour of creating and sustaining all three in their different respective timescales – decades, millennia and centuries. None of that makes good drama or good theology inevitable – those are always in doubt until they actually occur in performance. But if the performance does seem to go well, the gratitude extends back millennia.

There is also the interpenetration of theatrical, Christian and academic communities, especially as seen in the core members of

the collaboration. Each had learned something of the language of the others, but also enough to know that they could not do without the experience and expertise of each other. Nigel Forde describes this well.[2] As a theologian I found myself stretched into new theological sensitivities and articulation by the encounters, rehearsals and performances, but the enduring sense is of amazement at the sheer achievement of playwright, director, actors, designer, composer, manager and technical experts in actually producing a performance on time out of what seemed like chaos.

Till Kingdom Come – *The Bible*

'But stories are fearful things', says Margaret, 'They tease you with their truth even when they are untrue. [PICKS UP THE BIBLE] And this is the most fearful one of all.' The Bible runs through the whole play, just as it pervaded Cromwell's England. Whereas in the Lambeth Conference the drama was directly based on biblical texts, here the Bible as a whole is a focus of controversy. I find three key themes, all of which are both interrelated and of continuing importance: the complexity of biblical interpretation; the relation of the Old to the New Testament; and the truth of drama in relation to the truth of the Bible. In each case I detect a certain bias – the play seems to prefer one approach. While bearing in mind Nigel Forde's extreme caution about being didactic, yet as a theologian I find here some lessons worth highlighting. So I will risk being didactic.

On the subject of biblical interpretation the play offers a wonderful image:

MARY: And the mind of God has been opened to Robert Lockyer.
ROBERT: No, to all of us; it is there on the open pages of Scripture.
MARY: And the closed ones as well. Don't forget those.
KATE: Closed ones?
ROBERT: What are you talking about?
MARY: You open your scriptures, and what do you find?

'And they slew Oreb upon the rock of Oreb, and Zeeb they slew at the winepress of Zeeb.'

ROBERT: Yes, I find that in Judges chapter seven. 'The sword of the Lord and of Gideon.'

MARY: But to find that, you have to close the pages of Deuteronomy where I read that the Lord says 'Thou shalt not kill.'

ROBERT: Oh, I see . . .

MARY: So that every time you find the mind of God on the open pages of your scriptures, you must close off another part of his mind which is too awkward to be considered.

ROBERT: Only if you believe that God has done with the world; that he won't listen to his people or guide them or answer their prayers or reward their search after the truth. God speaks still – and we can listen.

MARY: Or we can let God be God and get on with being men and women.

That's the best way of doing God's work in the world at any time. That picture of the open and closed pages is a vivid way of stating the complexity of taking seriously the Reformation maxim that 'Scripture is its own interpreter', and that one part should always be interpreted in the light of others. Neither Robert nor Mary seems to face the extent of the problem. Robert appeals to immediate communication with God, which, as the rest of the play makes clear, bypasses the messy processes of interpretation and discussion at the cost of a stark conflict between rival absolute claims about what God is saying now. Mary too opts out of the process of debate. She offers a pragmatic, commonsense solution that might also lead to a conflict between different ways of 'doing God's work in the world' which cannot negotiate with each other by reference to the Bible.

Is there a better way? I think we find one in Bellerby. He sees the individualism of Robert's and Mary's ways, their inadequacy in failing to do justice to how teaching has been worked out in the Church through centuries of study, debate and deliberation. In discussion with Robert he quotes Richard Hooker:

BELLERBY: 'When they and their Bibles were alone together, what strange fantastical opinion entered their heads, their use was to think that the Spirit taught it them.' There is no text which the wit of man can interpret which the wit of another man cannot re-interpret to mean just the opposite . . .

The constructive part of his position is well stated later. It comes after Robert has been condemned to death and Bellerby has found Mary crying out in desperation to God: 'Why? Where are you?'

BELLERBY: That kind of prayer I understand.
MARY: But it does no good. He won't shout back; the most he'll do is whisper and because he whispers we don't catch every word. How can we know what to do?
BELLERBY: Yes, how? But these are not the questions we should be answering now, not just at the moment.
MARY: They ask themselves very plainly.
BELLERBY: Yes, they do. But here we are in the weave, the very texture of events. To see the pattern – even to imagine one if we can't discern it – we must be patient; we must wait.
MARY: Time the great healer.
BELLERBY: There is that, but I was thinking of time the revealer. The authority of Scripture is in its truth throughout history not in what we can suck out of it in an evening. The Bible is not a set of dismal instructions but a meditation on how things might be. We need time in order to step back and understand; understand the shape of purposes. We can't grab at events as if they had the authority of Robert's kings and prophets of a thousand years ago. The sense of history, reason and tradition have been all too easily set aside by Cromwell in his extraordinary conquests.
MARY: And he is wrong?
BELLERBY: You know, I can't say that in all certainty, I can't. I wish I could. Only time will tell us. And maybe time has told Cromwell something he didn't expect . . .

Bellerby's idea of being 'in the weave, the very texture of events' with the authority of Scripture being 'in its truth throughout history' as worked out through reason and tradition is, of course, a classic Anglican statement. The counter-question, frequently put in the play, is whether it can respond to the urgencies of history which cannot wait that long for decisions. I see this tension as pivotal in the drama, and I will return to it in the next section. First, however, I will comment on the other two biblical themes.

In the meeting with Professor John Morrill as we developed the idea of the drama one of his most memorable points was the result of his research on Cromwell's use of the Bible. He noted that the overwhelming number of references by Cromwell were to the Old Testament, with relatively few from the New Testament and least from the Gospels. The play takes this up:

BELLERBY: I believe he is honest, I know he is brave. I fear he is misled.
ROBERT: By God?
BELLERBY: By his need to see the Old Testament re-enacted through him. Does he study the Gospels? Does he talk of them? Does he live in their light?
ROBERT: He would not be so arrogant as to model himself on the Son of God.
BELLERBY: So he goes back to the prophets and the judges. There is no one more dangerous than the capable man who believes his lips have been touched with the coal.
ROBERT: You don't believe he is a godly man?
BELLERBY: One can be a godly man and still do the wrong thing. But if he is wedded to the Old Testament, it explains his attitude to the King . . .

This point is repeated even more sharply in the final exchange with Robert, when Bellerby says: 'Take a leap out of the Old Testament, Robert, and into the New . . .'

Here Bellerby seems to be recommending something that I would see as in tension with what I have quoted earlier. It seems

like a mirror image of Cromwell, only swapping New for Old, rather than the earlier insistence on mediating both Old and New Testaments through ever deeper engagement with history, reason and tradition.

But perhaps the most stimulating topic is the relation of the Bible to Shakespeare. Cromwell banned the theatre, and Nigel Forde's creation of a scene in which the fugitive Robert is harboured by banned Shakespearean players is a brilliant *coup*. It is also, understandably, manifestly pro-theatre. The great issues of the relation of the Bible to culture are raised, and the players, appropriately, give their position by quoting Shakespeare. Here, through *Julius Caesar* and *Macbeth*, we see how drama can offer truth by drawing us deeper into the texture of history. But Nigel Forde's basic statement on this is his whole play, now illuminated by his own account above. I would just add one comment. The role in the play of Virgil, Ovid and other classical learning signals the most formative of all engagements between the Bible and culture, the centuries-long relationship between the Hebraic and the Hellenistic in the Roman Empire and afterwards. This is part of the 'texture of history' for the play, and if I were summing up its lesson I would say it teaches us to avoid shortcuts which tempt us, by their ideologies of success, or of immediate experience, or of direct scriptural application, to leap out of history and claim a privileged position exempting us from the long haul of historical learning and messy, non-violent debate.

Decision, Patience and Responsibility

That leads to my final point about the play. Any abstraction of its meaning from its plot, characters and events is, of course, inadequate and must always be followed by returning to the full richness of the embodied drama. Yet as a moment in interpretation such abstraction has its contribution to make. I see the culminating statement in the passionate exchange between Robert and Bellerby near the end of the play:

BELLERBY: I'm sorry, Robert, but I hate your holy decisiveness.

ROBERT: And I hate your holy patience.

This is what Nigel Forde describes[3] as having been focused through Bonhoeffer's *Ethics*.

Reading the play with that as a key, one can see again and again the tension between urgency and the long haul; between 'history-making' and ordinary life; between a sense of God's direct call and its cautious testing over time; between fighting and candle-making; between utopian visions of justice, freedom and equality, and local, practical 'loving the ones you know'. Most of the best lines are Bellerby's, including those about Bonhoeffer's own key ethical concept of responsibility: 'What God is saying to Cromwell does not necessarily apply to you. We have to take responsibility for our own lives, our own actions.'

Yet this is no straightforward didactic play. Any lionizing of Bellerby as a Bonhoefferian ideal fails. There is an agonizing question about adequacy to a historical situation in which decisive action in the public sphere is required. If Bonhoeffer himself was right to take part in the plot against Hitler which led to his own execution, then it is hard to imagine Bellerby breaking out of his rather privatized ethic in order to do anything comparable in his time. His living 'in the texture of events' seems to lack a full conception of taking responsibility for events beyond the local. Yet even here he is genuinely complex, and he does appreciate Cromwell's dilemma in government – 'and maybe time has told Cromwell something he didn't expect'.

Bonhoeffer's thoughts about the tension between radicalism and compromise were in the context of a theological ethic that united affirmation, judgement and transformation of the world.[4] These in turn were correlated with the life, death and resurrection of Jesus Christ – in other words the ethic was connected with the three acts of the gospel drama. For Bonhoeffer, in Jesus Christ God has decisively come together with the world, and the form of his presence in the world is simultaneously that of affirmation, judgement and transformation. Here is a fruitful

model for the relationship of theology to narrative: to think through the gospel story both in terms of the simultaneous inter-relation of incarnation, crucifixion and resurrection and also in its intrinsic relation to the whole of reality and history. There is no formula here – it is a recipe for ever-fresh engagement with the particularities of Bible, theology and history.

And it is extremely interesting that Bonhoeffer himself was not able to be content with the Bible, theology and history. His prison writings include fiction, poetry – and drama.[5] His final writings are radically interrogative in these and other genres, especially letters. The core question, which can also be sustained by Nigel Forde's drama, is: How is our world, including our churches and ourselves, to be affirmed, judged and transformed? But Bonhoeffer also faces that ultimate question which Elizabeth is faced with after her son Robert's execution, and which Bonhoeffer's own death has posed for many others:

> ELIZABETH: Ten o'clock. At ten o'clock, in dreadful silence, half my motherhood is torn from me. Does the world stop turning? No. Do the birds stop singing? No. Is there a God?

A personal coda

The collaboration with Riding Lights that has been the focus of this chapter has been just one aspect of my own engagement in theology through the arts, and in conclusion I will consider this more broadly.

How does theological thinking happen? There is a complex mix of factors which it is impossible to separate – and it is probably unwise to attempt to do so too precisely. Any theologian in whose life the arts play a significant role knows that they help shape theological thinking in diverse ways, many of which are very indirect and hard to identify. Theologians who never refer directly to any poem, novel, painting or piece of music may yet be profoundly influenced by the arts. Indeed, I suspect that this pervasive, indirect shaping of thought in

combination with other factors is by far the most important. I have never before now referred in print to the novels of Sigrid Undset, but the characters and community life of medieval Norway that she portrays over thousands of pages are 'there' somehow when I think about people, history, faith and church.

Yet clearly anything so important is worth explicit consideration. The formation and learning that can happen through theology in interpenetration with the arts can be enhanced to the benefit of both sides. This is a relationship worth developing further, and one way of doing this is to try to draw lessons from past practice.

Jeremy Begbie has invited me to think in this regard about my own written theology. What strikes me is how intrinsic to it the arts have been. There has been no programmatic decision to do theology through the arts (though the stimulus of participation in the *Theology Through the Arts* project has recently put it more explicitly on the agenda), but again and again at critical junctures in particular theological writings the contribution of the arts has been vital. This has not been so much a matter of illustrating theological points with artistic examples; rather it is as if a satisfactory theological inquiry has required the arts.

That was the case in doing a doctorate on Karl Barth's interpretation of biblical narratives – a crucial line of inquiry was into literary criticism, especially of realistic novels.[6] The poetry of the Psalms, Patrick Kavanagh, Gerard Manley Hopkins and Dante's *Divine Comedy* was constantly present in discussion with Daniel Hardy as we tried to think through the relation of praising to knowing God in *Jubilate: Theology in Praise*.[7] Perhaps the most sustained engagement with poetry was in attempting to write a basic spirituality in *The Shape of Living*.[8] I had appreciated the poetry of Micheal O'Siadhail for many years. As the book took shape, time and again his poems opened up and suggested themes. In the end each chapter seemed to be conceived by trying to discern a wisdom in relation to a double intensity – above all, the Bible and its continuing generative inspiration; but also O'Siadhail's deep, daring, finely crafted poetry.

Within theology it seems to me that the question of genre is

one where there is most overlap with the arts. Indeed one can see a great many theological discussions and disputes turning on questions of genre. How might the poetry, narrative, law, prophecy (often in poetry), proverbs, and other genres of the Bible be done justice to in doctrinal discussion? There is often a suspicion that theology in the form of doctrine and argument fails to honour the integrity of those genres, tending to reduce them to an abstractable didactic content. But are there modes of theology that can do better in order to fulfil the basic intention of doctrine to learn and teach truth in relation to God?

In *Jubilate: Theology in Praise* Daniel Hardy and I wrote the nine chapters in a genre that might be called one of discursive wisdom, drawing on many genres and oriented towards a habitable theology for today. But we were aware of how different this was from much other theology from which we had profited, so we added two appendices. Appendix A, 'The Systematics of Praise', was a conceptual, systematic account of our theme that resonated with the main doctrines of systematic theology. Appendix B reviewed relevant literature within a broad historical framework in the genre of commentary. My sharpest lesson in the significance of genre came during five years of wrestling, in collaboration with Frances Young, with Paul's Second Letter to the Corinthians. We were both pressed hard by a colleague specializing in Spanish literature, Gillian Weston, who came to our seminars on the letter and who insisted again and again on raising the question of its genre. That provoked Professor Young to the research that led to a breakthrough insight: the unity and structure of the letter is best illuminated by comparison with the genre of written legal defences that were part of the culture and educational curriculum of the period.[9]

The most recent fruit of my fascination with multiple genres as essential to theology is in *Self and Salvation: Being Transformed*.[10] It tries to combine doctrinal teaching with meditation, poetry, dialogical discussion, biblical and liturgical commentary, and biography. The arts have helped shape it throughout – for example, besides poetry and drama, the theme of the face and

facing is developed in dialogue with the tradition of Christian art, and there is a pivotal discussion of 'the singing self'. Whether it 'works' is of course an open question; but from the point of view of its authorship there is no doubt about the intrinsic relation between genre, arts and theological content.

There are three main lessons I draw from years of trying to do theology in such ways.

First, there is the irreducibility to each other of the different genres, arts and doctrines. This means that none of them can claim completeness and each is continually to be opened up to others.

Second, if this is not just to be a rich riot of diversity but is to be related to the triune God, then we are invited into an imaginative and intellectual labour of interrelation, interpenetration, and discerning the deep connections.

Third, it helps to have some name for this labour. My favourite is 'seeking wisdom'. This does not aim at a super-genre or dominant art form or doctrine, because part of its wisdom is in appreciating the irreducibility of genres, arts and doctrines. Rather it is about forming communities and conversations in which those with different vocations – artists, theologians, and many others – can share the wisdom they have learnt and can come into fresh wisdom together. I do not think there is any short-cut to theological wisdom, avoiding these complex but endlessly fascinating engagements. But this is not to discourage those whose vocation has not led them into the arts or theology. The desire for wisdom is the heart of the matter; and 'wisdom's children' form a community in which there are many surprises regarding seniority and importance.

It is of great significance that, as the early Church explored who Jesus Christ is in relation to God and the whole of creation and its future, they returned frequently to Proverbs 8. Wisdom is there pictured at the heart of creation, a master worker beside God:

> I was daily his delight,
> rejoicing before him always,

rejoicing in his inhabited world
and delighting in the human race.

(Prov. 8.30b–31 NRSV)

The call, promise and warning which follow might be guiding maxims for theologians and artists in their relations with each other:

And now, my children, listen to me:
happy are those who keep my ways.
Hear instruction and be wise,
and do not neglect it.
Happy is the one who listens to me,
watching daily at my gates,
waiting beside my doors.
For whoever finds me finds life
and obtains favour from the Lord;
but those who miss me injure themselves;
all who hate me love death.

(Prov. 8.32–36)

Notes

1 The remarkable set created by Sean Cavanagh included several coffins used to great effect in the action.
2 See above, pp. 59–70.
3 See above, p. 68.
4 Dietrich Bonhoeffer, *Ethics*, London: Fontana, 1964, ch. 4.
5 Dietrich Bonhoeffer, *Letters and Papers from Prison*, London: SCM Press, 1971.
6 David F. Ford, *Barth and God's Story: Biblical Narrative and the Theological Method of Karl Barth in the Church Dogmatics*, Frankfurt: Peter Lang, 1985.
7 Daniel W. Hardy and David F. Ford, *Jubilate: Theology in Praise,* London: Darton, Longman & Todd, 1984; US edition, *Praising and Knowing God*, Philadelphia: Westminster Press, 1985.
8 David F. Ford, *The Shape of Living*, London: HarperCollins, 1987; US edition, *The Shape of Living: Spiritual Directions for Everyday Life*,

Grand Rapids: Baker, 1998; 2nd edition, Grand Rapids: Zonderran, 2002.
9 Frances M. Young and David F. Ford, *Meaning and Truth in 2 Corinthians*, London: SPCK, 1987; US edition, Grand Rapids: Eerdmans, 1988.
10 David F. Ford, *Self and Salvation: Being Transformed*, Cambridge: Cambridge University Press, 1999.

9

The Play Beyond the Play

BEN QUASH

Introduction

Why is drama theologically interesting? Because of the way it opens a window on to the dramatic character of human existence in the world, in relation to a God who is himself *acting* – in, for, and with human agents, all the time.

We wanted a piece of live drama that focused this vision of the dramatic character of life before God, without foreclosing any of its open questions. Working as a community of theologians with a community of dramatists – a playwright (Nigel Forde), two directors (Paul Burbridge and Bridget Foreman), a designer (Sean Cavanagh, whose eventual set constructed in the crossing of Jesus College Chapel had an astonishing impact), and, eventually, a cast of actors, meant that we had to pull what might have been just an abstract interest into something concretely particular and gripping: a real play about actual people.

At the heart of drama – as the Greeks knew well – is *agon* (struggle). This is why the main characters in a drama are called 'protagonists'. The decision to set a play in the shadow of that great historical protagonist, Cromwell, arose in part from a conviction that in the English Civil War the nation's life took new shape in a crucible of intense confrontation. The millenarian fervour of the time set all the antagonism around it against a horizon of God's utterance and action, in a maelstrom of debate over Scripture, ecclesiastical authority and political power. Who had the true interpretation of God's word and will? How were people to act with one another when they disagreed profoundly, and yet recognized themselves as all standing together within the

single horizon of God's greater drama? How were idealism and religious principle to be balanced against family loyalty and local fellowship? Could the Kingdom be brought in on earth by the agency of men, and at what human price? The 'pod' group became convinced that the period of the Civil War, which established so many of the abiding features of our own political and religious world, still had the power to speak directly to our contemporary situation in the medium of drama. This was the beginning of a process that would lead to actual characters materializing in front of us – the physical embodiment of a drama about how to act, and act *well*, in the world.

The 'pod' group

Working in the 'pod' group, and being part of the process that eventually brought *Till Kingdom Come* to performance in Jesus College Chapel on 13 September 2000, has meant that I now look at this play in a way that I would never have looked at a play before. The finished text – and any specific performance of it – has a hinterland of extraordinary interest and beauty. It has traces and contours of conversations, experiments and rewrites; it has blind alleys, high points, low troughs, places of rest and refreshment and laughter in its background – those interactions of real-life characters that are the interactions that *made* the play. Knowing this about *Till Kingdom Come* makes me look at other plays in a different way, too – they all, I imagine, have such a hinterland, such a history.

Another image for the play is that of a palimpsest: it is layered in fascinating ways. This came about as Nigel Forde responded to suggestions and concerns from the company and the 'pod' group, and did successive revisions. It's a process that carried on even after the play began in performance. *Till Kingdom Come* changed significantly between the time of its initial tour and its premiere at the TTA festival, and it has subsequently changed again. But it is the product of its changes. Its richness is attributable to those bits of previous layers that are now invisible, as well as to those that remain on the surface.

One of the most intriguing documents I have retained from the work of the 'pod' group is something called a 'development notepad'. It is a conversation in print that Paul Burbridge and Bridget Foreman made possible following the initial read-through and early experience of performing the play, and before the production for TTA. The comments, suggestions and questions of a range of people (the historian Bob Whiting, members of Riding Lights, David Ford, Dan Hardy and myself) are displayed on the page in interaction with each other, after circulating via email. The dramatic form which the 'pod' group process itself had is displayed on the page. There are the *dramatis personae*; there are their lines. And it is a good read! It makes you want to know what will happen next. It is part of that dramatic hinterland to the play I have already mentioned; part of a 'play beyond the play', and a reminder that stage drama is in many ways the distillation of aspects of the dramatic medium of 'real' human life and creativity out of which it is born.

All this suggests to me that a play is better conceived as in dynamic relationship with its past and its future than as (at any stage of its creation and life) a finished product. Lorraine Cavanagh makes this point too. Intrinsic to it is its 'depth' – the ground of ideas, images and pragmatic possibilities that it draws on and is nourished by. Intrinsic to its coming alive in performance is the dynamism of its interaction with the people who interpret it: its director, its actors, (its 'pod' group, in the case of this play!), and, ultimately, its audience.

In this respect, the resemblance between a dramatic work and a work of theology (whether a dogmatic treatise, a sermon, a hymn, a prayer, a conversation) is very remarkable indeed. Theology is always, intrinsically, in dynamic relationship with its past, its future and its interpreters. It is work in progress. Good theology is kept in motion, above all, by its relationship with the living God, whose life in the world and self-disclosure to human beings is not delivered in fixed form or codified in any sort of timeless way. As Hans Urs von Balthasar writes, we find in theology a 'kinetic variety of forms and styles', all of which are needed 'to express the one truth . . .'. This, he says, 'arises

because of the unimaginable fullness of individual traits in peoples, epochs and personalities in their unique talents and missions', all of which provide the context of theological thought and construction, in response to the history of God with his people.[1] Theology, as a consequence, 'will burst the confines of any specific and limited structure of thought'.[2]

I want to turn now to look more closely at this overlap between theological and dramatic concerns, and to focus the consideration through the underlying question of 'the good'. *Till Kingdom Come* is a play that focuses this question particularly sharply, as I have already hinted – how can one act well, in immensely compromised circumstances? It is the question that breaks the surface of the play again and again – in Bellerby's questions to himself ('And now what do I do?'), in Margaret's questions to Robert ('How can I talk to you . . .?'), and in a host of other interactions. In its deployment of this question, *Till Kingdom Come* achieves something we were very keen it should achieve. Without losing its essential particularity, it highlights something that is at the heart of drama more generally – that all action takes place against a 'horizon of meaning', and must orient itself accordingly.

What is the nature of the good?

Neither drama nor theology can escape the question of the good. It is too basic a question. It is the question by which we situate ourselves in relation to the experiences, enticements, opportunities and chains of events in the world around us, and decide how we are going to respond to them.

'[Art] links things together, it reveals things', says Francis, the actor-in-hiding who seeks to persuade Robert Lockyer of the truthful power of drama as they share time in a 'safe house' for fugitives from Cromwellian law. He is right. A piece of literary art interprets experience and events in one way rather than another – narration is always interpretation, and a drama chooses what it will include and what it will leave out when it narrates something. It makes the decision that what it is telling is

important in some way, and that its intended audience will have a reason for wanting to read or watch it. Why would it make this assumption if it did not believe that what it is telling (or narrating) is *in some way* related to *some sort* of 'horizon of meaning' or significance?[3] And who would deny that the question of the good was in some measure a part of that horizon of meaning, within which all our interpretative activities are situated? Drama, of course, is a many-faceted wonder, and I would not for a moment suggest that its purpose is *only* to help us deliberate on moral questions. Nevertheless, this is *one* of the ways we engage with drama, and I hope it will not seem reductionist to use this section to concentrate on this *one* aspect of drama.

A key part of the way that we human beings evaluate the good has to do with our sense of the future. We project possibilities forward, and measure them in the context of an imagined future state of affairs. Depending on whether or not we like what we imagine up ahead of us, we decide our position in relation to present possibilities. The contemporary moral philosopher Alasdair MacIntyre takes up this theme in his book *Dependent Rational Animals*:

> [A]s a practical reasoner I have to be able to imagine different possible futures *for me*, to imagine myself moving forward from the starting point of the present in different directions. For different or alternative futures present me with different and alternative sets of goods to be achieved, with different possible modes of flourishing. And it is important that I should be able to envisage both nearer and more distant futures and to attach probabilities, even if only in a rough and ready way, to the future results of acting in one way rather than another. For this both knowledge and imagination are necessary.[4]

Till Kingdom Come makes this prospective orientation of human lives a central theme, and its success in doing so is part of the play's dramatic truth and force. Working out a proper relationship to the future is what is implicit in Bellerby's 'And now

what do I do?', and in his recognition that Robert and his own daughter Margaret in a certain sense need to 'look forwards and plan ahead with optimism'. The fact that it is 'a meditation on how things might be' is one of the powerful resources that the Bible has to offer. And Mary, the brilliantly conceived character (who as Fifth Monarchist takes every opportunity to scan the skies in anticipation of the Second Coming) becomes, in some ways, the presence of a *horizon* at the play's very *heart*. Through her, the claims of what-will-be continually challenge the present and what people do in it.

As we may know from our Shakespeare (and as Francis would no doubt remind us if we didn't), the stage is often described as a 'scaffold'. I like this word, because of its suggestiveness. A scaffold is where human justice at its most severe is enacted in the form of criminal executions. The apparatus set up for scientific experimentation is a sort of scaffolding. And scaffolding is what always accompanies building work – it's a feature of all our human projects and endeavour. What do all these various kinds of scaffolding have in common – the stage included? They are all about trying to work out what we are involved in, in this world we find ourselves always already in the middle of. We do not have a clear view of the beginnings or of the end of our world – neither of our existence, nor of our physical universe. It is not obvious what it all means. As Bellerby says, 'we are in the weave, the very texture of events'. So we go about trying to interpret it all from the middle, by various kinds of exploratory improvisations which we with others decide we want to get involved in. We put up scaffolding, and construct things, to see whether they will stand up – stand up to scrutiny in a legal case, or to high temperatures in the laboratory, or to the test of time. Scaffolds are set up by a society for the staging of its shared experiences and common search for what being in this world is all *about*.

There are at least two conditions for this working well. First, we have to go about this search with others (in other words, it works best as a collective enterprise). Apart from anything else, we rely on language to undertake our explorations, and language is something we all depend on others to induct us into. And

second, we have to be passionate about this search. Only some-
one who *desires to know the answer* really asks questions.

Now drama is all about the patterning of particulars – parti-
cular people, particular settings, particular actions and words, a
particular time-scale – and all this in order to signify something.
Like language, drama is not a ready-made system of meaning.
It's not a logical code of signification, which will always mean
the same generally and timelessly. It emerges from a complex
interaction between circumstances, actors, text and audience
(this again is its social dimension). It is an *event* of signification,
never exactly repeatable a second time. You cannot communi-
cate the meaning of a drama in a set of propositions on a page.
Something is lost if you do that. Its significance is only really
apparent when you are present at the event – at a specific place
and time, with a specific set of other people – and when you are
involved in what is going on, part of the event yourself (in a way
that you could never be involved with a set of propositions).

If drama's patterning of particulars invites you to a *working
out of the good*, as I have argued it does – if it is a staging of
possibilities that are variously to be judged good or bad – then
the good is tied to particularity as well. The good, like the impact
of a drama, cannot be reduced to a set of propositions on a page.
The good is not something general and timeless. The good is
whatever is good *in this place, in this set of circumstances, for
this person, now*, and the good is seen to be the good *when it is
done*. Like drama, it has the character of an event. We do not
learn it before we get involved in action – like learning a theory,
or reading the instruction book for our new microwave oven
before using it. We learn it *in action*, as we go along. The good is
embedded in particular interchanges. The 'proof' of the good
cannot be in a rational system; it can only come about – we might
say – 'in terms of life'. Once again, Bellerby has the line that sums
it up best: 'Man and woman cannot be good in general, only
in specifics.' This is why I think drama is so important to
our exploration of ideas of the good. It recognizes – more than
most theory can ever do – that some things need expression in
event-form, or 'in terms of life'. The scaffold of drama enables

us all to get involved together with this 'working out of the good'.

The dark side of this, of course, is that 'particular actions' are also what arise in the working out of beliefs that may, in one way or another, be far from good – which is to say, far from adequate to the complexity and fragility of human situations. Working truth out 'in terms of life' is exactly what Robert, and (never seen, but always present) Cromwell are trying to do. 'We have dared to rouse ourselves, to *act* our creed,' says Robert. The test of whether this working out of beliefs in action is good or not is, though, precisely the *future* they in *actual fact* make room for. One of the things the play does so well is to pose *agon*, conflict, alongside that other most basic piece of dramatic currency: exchange, or gift-giving.[5] Those who prevent *agon* from becoming the obliteration of any future at all are those who mediate the shared space in which the conflicts happen but stop these conflicts from having what would be a terrifying 'last word'. They are Elizabeth, with her fierce commitment to the requirements of hospitality, and her conviction that 'we can have different opinions and still respect one another'; and Mary with her humour and large, encompassing horizon, and (although he is compromised) Bellerby, with his belief that 'everyday life' must be the medium of salvation, if we are to be saved at all.

Through being a play about real human lives under duress, *Till Kingdom Come* becomes a play about the question of the good. It is about how one can continue to remain in (dramatic) relationship with one's fellow actors, even when in the profoundest disagreement with them. It is about how the reconciled reality held out to us in God's drama can take shape in a world where authority is always ambiguous and humanly compromised, and we are always under pressure to turn away from those standing against and around us, and so deny our common placing on God's stage. It is about how to keep the drama going, when all the pressure is prematurely and artificially to end it, by one's own violent or impatient intervention. It is a theological drama, not just because it has a religious theme, but because the most basic questions it raises about agency, conflict, and 'the good' go to the

heart of our created condition, and make us think freshly about who we are and how we are to act.

Distributed power

In this final section, I want to think about the extraordinary way that collaboration between a wide range of people is constitutive of the power that drama is able to release. It was also the secret of the 'pod' group's productivity, and it is suggestive of some quite profound truths about what 'power' is, and how it is conceived (and frequently misconceived) in the modern Western mind.

Most people would agree that good drama is a 'powerful' thing. By this they usually mean that it makes a great impression on them. It presents to them vivid insights and stories – insights and stories which remain in their minds and sometimes even change the way they look at the world and behave in it. But who has the most 'power' in the staging of a 'powerful' play?

There are a number of obvious possibilities. It could be the playwright. It is the playwright who provides the script, which you might say is the raw material of a play. It is the imaginative energy and the words of the playwright which give the players something to conjure with. The basic story – good or bad – comes from the playwright's pen; and if it is good, then the playwright takes the credit.

But then there is the director. The director has the power of interpretation. A play can mean many different things, and it is the director who may turn a particular face of the play to an audience, making it strike home in one way rather than another. A bad director can kill even a good script; a good director can bring alive even a poor one.

The actors, of course, have power to interpret as well, even though they do not have the director's distinctive co-ordinating role. In addition, they have a unique sort of power which the director never has: the electric power of immediate contact with an audience; the power of presence. This makes the actors another kind of candidate for 'most powerful' in powerful

drama. When we think back to plays which made a great impression on us, the chances are that we will remember particular actors, and the quality of their interactions with each other.

Can we identify one pre-eminent provider of dramatic power from amongst all these alternatives? I don't think so. In fact, the power we encounter in good drama is impossible to attribute to any one person. Paradoxically, the overall power of a dramatic performance is proportionate to the *distribution* and not the *concentration* of power in any one person. The worst sort of drama is the sort where a character like Bottom in *A Midsummer Night's Dream* is allowed to take over – wanting to play all the parts ('. . . let me play Thisby too. I'll speak in a monstrous little voice . . . '; 'Let me play the lion too. I will roar that I will do any man's heart good to hear me'); thinking he knows how every part ought to be undertaken ('That will ask some tears in the true performing of it'); and *never* listening to what anyone else has to say. Bottom is an archetypal show-stealer, the lamentable character of whose eventual performance (so affectionately presented by Shakespeare) is a perfect judgement on his pretension.

Bottom's failures demonstrate that dramatic power is not the product of self-assertion, but of an extraordinarily delicate sensitivity which is often almost passive in character. I can clearly remember attending a drama workshop as a teenager when we were asked to act (silently) a man waiting for a bus. Our initial instinct was to fill the space with our own activity – to do a lot of clichéd 'waiting-for-a-bus' things – pacing to and fro, looking at our watches, and so on. And then the instructor pointed out to us that a really good performance of waiting for a bus (a much truer performance) would be simply to stand still, with a slightly vacant look, for a long time. To do *less* not *more* – because that is how people (on the whole) *actually* wait for buses.

Bottom's blustering ineptitude is also a reminder that creative power resides not in individuals alone, but in the quality of their relationships with each other, and that in a collective enterprise like the staging of a play the best relationships are those in which

the parties know when to give way, when to listen, when to wait. The power unlocked in a good drama is not the property of the author, or the director, or any single actor; it resides in the spaces between them, in their disposition towards what their collaborators have to offer them, in their attentiveness to each other, and in their creativity in working with what is simply 'given'. The best drama emerges from a profoundly receptive exchange among the actors themselves, and between the actors, the author (usually via the text) and the director. This produces what von Balthasar called 'a threefold dramatic creation'.[6] The individual actors' imaginations develop best within some antecedent context of meaning – in other words, they must be sensitive to the author and what he or she 'meant'. But the author's work is never to predetermine every aspect of what actors and director will do. The successful author's fundamental quality, where drama is concerned, is what Schlegel once called a 'magnanimity' that makes room for the rich variety of other people's interpretations and freedom. And the director, meanwhile, is not in the business of treating actors like 'super-marionettes' who are inanimate figures until animated by the director's omnipotent will. The actor, as von Balthasar says, is 'not a mere musical instrument',[7] and the role of the director is to mediate and elicit rather than to manipulate – to divine the springs of creativity that are already there, and temper the diversity of the actor's various interpretations and styles into a unitary (though not monolithic) whole.

All this is a lesson in what might be called 'organic reciprocal influence',[8] and the power that it unleashes. Drama offers a sort of parable of the fact that the exercise of power resides at least partially in letting other people act. The secret is not to suppose that your agency is incompatible with the agency of others – that there is competition for a limited 'space' of agency. Your agency does not need to push the agency of others aside in order to triumph. The smallest acting area can often witness the most mutual, liberative and powerful concordance of your activity and the activity of another, or many others: a stunning piece of ensemble playing, in which you are at your best, but cannot take

the credit for it. Was your dazzling performance achieved by you or elicited by another? The answer is *both*.

Just so, in dealing with the Christian God, we ought not to be in the business of identifying which actions are our achievements, and which God's puppetry, in order to attribute relative quantities of power respectively. That is to misunderstand and mislocate the power which is God's, just as much as the power which we find at work in and between ourselves. The highest instance of power we have been given to know in the God of Jesus Christ does not compete for a limited arena so that it can exercise itself in brute solitude over against us. On the contrary, in Kierkegaard's words:

> To love and *to be loved* is God's passion, almost (infinite love!) as if he himself were subject to the power of this passion, almost as if it were a weakness on his part, whereas in fact it is his strength, his almighty love.[9]

In this lies the power of the greatest drama ever played. And in this lay the secret of the inspiring process of concordant, mutually-generous activity which it was a privilege to share, with Riding Lights, and with all who were involved in *Till Kingdom Come*.

Notes

1 Hans Urs von Balthasar, *The Theology of Karl Barth*, San Francisco: Ignatius Press, 1992, p. 251.
2 Von Balthasar, *Karl Barth*, p. 253.
3 The emphasis on the necessity of a 'horizon of meaning' to drama is a distinctive feature of Hans Urs von Balthasar's work *Theo-Drama* (San Francisco: Ignatius Press, 1988–94). Much of what I will go on to say about literature, and especially drama, derives from von Balthasar's work, and ideas like the need for the good to be worked out 'in terms of life' come from him.
4 Alisdair MacIntyre, *Dependent Rational Animals*, London: Duckworth, 1999, pp. 74–5.

5 Both David Ford's recollections of the Lambeth Conference production of *Wrestling with Angels* and Lorraine Cavanagh's chapter also draw attention to the importance of such exchange – in drama, as in life. See especially pp. 71–80, 105–113.

6 Hans Urs von Balthasar, *Theo-Drama I: Prologomena*, San Francisco: Ignatius Press, 1988, p. 269.

7 Von Balthasar, *Theo-Drama I*, p. 300.

8 Von Balthasar, *Theo-Drama I*, p. 274, quoting Claudel.

9 Kierkegaard, *Diaries* (1854), quoted in von Balthasar, *Theo-Drama I*, p. 277.

A Moment's Truth

Reflections on the Riding Lights Production of *Till Kingdom Come*

LORRAINE CAVANAGH

In an age of accelerated communication and of information technology which is able to shrink the distance between past events and the present moment, an audience gathers in the Chapel of Jesus College, Cambridge to hear of war and rumours of war, and of impending apocalyptic. We enter into a particular moment, not as hearers or readers of an imagined story but as participants in certain historical events. Cromwell's war is at its height and the questions which it raises become our own, as part of the drama of our continuing story.

Drama retains its hold on our imagination, perhaps because we are obliged to relinquish our grip on the familiar characteristics of the written word and of the process of story-telling, which distances us from the past and separates us from the sins of previous generations. The story, whether or not it is a true one, permits an ordered progression from beginning to end and brings, to the hearer at least, the security of being outside the event and of 'knowing' an outcome in which we had no part to play and in which we are in no way accomplices. In Jesus College Chapel on the evening of 13 September 2000, we not only hear of war and speculate on the imminence of the Second Coming from the safe distance of a few centuries, but are made accomplices, and thereby implicated, in the aftermath of a series of events.

A scene is set. We are to dwell on stark events unadorned by prose description. Characters are persons, universal perhaps,

who order their lives according to a different conviction about
fundamental beliefs for which all might be prepared to die. We
enter into their actions and seem to speak their words with our
own voices and as they take us beyond the passive receptivity of
reading and hearing a story, we know the pain and incompre-
hension which, far from being the stuff of peace, sustains so
many ideological conflicts.

Plays and performance extend the boundaries of story. They
also are a reminder that while knowing the story's ending may
blunt its sharpness, informed understanding makes it harder to
tell. The creative process, in order to be truthful, involves
struggle and we sense that this play was created in travail. The
hard won prize for the labour of creativity has left its mark on
the finished product, if such a product can be described as
'finished'. Our involvement is the price paid by writer and
director for allowing us to enter into their work and to continue
to question and to struggle with the theatre company for
solutions to the enigma of conflict. The audience is itself con-
fronted with an ongoing open question inviting us to re-examine
and re-experience the incomprehension involved in Christian
conflict, the fact that we are driven by an urgency which we do
not fully understand, any more than Bellerby understands his
God, who is also Robert's God and Cromwell's, and the God of
Joby Cloud. The play and its staging implicate us, the audience,
in its own struggle. It gives us a voice in the manner in which it is
performed, or perhaps it is that our own voices are returned to us
and the incoherence of conflict articulated on our behalf and
given shape, so that we can enter more fully into the ongoing
travail of collective faith.

As participants in these events we are asked to permit God his
own freedom to be as he chooses, for 'Neither is this Thou; yet
this also is Thou.' This is a freedom in which we share and which
we recognize in the unconditional giving and forgiving involved
in the struggle for understanding and of allowing others to be as
they are in their integrity, so the acceptance of forgiveness is as
vital to peace as the giving of it. It is a participation in the free-
dom of God which bridges the divides of incomprehension

between families and individuals, spanning the gap left by words, both said and unsaid. Refusal of gift becomes the refusal to hear peace when it is spoken, even when the terms and words employed seem strange or reprehensible. It involves acknowledging and owning what is not known, with respect to God and with respect to neighbour, speaking in each other's voices and so 'living in the light of the past, rather than in its darkness'.

Mary and Bellerby struggle to move from exchange to gift-giving in a reciprocal meeting of practical needs as, in a eucharistic moment, they reluctantly exchange candles for bread. Other moments of truth and light are obscured by Robert's limited vision of God as judge, and of Bellerby's as Creator-Redeemer, neither of whom 'could see far enough even to realize that [they] couldn't see far enough'. In these moments the audience learns again, not by logical deduction, but by a kind of collective remembering, that we can never see far enough into the past or into the future to make sense of the present. Freeing God into the present begins with letting go of the past and, if necessary, of its God, while recognizing that the past is all we have with which to fashion new beginnings.

We start at the end 'because that is what time has brought us to and that is what stares us in the face . . . There is no true starting place.' *Till Kingdom Come*, for all its waiting on the future, speaks from its end and so sharpens the present moment. There is a kind of truth in Lockyer's words to Margaret after his discovery of the circumstances of his father's death, that 'our hope for the future is only the past with a bright ribbon round it. We can say "let it go", but we can't do it.' But this is only a partial truth, reflecting the way in which moments and people are reconstructed in a particular way in our unconscious desire to tell a story, to make sense of our 'selves' and to fashion answers for questions which we do not properly know how to ask. As participants in the making of theatre, our questions are revealed to us. We are caught up in the sharpness of this present moment as the dislocation of time and truth expressed in the anguish of its unspoken question. 'Why have you forsaken me?' is the question which Robert dares not ask of his father, of Cromwell, or of

God. In this moment of revelation, as it embodies his own truth, our past is shown to us in the remembering of beliefs and convictions which in some way embody belief about self, other 'selves' and God. This is the kind of remembering which dictates actions, thoughts and the way we love or fail to love. It tells the story of human relatedness.

The heart of this production, and of the play itself, speaks of human isolation, of separation within family and community, across the boundaries set by the history of conflict, and of separation between ourselves and God. It is not that we are revealed as simply selfish, but as having, in Bellerby's words, 'forgotten how to love' and, as a result, how to believe or hope. The unspoken yearning for reconciliation which spans the separated worlds of Lockyer and Bellerby, and of Protestant and Catholic, translates itself into our own yearning to remember and rediscover truth, not only as objective proposition, but as a profound understanding of others which has been informed by the love of God.

We sense that forgetting, in this context, involves not so much a loss of intelligence which, as Mary says 'you don't lose if you've once had it', as that of 'forgetting' a working knowledge of the way in which it is connected to love. Bellerby's declaration (itself a misunderstanding) that Robert's intelligence had been 'twisted into a very strange shape, to leave off worshipping God and take to worshipping Lieutenant-General Cromwell' reminds me, somewhat surprisingly, of the 'twistedness' I experience on momentarily forgetting how to piece together a domestic appliance. As with the use of domestic appliances, the 'intelligent' connection which reveals simplicity and truth is briefly obscured by a 'twisted' memory. In this play, it is not that God or Cromwell is worshipped in any particular way (allowing for irony on the part of Bellerby), or not worshipped at all, but the separation of 'worlds' on stage and the words which pass or fail to pass between performers, reveals the 'twisted' way in which we choose initially to remember and subsequently to tell our story, with fatal consequences for understanding and for peace.

We, the audience, sense the disconnection in our own lives and

relationships and ask with Elizabeth whether the language we have used to describe those who come from a different 'world' from our own, and the judgements we have employed in the telling of our collective story, are capable of change, whether our names and the names of others can be given and received as gift, in order to arrive at deeper mutual understanding. 'Do names make a difference to us? Do we grow into our names or fight against them?' Or must we simply settle for 'one long process of compromise between what we want and what we will settle for, between what we must do and what we may do'?

The 'twistedness' of our memory as the manner in which we have remembered and told our separate stories, whatever these may be, is in the mutual incomprehension of Lockyer and Bellerby. Mary's veiled accusation threatens to reveal the truth of their situation; that were it not for a love which threatened to transcend these boundaries, and which proved fatal, Bellerby would not be welcome in her house. Had things not been previously 'named' in the cause of 'truth', un-nameable truths might have been spoken in love. Past and future were momentarily brought together, but not reconciled, in the grim reality of the present moment and we are left with the consequences, as though paralysed, in the yearning which remains between the separated worlds before us.

Lockyer's driving force, the motivator of his own inner conflict, is a passionate desire to see reality as the way things and people are in truth. The truth about his father, about Cromwell and about God himself is to be revealed and owned at any price, but he cannot see (as the audience sees) that the truth of things only reveals itself from outside the boundary of individual and personal experience, and from the way the individual self chooses to sustain and inform that experience. Distorted or 'twisted' memory, as a particular way of describing past events, therefore plays no part in truth telling and forgiveness, or in supplying the basis of hope for the future. But Lockyer's passion for reality must at the same time be respected for its own integrity, even if the reality to which he holds is only one way of questioning and understanding the past. Honouring integrity, as

Kate realizes in her exchange with Bellerby, is the beginning of forgiveness since it involves not knowing the reality of a given situation, or absolute truth, and consequently not judging. Robert is at first 'good . . . because he was persuaded' but can both he and Bellerby be 'good'? Can both be truthful? As onlookers, we remain outside their experience. To what extent then will the truthfulness of their situation impact on our own?

If there is an answer to this question we sense that it will embody the hard edge of a hope that does not consist so much in dreaming of an ideal future, or of falsely remembering an idealized past, as one which embraces the reality of the present by viewing the past in its truthful perspective. 'The past is like a great bell tolling; we have to let its echoes die away. How else can we hope to hear the voice of God?' The hearing of God's voice will undoubtedly involve conflict, binding it to the reality of forgiveness, of living with the truth of events and of coming to terms with the fact that no truth exists in isolation from past truths which only wait to be rediscovered in the present.

Thomas's diary tells his son a moment's truth which can only be fully understood when it is seen for what it is; a single moment in the pattern of time and of particular circumstances. Robert's incomprehension and anger belong to us as the pain experienced in the hardness of realities we ultimately cannot bear,[1] in the dismantling of ideals and illusions, of dreams and false dependencies, in the way that these are disconnected with the reality he so passionately defends. In the worlds we see on stage, past and future, reality and truth, are concentrated in a moment of tacit dialogue between performer and viewer, writer and hearer, designer and director, as in the struggle of writing and performance and of staging and design, the past is re-presented and once again questioned.

Mary, from her watchtower, searches the distance for the revelation of the Son of God and in the process reveals present truths, along with the hidden often unacknowledged belief that outside living memory no reality is too great to bear. Her world and her theology are limited to the confines of a watchtower, reminding us that God and the truth about God cannot be

confined to a single place or moment, or fitted into a particular intellectual construct. She converses, like Bellerby, with herself, disconnected from reality and from the world of everyday and yet bound to it, as she is bound to Elizabeth and the world of candle making, ironically perhaps, a metaphor for the need of light in the search for truth.

Plays and performance reveal what is hidden, rather than simply declaring what is true in a propositional way, so that *Till Kingdom Come* is more than a mirror reflection of past or present truths, since mirror reflections can only speak truthfully of what is visible from outside, at a glance, in a certain light. Furthermore, this is a production, and not only a play. It is born of the struggle which belongs to ensemble work and to the revealing of truth, and which imparts vitality to the written word and to its performance. We sense in that ongoing creative process (theatre as performance and as ensemble is always an ongoing process) a certain danger and with it a possible remedy for conflict, the fashioning of peace out of the stuff of war, as the play releases, rather than reflects or reveals a certain truthful questioning. The audience suddenly belongs to this process and is permitted to 'question' the way in which events relate to some all-comprehending and forgiving purpose; God's purpose, if we are to believe that Bellerby's God has a purpose, or that Robert's has one which is consistent with the God of the New Testament as well as the Old.

There are some who may have come to this performance believing that theological and sectarian differences do not matter, that the schisms, quarrels and wars of history not only belie the message of the gospel but are in themselves futile, but the written word and the performing of it have simultaneously revealed and contained our universal longing to know God and to understand each other. Whether or not we believe in him, we must ask 'What kind of God are we dealing with?' since 'Is there a God?' matters less to us than 'What is God like?' This is the question which hangs in the air unanswered, the question asked at the end which is the beginning, and which accuses us in the present of our failure to remember truthfully and to work with

truthful memory. It waits for an answer in the carefully placed silences of performance, in movement and scene change, in the dramatic pause of the unwritten word and in the sudden interruption of song. This is the yearning which makes sense of reconciliation and for which Robert had to die. It is in the heart of believer and agnostic alike, and the theatre company, as though in travail, works to realise it for us.

Note

1 T. S. Eliot, 'Burnt Norton', *Four Quartets*, London: Faber & Faber, 1944.

THE WAY OF LIFE

The Way of Life

Ely Cathedral, one of the most spectacular edifices of the medieval era, is already replete with art. The challenge to mount a permanent sculpture on a vast plastered blank wall, immediately adjacent to the main west door, was therefore a colossal one. With funding having been generously provided by the Friends of the Cathedral, the Dean, the Very Revd Dr Michael Higgins, approached Theology Through the Arts. *The sculptor Jonathan Clarke was eventually chosen and commissioned to work in a 'pod' group with Alistair McFadyen (Leeds University), John Inge (Residentiary Canon at Ely) and Marianne Edson (representing the Friends of Ely Cathedral). The result was* The Way of Life *(Plate 8), dedicated at a Choral Evensong on 17 March 2001.*

Here the collaboration is described at length, a process in which the group was compelled to intertwine theology with a myriad of daunting practicalities, not least that of getting colossal pieces of aluminium to stay on a wall. In his interview, Jonathan Clarke notes that the 'gaps' between the different languages and perspectives of the group did not inhibit under-standing and communication; indeed, he comments: 'it was help-ful to keep a sort of distance of "non-understanding". That way we didn't make wrong assumptions.'

Alistair McFadyen and John Inge offer two theological ways of responding to and expressing the 'journey of theological intensification' which this group shared, centring on the motifs of 'sacrament' and 'blessing'. Vanessa Herrick, Chaplain of Fitz-william College, Cambridge, offers an 'outsider's' view of the

dedication of The Way of Life *and highlights the resonances between the sculpture and a labyrinth already set on the floor beneath it.*

The leitmotif of integrity *is one which emerges frequently: the group's concern to do justice to the integrity of each member's distinctive contribution, the integrity of the Christian faith in all its irreducible richness, the integrity of a building of immense size, subtlety and power, and (not least) the integrity of different responses to the finished piece. In each case the integrity was found to be dynamic – not simply something to be respected at a distance, but something which could be developed, enhanced and enriched.*

Art in a Cathedral

ALISTAIR MCFADYEN AND JOHN INGE

Cathedral as art

Even seen from far off, across the fens, Ely Cathedral is an amazing building. It impresses, not only by virtue of its scale, or the staggering achievement it represents in terms of engineering and architecture. It impresses, even at a distance, as a work of art. Even the basic features of its shape do not seem to be simply functional in pragmatic, engineering terms. This sense is heightened as one approaches. Gradually, it becomes clear how much of the external presentation can have no direct, functional relation to dimensioning the space inside or supporting the structure.

Entering Ely not only confirms; it intensifies all such impressions. It is easy to be overwhelmed by the sheer abundance of imagination, creativity and scale; by the commitment of human imagination and resources of quite staggering proportions, sustained over many generations. Some will wonder at the human spirit responsible for such a work. But many will find their attention directed towards that which had so gripped the human spirit that Ely Cathedral is the response. Captivated by a sense of the overflowing abundance and generosity of God, the human spirit has stretched all its imaginative, intellectual and (not least) material resources in response. It is as though the God who is so abundantly 'more than necessary'[1] entices, invites and seeks what is 'more than necessary' in response (thanks and praise are the main paradigms). The Cathedral, then, is an act of worship, extended over the generations.[2] It is not a building whose chief characteristic is functional utility. It is not a response

that calculates what God deserves and gives what is necessary, but only that and no more. It is not driven by calculating necessity; rather, the sense that what God has done is unearned, can never be repaid and does not seek repayment (i.e., is grace), a sense of overflowing joy and delight in the abundance and amazing generosity of God. It is this spirit that built the Cathedral and is present in its very stones and mortar. It is a spirit driven to do what is at the same time not strictly necessary, yet more than necessary: to give thanks and praise, to worship. Being filled with a sense of the abundance of God and of human life in God, is to be compelled to this kind of excess.

Cathedral as worship

The Cathedral, then, is not just a place where worship happens, a container for present worship. Neither is it a monument to past worship, and not only because it continues to be sustained by people taking responsibility for it now (maintaining its fabric, renovating it, adding to it, and so on). The Cathedral *is* worship (and in this way is art of a specific, theological kind). It is worship because an essential element of its artistry is to catch us up in the same dynamic of faith as came to expression in it. In its stones, décor and artwork, we do not only observe a response made by others as they were gripped by the reality of God; we ourselves are put in touch with that reality and invited to be stretched in response. The nature of the art is such that it can pull us into that same captivating, stretching and freeing dynamic of overflow, as God's abundant plenitude and free generosity is answered in the abundance of freed human creativity in thanks and praise. Our eyes are directed to see that to which they were responding and to respond ourselves. Immediately on entering by the west door (and how rare it is now to be able to enter a cathedral by the west door), one enters this dynamic in microcosm. The architecture pulls one's gaze upwards, towards 'heaven'.

Commissioning art as worship

The decision and vision of the Dean and Chapter of Ely to use funding generously provided by the Friends of Ely Cathedral to mark the millennium by commissioning a work of art should be understood in this way. It is not simply the addition of an extra piece of decoration, nor the reverent display of an independent, self-standing work of art, as in a gallery or museum, nor yet of an adjunct or an aid to worship. This commission, and not just the art itself, *is* worship. It has involved the marshalling commitment and direction of imagination, resources and effort towards an end that is not necessary to the fabric of the building, and which was also open and not known. (The decision that it would be a sculpture and where it would be sited were taken after agreement to raise and commit funds for a work of art; the sculptor was chosen later than that and what he would produce was to emerge through the 'pod' group process at a relatively late stage.) The Friends' commission shares in that long history whereby people have taken responsibility for the Cathedral in ways that are excessive in relation to what is strictly necessary for the maintenance of the fabric.

The Friends' decision was taken as a massive millennium restoration project was drawing to completion, after fourteen years. The contrast could easily be overdrawn between that project, directed towards the refurbishment of what was already in place, and the Friends' desire to introduce something new. The massive nineteenth-century restoration, masterminded by Gilbert Scott, involved the total transformation of the interior of the Cathedral and the harnessing of much artistic expertise. By contrast, the twentieth century saw the introduction of very little that was new, and rather less that was not functional (Hans Feibusch's *Christus* and David Wynn's *Noli Me Tangere* notwithstanding). The millennium refurbishment is a truly impressive achievement. The fabric of the Cathedral is arguably now in the best state it ever has been. But its aim was not innovation or new creativity. It was to repristinate, protect and

preserve what was already there; to conserve for this and future generations, without altering the visual impact of what was being restored. This should not be interpreted too quickly as representing a view of the Cathedral as monument rather than worship, as though the love for the building could be divorced from any sense of the building as worship. It would be truer to say that such comprehensive renovation represents trust and confidence in the achievement of the past in fashioning a building that still worships and has power still to resonate with contemporary visitors and worshippers, stirring us to our own worship.

Yet, whilst the contrasts can be overplayed, Dean and Chapter and the Friends were doing something significantly distinct (indeed, riskier) from funding a renovation project in commissioning new, creative art for the Cathedral.

Commissioning creativity

After much deliberation and consultation, the Dean and Chapter identified a site for the proposed work: a large, plastered blank wall on the north side of the space underneath the west tower, constructed following the collapse of the north-west transept.[3] This is an enormous space, visible to the visitor immediately after entry through the great west door. It is in the shape of a Gothic arch framed by stone, 5.5 metres wide at its base and 15.5 metres tall. The stakes in all this were high, not only because of the money involved and the international importance of Ely as a building as well as a centre of worship. On both those counts, the project demanded an artist capable of producing something worthy of the building. More importantly, though, the project required someone open and free enough to risk a highly public act of worship that would resonate with and enhance Ely as worship. When the Friends accepted the suggestion of the Dean and Chapter that they should all work together with *Theology Through the Arts*, it was clear too that the artist would have to be open to an innovative unique brand of collaboration. The aim of the partnership with TTA would not only be to produce a piece of art of high quality and general accessibility, but also to

pioneer a new, collaborative model for the commissioning of art for cathedrals, alive to their theological and social dimensions.

That a sculpture would be the best art form for the space was a fairly easy and quick decision. A long list of possible artists was drawn up by Fiona Bond of TTA and John Inge. A number of people who had expertise and experience in commissioning for places of worship were asked to suggest names of possible artists. The starting-point was to search for an artist who

- was a sculptor able to work on a large scale;
- was probably based in the UK;
- was respected in the mainstream art world;
- would enjoy the collaborative aspect of this commission;
- had an interest in Christian theology;
- had a generosity of spirit for dialogue and communication;
- would be excited by pioneering new models by which theology can be explored through visual art.

The artists suggested were contacted and told about the commission and the process. In addition to providing a portfolio of their work they were asked to answer three questions – what interested them most about the commission, how they would do justice to the theological and artistic strands of this project, and how they would see this commission enhancing/complementing their own work. The responses were used to draw up a shortlist of three candidates, subsequently interviewed by the Dean and Chapter, together with two representatives of the Friends. Those interviewing were unanimous in selecting Jonathan Clarke. One of the factors that swung the decision his way was the portfolio he had brought with him of a set of Stations of the Cross recently completed for Southwell Minster. All warmed to these, but were even more forcibly struck by what Jonathan described as a doodle he had used to decorate the back cover of the folder of photographs (Fig. 2 p. 138). This showed a cross, the leg of which was not straight, but squiggly, looking like a path or a tail. It gave rise to much positive comment about its suggestive power, and it became clear that all present would be

happy to see something like this design on the wall in question, though it was left to the 'pod' group to begin their deliberations afresh.

Art in its place: a story of inspiration, integrity and contingency

Integrity in the 'pod' group

'You can't produce a work of art by committee' say the sceptics. (Even worse, if a camel is a horse designed by committee, then a committee with a theologian on it is surely capable only of designing a camel unable even to go through the eye of a needle.) Though it would be inaccurate to describe the working group which surrounded Jonathan Clarke as a committee, our experience proves that the sentiment behind such a remark is very mistaken. It implies that a work of art can only be the result of the inspiration of an artist working alone and that no other person can have any constructive role in the process. Indeed, perhaps it suggests also that others can only contribute by hemming in or constraining the inspired creativity of the artist. Inspiration and the freedom of artistic creativity tend here to be understood as individual and internal to the artist. Creative inspiration is therefore free in the sense of being free *from* external influence. Such a view of inspiration seems particularly ill-matched to the task of setting a work of art in a cathedral, with the intention of engaging a wide variety of people with an aspect of the faith for which the Cathedral stands. (It also seems ill-wed to a good theology of the Holy Spirit and of responsive human spirit.) That seems to require a mode of attentiveness to the realities of the Cathedral, faith and God that cannot be exclusive of other people and perspectives. What we discovered through the 'pod' group process was that artistic creativity may be freed by and through conversation because, in the end, it is freedom *for* responsiveness to a reality that is neither individual nor internal. It was our experience that the right kind of

community may form part of that patterning of attentiveness to the reality of faith, world and God that inspires the artist to make a response that is nonetheless still their own, and which engages people in their own searching response to these same realities. The involvement of others in the creative process seems to us to be particularly important in the commissioning of a work of art for a place of worship.

The 'pod' group created a conversational context surrounding the design and erection of the sculpture. The three of us who joined Jonathan to form that group were chosen in part because of our membership of three distinct 'interest groups': cathedral clergy, the Friends and academic theology. The phrase, 'interest group', is a little misleading, however. For we were not there as representatives of the already established views, preferences and fears of our constituencies. Were we there as representatives of vested interests in that sense, the 'pod' group process would quickly have degenerated into the politics of negotiation of agendas that had been formed outside of the 'pod' group. But neither would it be right to think that where we had each come from was irrelevant, as if the 'pod' group invited us to enter into creative artistic encounter, naked of anything outside of it. What our backgrounds gave us was a specific kind of interest in the work of art to be produced, and a recognition of its significance in relation to these interests. This is interest in a quite other and more expansive sense than a vested interest. Our involvements (in caring for the Cathedral, in attending and leading worship there, in explaining what it stands for to countless tourists and pilgrims, in a professional concern with Christian doctrine) made the project interesting and significant to us. The 'pod' group process invited us to think and speak from the distinct integrity of these interests in an open and expansive way, one that would nurture, contextualize and resonate with, rather than constrict, the artist's creativity. The 'pod' group worked in large part by creating a synergy between the distinct integrity of each voice, rather than trying to merge them all into a single voice, squashing distinctions and differences.

In the 'pod' group, the Friends of Ely Cathedral were

represented by Mrs Marianne Edson. The other members were Jonathan Clarke and ourselves. The first meeting of the group was a residential at Ely from 28 to 29 October 1999. That meeting was a very valuable one for many reasons but, perhaps most importantly, because it allowed trust to develop between members of the group. It was striking that all were willing and able to speak at an unusual depth about their life and faith, and a considerable warmth developed between us. A good group dynamic is an indispensable ingredient in the TTA method of working if it is to be successful and creative. In our case, we found a warm, engaged and easy-going respect of the integrity each represented. That was partly facilitated by a quickly established culture of humour that communicated a general lack of preciousness about our distinct vocations that – perhaps paradoxically – allowed them to be taken with appropriate seriousness too. It is a great credit to Jonathan that there was never any hint of suspicion that the rest of us might hinder his creativity or threaten his integrity as the artist. From our first discussion, it became clear to the rest of us that Jonathan was approaching this commission with a distinctive notion of creativity appropriate to the task, coupled with a deep and genuine appreciation of the opportunity it afforded him. An essential ingredient of that sense of creativity was a desire to respond to the nature of the space to be the site of the sculpture: the integrity of the building and all it stands and has stood for – the integrity of its social and theological reality. In addition to his own sense of the aesthetics of this space, that made Jonathan immediately open to the understanding, sensibilities and sensitivities of other members of the group, shaped by the contexts from which we had come (in two cases by years of worshipping in the Cathedral).

The integrity of faith

Some of the early discussion of the group focused around what criteria might be used for deciding upon a design. The group took the TTA brief to mean that whatever we chose to do should assist in discovering and exploring the faith. Hence, the integrity

of Christian faith was quickly established as one significant criterion for deciding on a design. (Since this was a work of art commissioned for a Christian cathedral, that bore an immediate relation to the integrity of the building too – discussed in the following section.) The openness quickly established in the 'pod' group that allowed us quickly and easily to speak in an intimate way about our spiritual journeys and our beliefs also made clear how varied Christian faith is. This in large part reflects the nature of that faith and of its integrity. The integrity of Christian faith is neither one-dimensional nor static. It is not capable of simple unitary formulation in some single, authoritative account or way of being that imposes itself on us as a monolith, squashing the integrity of our own being and life. Christian faith attests to the reality of God's creative and saving encounter with the world, and it does so in such a way that invites our lived response in the integrity of our being and situation. The integrity of our faith is found as we are gripped by the Christian story in the integrity of our being and life with its transforming resonances. In that way, we come to participate in the transforming reality which the gospel not only bears witness to but actively communicates in the here and now. It is a dynamic integrity, to be discovered in exploration, interaction and communication. That seems to be recognized in the TTA brief. The emphasis on exploration is not due to tentativeness in conviction, but to the very nature of Christian faith. This is what makes art forms that work by rich indirection so appropriate to faith: people may be gripped to engage with a symbolic carrier of an aspect of the Christian story and work out what it means for and requires of them in trans-forming, participatory response. At its best, non-literal art may do more than attest to the fact that God is at work in the world; it may draw people into the dynamics of that work and into transforming relationship with God. God appears to work by seeking and empowering us to work out our own, living response to the reality to which the Christian gospel attests, by setting us in the space of freedom to make our own response. What is appropriate to Christian communication, therefore, is something that may engage people in their own integrity, to make a

response in which that is both transformed and intensified by the gospel.

All this seemed to require us to do more than communicate a simple, direct message, capable only of a single and obvious interpretation. At the same time as having an immediate impact upon people, the sculpture should therefore be capable of engaging people in all their diversity, helping them to explore and discern something about Christian faith for themselves, from where they are. This balance between the possibility of multiplicity of interpretation (engaging people in their integrity) and clear impact (communicating the integrity of faith) is a difficult one, as we later discovered. It became clear, too, that profundity is not at all to be equated with complexity. One of the most striking pieces to be installed in a cathedral recently is Stephen Cox's *Eucharist* at Newcastle Cathedral, which is astoundingly simple in design. It shows just a circle with one fracture in it. This will immediately invoke eucharistic imagery for 'churchy' people, who will see this as a fractured host. However, as with the eucharist itself, there are many resonances, and the symbolism can work on several different levels. It could just as well be a broken world as a broken host. The genius of this piece of art is that the theological symbolism is clear, and yet capable of resonating with all sorts of other images. At the same time (and no less importantly) the piece has great aesthetic merit, partly because of its simplicity.

It became clear early on in our process that this twin concern for the immediacy of high aesthetic quality and the communication of the faith in a way that might generate multiple interpretations and responses is at the heart of what commissioning for ecclesiastical buildings should be about. This is summed up by a caption accompanying a photograph in *Flagships of the Spirit* showing a *Christus* by Peter Eugene Ball, which the latter produced for Winchester Cathedral: 'a balance between clear theological symbolism and true art is one of the issues central to commissioning'.[4] If too much weight is given to the former, the likelihood is that the Church will become home to second-rate art. If emphasis is exclusively on the latter, the piece may have no

relevance to the Christian faith, a result which is equally unsatisfactory. Part of our journey of discovery involved recognition that the simplicity apparently required for immediate and wide aesthetic appeal need not work against the possibilities of complexity and multiplicity in possible interpretation and response. Indeed, simple designs appear to be rather more open to multiple interpretations and responses. On the other hand, the attempt to guide people by design into one or more specific responses and interpretations tends to produce 'over-design' and a somewhat literalist (as well as muddling), aesthetically unappealing complexity (in order to head off unwanted interpretations). This seems to marry both an artistic and a theological intuition: that genuinely personal responses require less direction in creative design – something that came only slowly to those of us used to working with words geared towards almost mechanical precision in the elimination of ambiguities in meaning. A simpler design might serve all three purposes at once, engaging people in the depths of their own integrity and lending itself to multiple responses, clearly communicating from the integrity of Christian faith and being aesthetically pleasing. Being true to the integrity of faith need not necessarily, therefore, work against the integrity of those who engage with the work of art or that of faith.

The integrity of the building

The intention from the outset was to have a piece that, in addition to facilitating engagement with faith, would engage also with the integrity of the building. Given the nature of the building, of course, these two intentions are not unrelated. On a minimal interpretation, engaging with the integrity of the building would mean the work 'respecting' or 'fitting in with' what the space now is, how it is constituted and with what is already there. On a more maximal reading, however, rather more might be promised: that the piece might resonate in new ways with what the space now is, creating new synergies which develop the previously established integrity of the space.

Something of this kind might be hoped for in relation to any

form of art, that it would resonate and produce new synergies with its 'place'. But a sculpture specially commissioned to be set permanently in one physical space perhaps differs significantly in this respect from a work of music or drama, say, designed to be performed in different places, while maintaining (indeed, finding anew) its own integrity with each new performative context. And with performative art, the 'space' of each performance is generally (though not always) more significantly constituted by the social (the audience) than by the material (important though the architecture of stage and auditorium is). Of course, the 'audience', with their social, cultural and psychological integrity, are also significant for the sculpture. There is a sense in which the sculpture 'performs' anew with each encounter: new people make for a new performative space as they engage with the statue from their own integrity. Nevertheless, the physical setting achieves a higher significance for a permanently sited statue, simply because it is constant, but also because (in this case, at least) most people who see it will place themselves in its space because of what the space otherwise is – because of the integrity of the building quite apart from its housing of this piece of art. Most who see *The Way of Life* will do so because they are visiting a place significant to them as a place of worship, of pilgrimage, because of its architecture, and so on. Brought to Ely for reasons of their own, representing already a resonance between their integrity and that of the Cathedral, which gives Ely a significance for them, each encounter with the sculpture already includes place as well as person. The dimensions of personal and social integrity cannot be separated out from that of the material and its social, cultural and theological significance for visitors.

But there are even more basic reasons why a sculpture of this sort is obliged to engage with the integrity of the building. At the very least, a sculpture designed to hang from a wall is required to engage with the *material* integrity of the building from the outset. Time and again, this imposed itself on our deliberations and designs. It was all the more important because the medium in which Jonathan always works (cast aluminium) and the size

of the anticipated sculpture made questions of physics and mechanics essential: would the wall be able to support the weight of the proposed sculpture? Yet, in dealing with such questions, one is not dealing with issues that can be resolved by applying the laws of physics and mechanics alone. For, even in negotiating the material properties of the wall, we were driven to consider issues that were not only physical or mechanical. The wall, as a wall in Ely Cathedral, is more than a set of material properties, and so navigating the physical difficulties they posed for the mounting of this piece required attentiveness to other sorts of contingencies. For example, the most obvious way of dealing with the major difficulty posed by the fact that the plaster and wood wall would not hold the weight of the sculpture would have been to take the 'tail' of the sculpture to the ground for support. But that would have meant moving notice stands, carefully and lovingly crafted and placed there with measured attentiveness to the integrity of the Cathedral and its various functions. Such an action would arguably have involved compromising the integrity of the building – and of those who had expressed their love of and care for it so recently by making this provision. The very matter of the Cathedral wall is more than purely material. It is social, ecclesiastical, theological, psychological, cultural space and these dimensions of its physical reality also had to be engaged with at the very beginning of the design process. It is also legal space, and the alterations required to strengthen the wall had to be approved by several local and national committees before work could proceed.

Engaging with these particularities of place (including others, such as the shape of the wall and the door at the foot of the wall – would this be incorporated into the design in some way?) was unavoidable on pragmatic, if on no other, grounds. A number of overlapping contingencies constitute the reality of this space and give it its present integrity (without the sculpture). Failure to adapt to the particular and contingent reality of the wall and of the Cathedral in all these dimensions would have been impractical. A statue design heedless of the integrity of the building would have a strong, assertive and independent integrity of its

own. It is tempting to suppose that such an approach would maximize the creative freedom and integrity of the artist and his vision – just as giving him free reign to work without having to engage with others in conversation might also be supposed to do. But this would have run the serious risk of proving completely impractical for mounting in this contingent place. Does this mean, then, that the work of art and the creative inspiration of the artist are compromised, if not lost? Because all these contingencies of the place had to be engaged with in the initial stages of our conversation, as part of our deliberation over a possible design, it is not really possible to speak of the integrity of the statue or of artistic creativity, inspiration and freedom apart from that of the space, in all its contingencies. One might say that the integrity of the place has entered that of the statue, in the very heart of its conception. It would not have been and would not be what it is without this place. It makes no sense to speak of the integrity of the artist's imagination or inspiration, or of that of the sculpture itself, without reference to the Cathedral. Creativity and inspiration appear here to be contingent: to resonate with the contingencies of place. They need not be thought of as limiting creativity, so much as channelling and shaping it. This proved, of course, to be as true of the more spiritual and theological dimensions of the Cathedral's integrity as it is of its material (which, as we have suggested, cannot in any case be considered apart from the theological and spiritual).

Engaging integrities

Nuts and bolts

Our experience of the 'pod' group process involved the interaction and interweaving of all these integrities from the first, though we were not always quick to realize either their significance or their legitimacy. That was especially true as regards some of the 'nuts-and-bolts' considerations relating to the integrity of the building. These seemed to us at first to be both a distraction from and interference with our 'real work' of

supporting artistic creativity. We did not immediately use the language of contingency rather than limitation to describe all these issues. Whereas we initially regarded issues that appeared to be matters of pure physics or engineering as unavoidable laws of nature, and questions of 'seemliness' that related to the situation of the sculpture as perfectly legitimate (e.g., an abundance of figures already, some in proximity to our site, the paucity of crosses and the need to avoid a design that would so impose itself at the visitor's entrance that it would distract from the striking impression the Cathedral initially makes, so working against its integrity), it is probably true to say that we initially found considerations such as the noticeboards an irritating constraint.

An initial design: an inverted cross and God as superhero

On the other hand, the process of getting to know each other seemed immediately apposite to our task, not least because recounting our stories wove together our accounts of ourselves with our accounts of how we construed our faith. This proved illuminating in particularly significant ways about Jonathan's work. He spoke of his anxieties about the world, heightened since becoming a father, which inform his work. He explained how this led him to emphasize divine intervention in his theology: God acting in the world to obliterate the evil that threatens human existence – an emphasis that corresponds to the role and activity of superheroes in his work. This theology of the power of God and corresponding human hope underlay the tentative design that Jonathan had worked up for the first meeting and brought with him: a large, inverted cross descending onto a confused mass of snake-like tails, representing the chaos of evil, and rubbing them out (Fig. 1). We worked on this for some time, experimenting with different representations of 'evil' and of God's activity. The image of a cross seemed to us all to resonate strongly with the integrity both of the building and of Christian faith. It is the central representative symbol of Christianity, yet there are very few in the Cathedral. Moreover, a cross on this

Figure 1

space could establish particularly strong resonances with the
Feibusch *Christus*, which stands slightly to the side of this space.[5]

Getting (the) cross

However, after some extensive deliberation, we decided against
adopting this design. Our concerns were both artistic and theo-
logical. We were concerned that the symbolism might be overly
complex and unclear, leading to an unhelpful pluralization of
possible meanings and interpretations. In particular, the inver-
sion of the cross might appear to be of central importance and its
significance therefore misinterpreted (even perhaps found offen-
sive); the twisted mass of evil could easily be misinterpreted; or,
if understood as intended, could be viewed as swallowing up the
cross, rather than the other way about.

In its intentions, the design had a good deal to commend it
theologically, communicating great confidence and hope in
God's power to sort out the chaotic mess of human sin, evil and
wickedness. And yet, even if the symbolism could be made clear-
er, we were concerned that the intended message did not sit well
with the central image of the cross. For the cross suggests a some-
what more nuanced picture of God's power than that of a super-
heroic intervention ridding the world at one stroke of all
opposed to the good. In part, perhaps that is because the strate-
gy of cross and resurrection acknowledges the intermingling of
good with sin and evil, such that salvation has to work through
both. The power of God on the cross is not that of the absolute
and irresistible force of the greatest superhero. This is God suf-
fering death in human history, in order to take on the whole his-
tory of death and sin. Neither is the resurrection the work of a
superhero. When, in the first *Superman* film, Lois Lane is killed,
Superman flies round the world counter-clockwise, in order to
turn time back so she can live again. But the resurrection is not
like that. In the raising of Jesus, God's power is at once more
potent and more vulnerable than that. Resurrection does not sort
out the cross by undoing it, turning the clock back or making it
as if it never happened. The death is not undone and human

action set aside; rather, what human beings do is allowed to stand and God works through and with the chaos of sin and death. So Jesus is not returned to the life that he had before, but raised to a qualitatively new mode of life, one that has gone through death and in which death itself is drawn into the unimaginable abundance of life in God. The God of resurrection does not deal with sin, wickedness and evil by rubbing it out, nor with sinful human beings by setting them and their action aside. Rather, God works with what has actually happened in the world, not by cancelling out the integrity of human beings and of their action, but by working with, in and through them. God pours out transformative energies and potentialities of life in unimaginable abundance, precisely where the powers of sin, evil and death seem most potent and focused. God does so in ways that seek, empower and energize our own response so that we may be incorporated into the dynamics of transformed and transforming life. The raising of Jesus' body is immediately and intrinsically associated with the raising to new life of the broken social body of the disciples and subsequently issues in the giving of the Spirit at Pentecost and the commissioning of the apostles in their mission: to communicate this transforming power to the whole world. This is a rather different form of power than is the stuff of superhero fantasies.

Interlude: attempting clarity; tempting over-design

We did not spend much time trying to find ways of representing this more subtle view, or adapting the design to head off unhelpful interpretations and responses. Anything we came up with appeared too directive or to involve overlapping allegorizations (where each design element had a specific meaning) and consequently seemed 'over-designed'. Because we had found compelling theological reasons for moving away from this initial suggestion, we perhaps failed, in our haste to make progress, to notice the significance of our attempts to achieve clarity. It only became clear to us later on, in discussing another design, what assumptions we were making about the nature of both artistic

and Christian communication and also how our attempts to ameliorate difficulties in design, with every deliberation, led us further away from the simplicity of artistic inspiration we were seeking.

The cross on the way

So, in part because of these theological concerns, but in part also on aesthetic grounds, we decided to try to generate other design ideas. But there was much that we were able to bring forward from our deliberations thus far. We had come to appreciate a number of things that we could take had impressed on us the resonances that a cross would establish, both with the integrity of faith and of the Cathedral. Despite the centrality of the symbol of the cross for Christian faith, there were only two crosses represented in the Cathedral at that time. Since (as the commissioning committee had already pointed out) there was already a preponderance of figural representations and, especially as this included the figure of the raised Jesus in the immediate vicinity of the site, an empty cross had much to commend it, in relation both to the integrity of the Cathedral and of faith (as well as to that of the artist). As well as a place of worship, Ely has had and retains immense significance as a place of pilgrimage. Significantly, the fabric of the building attests to this aspect of the Cathedral's integrity in the labyrinth design on the floor underneath the west tower: 'our' wall. In our discussions from this point on, we decided that we would like the statue to bring out this aspect of the Cathedral, which could also resonate with the idea of Christian faith as itself a journey.

Back to the doodle

Our deliberations thus far had also helped us recognize the need for simplicity of design. It was at this point that the group considered the doodle which had so entranced the appointing committee – and which had played some part in securing the commission for Jonathan (Fig. 2). Jonathan himself regarded it

Figure 2

from the first as no more than a doodle and did not expect any-one to take it seriously. However, continued discussion made it clear to everyone that this design brought together several impor-tant themes and satisfied some conditions: it was a cross, the winding 'tail' of which could be understood as a path. It seemed to afford an opportunity to present a familiar, central symbol of Christian faith in an unfamiliar guise that might provoke resonances not usually combined with it, but also of central significance for the Cathedral and the life of faith.

'Improving' on simplicity

We discussed ways of making the design clearer in its intent and more aesthetically engaging, and developed the idea of giving the sculpture texture by incorporating representations of people on the cross, so small that they would hardly be distinguishable from a distance. This was a suggestion which was attractive to Jonathan, since carved characters, in his typical 'oblong' style, had been a trademark of his previous work. Those nearer the beginning of the road (the bottom of the sculpture) were to be very schematic, little more than bare oblongs; those nearer the cross-piece were to be more well-defined as human shapes (Fig. 3). In addition to giving texture to the piece, we hoped to suggest human beings being drawn towards and ascending the path to the cross. (The very careful observer might find the single, Christ figure that remains from this stage of our discussion, though binoculars may be needed.) We left the meeting at which this proposal had emerged with great enthusiasm, confident that we had arrived at a strong design. Jonathan agreed to work on a maquette to bring to our next meeting.

Difficulties in design

However, Jonathan arrived at that meeting having developed serious technical and aesthetic misgivings over the design that had previously attracted consensus and had, in the meantime, worked in a particular direction towards an alternative. His

Figure 3

concern was primarily to do with the people on the cross that were to provide 'texture'. As he worked with the design, he felt that they looked increasingly hemmed-in and sardine-like, lending the sculpture a 'concentration camp' feel. The rest of the group had arrived still enthusiastic about the previous 'agreed' design and expecting to see progress in that direction, whereas Jonathan had moved on beyond the previous discussion in a new (though not entirely unrelated) direction, which he was anxious to test out and explore with the rest of the group.

This was a fascinating point in the process. Had a very good relationship between the members of the group not already been established it could have been very difficult indeed. As it turned out, we did not try to persuade each other in favour of one design over the other, but attempted, rather, to regain a sense of the criteria by which decisions about design are made and to discuss the old proposal, Jonathan's worries about it and potential alternatives in relation to that. This respected the integrity of the group and the commitment previously made to the design, but allowed it to be drawn into the trajectory of Jonathan's concerns and to engage with Jonathan's artistic integrity and where that had led him – to catch up with him, to come to appreciate his reasons for moving on and draw all of this back into the dynamics and identity of the 'pod' group. This, and the subsequent discussion about the new proposal, involved rehearsing reasons why the 'old' design had been favoured and replaying the relationship between the aesthetic and the theological.

The blooming cross: clarity of intentions tempts over-design again

Then began a process which taught us a great deal once again about the difficulties of trying to design-in too much direction and clarity. Broadly, our development of Jonathan's new idea attempted to add two dimensions to the initial simplicity of the winding cross doodle. Whilst we had not yet fixed on the title, we knew that we wanted the sculpture to make allusions to 'the Christian way', to faith as a journey. But we wished to avoid

suggesting that there was only *one* such way, that it was a simple, straightforward and direct matter. In a way, the winding path of the tail of the cross already suggested something of that, and the fact that the 'road' travelled ended with a cross also suggested that it might not be easy. We took the idea further, by incorporating additional paths, winding their way along similar routes and round each other (Fig. 4).

We also knew we wanted to draw attention to the great paradox of Christian faith, that the basis of hope, of real and full life, is an instrument of execution and, indeed, the torture and death of a human being and of God. The familiarity of the cross, its sometimes too easy association with the victory won over death in the resurrection, its over-use in trivial contexts as decoration or adornment – all conspire all too frequently to evaporate it of the sense of its costliness.

It was with these twin aims in mind that we began again attempting to encourage some interpretations, responses and allusions and discourage others. This time, our experimental design was not less allusive and more direct, but it did become much less clear as different symbolizations overlapped in ways that competed with one another. In addition to the plurality of possible paths, we experimented with the idea of making the head of the cross suggest a blossoming flower, to indicate the abundance of new life wrought from the instrument of torture and execution. The twisting 'tails' of the cross we made narrower and more pointed at the bottom end, the more to suggest roots of the flower at the top. The more they suggested roots, however, the less they looked like routes. So, to encourage the suggestion that these might also be seen as paths along which the observer might travel or be travelling, Jonathan created a design for the blossom, whereby the 'tails/roots/routes' turned into human figures (Fig. 5). Similarly, the more the head of the cross suggested a flower, the less cruciform it appeared; the more it looked like a cross, the less it suggested a flower; and the more defined were the heads and upper torsos, the more the lower portions appeared to be serpent-like tails.

Figure 4

Figure 5

PARTHENOGENESIS

Plate 1. James MacMillan

Plate 2. Michael Symmons
Roberts

Plate 3. Rowan Williams

Plate 4. Nigel Forde, playwright

Plate 5. Robert Lockyer (Richard Hasnip) is greeted on his safe return from the Parliamentarian army by his sister, Kate (Jocelyn Brooke-Hamilton). Photograph by Bridget Foreman

Plate 6. Robert Lockyer (Richard Hasnip) and Margaret (Charlotte Jones) caught up in the madness of civil war. Photograph by Bridget Foreman

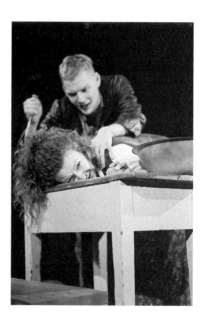

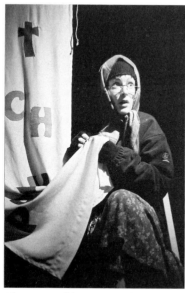

Plate 7. Fifth Monarchist Mary (Charlotte Jones) sews religious banners while waiting for the second coming of Christ. Photograph by Bridget Foreman

THE WAY OF LIFE

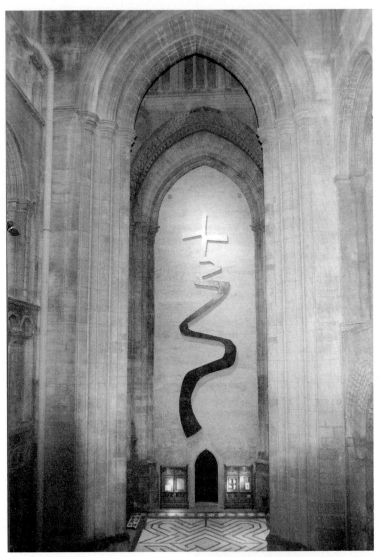

Plate 8. *The Way of Life* at Ely Cathedral with labyrinth below. Photograph by Paul Cudby and Alex Logan

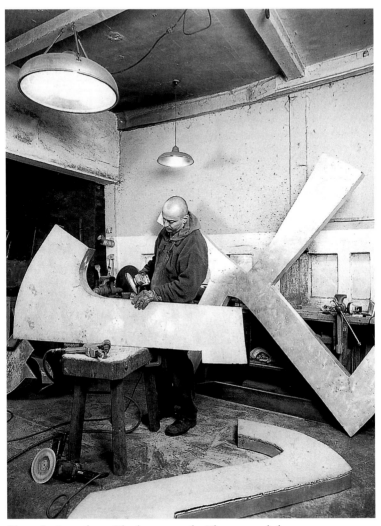

Plate 9. Jonathan Clarke at work. Photograph by
Lesley Anne Churchill

Plate 10. Paul Spicer

Plate 11. Tom Wright

Plate 12. Section of original manuscript of *Easter Oratorio*

Plate 13. Photo of a drawing of the performance of the
Easter Oratorio at Ely Cathedral on Saturday 16 September
2000. Drawing by Honor Brogan, photograph by
Robert Yardley

The travail too heavy laden

These reservations about the design were, in fact, slow to emerge. Conscious of the way that time was slipping away if we were to meet the TTA schedule for an unveiling at the arts festival in Ely in September 2000, we perhaps did not allow ourselves the perspective that develops with time that had proved decisive in moving away from the previous design. We committed ourselves to the new design, Jonathan made a maquette and this, in turn, was presented to the Cathedral Fabric Advisory Committee (FAC). Here matters took an unexpected turn. The aesthetics of the design received unanimous support from members of the committee. (However, we later thought it significant that clarity as to its theological intentions depended on the verbal explanation and commentary provided at that meeting by John.) Most seriously, the FAC had gained clarity about the composition of the wall and its limitations in load-bearing. They had also formed clearer views as to the sort of strengthening that they would rule out as compromising the material or aesthetic integrity of the building or, indeed, the aesthetic integrity of the statue (by hanging it from steel beams embedded in the arch, say). Whilst they approved the present design, they were certain that the wall could not be strengthened appropriately to bear its anticipated weight (750 kg).

Furthermore, permission for any permanent, material alteration required to transfer the load from the wall to the arch (likely to be necessary even with a significant reduction in weight) was not in their gift, but would require the assent of the Cathedrals Fabric Commission of England. Consequently, and with great sensitivity, they asked the 'pod' group to consider amending the design in order to reduce its weight, offering the suggestion of reducing the number of 'twists' in the 'routes' (this would also aid clarity, they thought). It was primarily the contingencies of the building, therefore (though, significantly, the FAC discussion had also expressed somewhat muted concerns about the clarity of the statue's impact), that forced a rethink of

the design and the project before it could go forward to the national advisory body. This made it impossible to achieve the original goal of dedicating the work during the course of the TTA Festival, but yielded sufficient time to take stock and, in particular, to take seriously the results of the very full and careful consideration of the current proposal by the FAC.

Confidence in unforced simplicity

When the 'pod' group met again, we looked with new eyes and found that we had reservations of our own concerning the clarity of our design, which eventually persuaded us not to amend it in order to reduce weight, but to return in truer fashion to the simplicity of Jonathan's doodle (Fig. 2). We had been all round the houses, had allowed it to stimulate more complex variations, but found it continually resurfaced in its integrity in our discussions when we had to go back to the drawing board. There was simply something engaging about it that refused to allow us to move far from it. The beauty of that design, as already noted, was its simplicity: there was a touch of genius in a work which had flowed straight from Jonathan's pen. But, because it had entailed no real effort on his part, Jonathan did not trust it. It did not seem enough and he had felt obliged to 'do more work on it'.

The revisions to that design had, by contrast, given it a complexity which might have been interesting, but which risked confusion. Eventually, with the help of external soundings, we came to see the proliferation of symbols had completely worked against the simplicity of the original 'doodle' to produce a complexity that might have been interesting, but which risked confusion. Consequently, it was less likely to engage people and, with uncertainty about the central symbolism, would be less likely to provoke multiple, confident related interpretations and responses. As well as the confusion created by overlapping symbolizations, the proliferation of tails and the change in their design made it less likely that the person viewing the piece would see themselves as taken up onto the 'road' to the head of the cross. The piece did not seem to incorporate the viewer in the

way the original 'doodle' had promised. The group wrestled with several questions. Is the aesthetic one thing and the theological another, simply overlaying it? What is the role of ambiguity and multiple resonance of meaning? At what point are ambiguity and multiplicity of images helpful in inviting engagements that help us see new things by presenting familiar images (like the cross) as others (flowers, etc.), and at what point does this become unhelpful and confusing?

Intuition rather than deliberative, rational effort had produced a design which had exhibited par excellence the twin concerns of artistic merit and clear theological symbolism. Whilst the deliberations in the 'pod' group did serve to help us see the benefit of some very small modifications to its shape, mostly it served to give Jonathan confidence in the merits of his 'doodle' as a serious work, with its own integrity that could withstand serious scrutiny. The 'pod' group process had also helped us to deepen our understanding of that original intuition. You might say that this discursive process had intensified the integrity of the design and its original intuition.

No one 'interpretation' would do it justice, but there is, at the same time, a clarity about its theological symbolism. By naming the design, *The Way of Life*, we are trying to indicate a number of associations, but without binding people to one 'right' master-interpretation. The phrase itself suggests that faith might be a matter of journeying along a way, of active discipleship in one's whole living, and not an isolated act of belief separated out from who one is and how one lives. The road is not straight and is wider at the base, just above eye-line. Our intention was that those viewing it, especially from directly underneath, might feel themselves drawn upwards towards the cross-piece itself and might see themselves as 'on the road'. We hope that the reality of the cross (rather than its sanitized associations) will be sufficiently in people's minds in this setting that the combination of the phrase with a depiction of an instrument of torture and execution, of life, not death, will itself prove stimulating and provoking. The title, associated with this symbol, also resonates with the phrase used by Christians (especially in Holy Week) to

indicate that the Christian way is costly (it cost God his Son and should be expected to be costly to us too, to cost us ourselves before we can truly find ourselves): the way of the cross. Yet the cross appears empty and suggests a post-Easter perspective, again reinforced by the resonances established with its proximity to the Feibusch *Christus*.

Theological discernment: blessing and sacrament

The 'pod' group discussions and process were hugely enjoyable and we learnt a great deal from them. In part, this was a journey of theological discernment, which gave rise to a varied tapestry of insights, none of them complete in itself. We offer here two distinct, though potentially related, ways of responding to and expressing that journey of theological intensification.

Creativity, integrity and the mediation of blessing

The obvious way of making a connection between Christian faith and theology on the one hand and the creative process on the other, would be to find a connection between artistic creativity and a specific doctrine or article of faith. The obvious candidate for that is the doctrine of creation. It is rather over-worked in this relation, but it is nonetheless worth sticking with for a little while.

The obvious and most straightforward way of relating the doctrine of creation to artistic creativity would be to draw some very direct analogies between the creativity of God and that of the artist: between God and the artist as creators.[6] But it is not clear that artistic creativity is to be privileged in this way above the more functional (and perhaps one could say a more mundane) creativity of a non-artistic sort – bricks, cars, houses, paper-making, Hi-Fi, or whatever; all such creativity, shorn of artistic claims, might be drawn into the same kind of analogical reference to the doctrine of creation as the production of the artist. Furthermore, the privileging of artistic creativity elevates the artist into a place of some discomfort to them. They are not

often to be found claiming to be modelling God's creative action in their own fashioning of material that is already given (whereas, according to the doctrine of creation, God creates out of nothing). Were they to do so, such claims would likely be greeted with a healthy measure of suspicion by the rest of us.

The easy association of artistic with divine creativity is problematic for a further, theological, reason as well. It is problematic because it tempts us to collapse thought of creation, both artistic and divine, into the point of origin and act of origination. So the doctrine of creation, it is supposed, concerns God's initiating, causal action which started everything off; similarly, the account of artistic creativity is simply how the artist had an idea, to which he or she subsequently gave material expression. In both cases, creation is reduced to the act of making something definite. It is over once the product is made. The term conventionally conveys the sense of a completed and discrete act far more readily than it does a sense of ongoing relationship. Both the doctrine of creation and the creativity of an artist are done an immense disservice in such a conventional view. Its deficiencies as a way of speaking of God's relationship to the whole of creation should be more immediately apparent than is often the case. The real task of the doctrine of creation is to give expression to the totality of God's dynamic, ongoing, active and intimate relationship with the world. That certainly includes God's causal responsibility for beginning the world, but it is far from exhausted by that. To speak of the world as God's creation involves affirming God as intrinsic to the world, its fundamental properties and order, without being a part of it. (This requires speaking of God's transcendence and immanence together, in which one is greatly helped by a good doctrine of the Trinity.) That the world cannot *be*, without God, and cannot adequately be thought in separation from God, nor adequately explained or understood without reference to God: that is the inner meaning of creation. It is much better construed in terms of relationship than of action, if we insist on thinking of acts as one-off, complete and discrete.

It is a deficient way of understanding the world as God's

creation to think of it as a one-off act that begins 'the world', after which God withdraws. The God we see in the Bible is not the stereotypical father who does his begetting and then thinks he can clear off without any reference to the Child Support Agency or mothering or tending, nurturing and looking after. Whilst they appear first in the Bible, the creation narratives are not the earliest traditions the Bible contains. Consciousness of God as Creator arose after and out of the Israelites' awareness of God as acting in history to save Israel. If this God could work through the history, not only of Israel, but also of other nations, then this was not a tribal deity, but a God whose power and responsibility were unrestricted and universal. Out of this developed the awareness that God was active in and responsible for, not only history, but the natural order. So the primary context for a theology of creation is that of the dynamics of God's dealings with human beings, and their dealings with God. The whole of the dynamics of God's relationships with human beings and the world are in view, therefore, when we speak of God as Creator. We are naming the extensiveness of God's activity, presence and interrelationship with the world.

To speak of the world as God's creation, of ourselves as God's creatures, and of God as Creator, therefore, is to speak of God's ongoing presence and action that sustains the being of the world. Indeed, 'sustain' is perhaps too thin and static a term for God's drawing of the world towards its own fulfilment. In both creation and salvation (which are properly inseparable theological concepts), there is an ongoing and dynamic relationship between God and the world, God and God's creatures.

Where would we be led, were we to press the analogy between the creation of a piece of art and the doctrine of creation, understood in categories of dynamic relation and not confined to those of action? We would need then to think instead in terms of ongoing relationship, rather than discrete, one-off and complete act of production. We would be invited to see a work of art as not simply an artefact fashioned at a particular point of time and then finished, its completion closing the point of creative activity. Rather, the creative action of the artist might better be under-

stood in relational and communication terms, which are more dynamic and open in time, as not coming to such a closed point of completion. A work of art is intended to call and entice people into a relationship with it. It appeals to them to engage with it in some way and to respond. It might do that through its aesthetic qualities or because there is something striking, even odd, not straightforward, about it that demands attention, that grips you and will not let you go until it has enriched or changed the way in which you see it, and perhaps that way you see some aspect of reality – even, potentially, reality itself. The work of art does further work, then, once it is completed. The creativity of the artist reaches out through the 'finished' product, producing responses and reactions from those that view it and enter into relationship with it.

Furthermore, visual art of the kind that Jonathan produces works largely by indirection, by suggestion, by not making the message absolutely clear and in a sense not deciding at the outset that there is *one* message. It has arisen out of an engagement with a reality and it presents the fruits of that engagement in its own aesthetic form in a way that invites us to engage with it and to respond as the people we are, out of our integrity, in the midst of our contingent lives. It is designed, in other words, to work through relationships formed with the integrity of its setting and the integrity of those that will see it in that setting. The integrity and 'essence' of such a piece of work as *The Way of Life* is not to be found in itself or in the isolated creative imagination of its artist. It is to be found only in the dynamics of relation and communication; only, that is, in interaction with the integrity of people in this place, with all the contingencies involved in that. It will therefore produce and provoke a wide (though not unrestricted) range of meanings and interpretations. For the integrity of the piece is found and discovered only through the medium of communication and relation.

The significance of relation and communication to the 'finished' work has, of course, been prefigured in the account we have given of the 'pod' group process, which has focused on the significance of the issue of integrity and on the relationship

between creativity and contingency, especially the contingencies that accompany particular relationships and engagements. Conversation and engagement did not appear to be an inhibition to the process of creativity as we experienced and have described it, but a part of it; not a constraint, but a way of shaping the reality and integrity of the work.

Is this not precisely the way that God is at work in creation and salvation – working with particularities, with the integrity of creation and creatures as they are and have become through the contingencies of their histories, with what we have made of ourselves? The contingencies and particularities of creaturely integrity (what we have made of ourselves, what we actually are) are not regarded by God as limitations, to be cast aside in order to start afresh. Rather, God draws the particularities and contingencies of lived, historical existences towards their fulfilment, in an intensification of what they (and therefore we) truly are. God works with our particularities, without compromising our integrity. And this involves far more than the sort of respect for difference and distinction that we generally think of in inter-personal relationships, so fearful are we that intimate relation will compromise integrity: creaturely integrity is not only respected; it is intensified. As the theme of creation runs through the Hebrew Scriptures, it is remarkable how frequently it is intimately and intrinsically associated with the notion of blessing. Blessing is presented as the fulfilling and intensifying of creaturely particularity.

Can we apply this theological notion to art generally and *The Way of Life* in particular? We think so, though recognize that the idea requires much fuller testing and working out. The way in which *The Way of Life* has engaged the particularity of the Cathedral in its conception and its making, and the way in which it now does so as a permanent feature in the Cathedral, might be construed as *blessing the particularity of the Cathedral*. Returning to our opening considerations, we might now go further and say that the statue is a specific, intensifying instance of the Cathedral's power to communicate the dynamic of faith to those who see and visit it. (Is it too stretched to say that *The Way of*

Life blesses the Cathedral that blesses?) *The Way of Life* grips people, not only in the way a secular piece in a secular setting would. To be gripped by it in the Cathedral is to be caught up in the dynamic of faith in which both Cathedral and sculpture have their being. To be gripped and caught up in this way is to have one's being stretched, challenged, affirmed as one finds an interpretation and response that is genuinely one's own. It is to be blessed.

Sacrament and salvation

In this final section, we want to be even more daring. We have said that people visiting Ely and encountering *The Way of Life* may be caught up in the dynamic of faith out of which both works of art were created. We have deliberately spoken of a *dynamic* of faith in order to steer away from the suggestion that all the work is done on the human side; that what is involved is an independent movement of the human spirit. It is, rather, the work of the human spirit *responding to, set in motion by, and incorporated into God's movement towards us*. What may be encountered in and through the material of the Cathedral and of the statue is the movement of God: the God of Jesus Christ in movement towards and for us.

It is helpful here to invoke a traditional (though contested) way of speaking of the mediation of God through the material: sacrament. However, the term is saturated with associations it has gathered through conventional use which are unhelpful to the dynamic picture we have been advocating. In particular, we must be wary of speaking of a mediation of the *presence* of God, where presence might be understood in static terms, as though God resides 'naturally' in the material. So understood, we may seek and find signs of God in nature and in material artefacts apart from any active self-giving of God. When God becomes almost a property of matter, such signs may then be 'read' apart from the history of God's self-giving in Christ. It is in part as a resistance to the possibilities of such a 'natural theology' (and a perceived, attendant, incipient tendency to turn everything into a

sacrament) that there are strong traditions against extending the language of sacrament beyond those explicitly affirmed in Scripture. We are sensitive to those reservations, but are convinced that sacrament is nonetheless potentially illuminating for speaking of what may happen through the art of a cathedral and of a statue. Indeed, we would risk saying more: at least some of the suspicions that restrict use of the term for 'the Church's sacraments' (how many of these there are is also disputed between different church traditions) can be assuaged if we avoid slipping into a static view and adopt a self-consciously dynamic one.

The God of Christian faith *is* through relation and the dynamic of active movement, both within Godself (a trinity of dynamic interrelation) and in relation to creation (the great drama of creation and salvation), where Father, Son and Spirit are in continual movement towards the concrete reality of the world and creatures in all their historical particularity and integrity. This movement of God is to and for the whole world (it is not primarily a matter of individual experience, but of the great drama of creation, incarnation and salvation), seeking its fulfilment, against the resistance of sin. It is universal, yet at the same time oriented towards all of us in the full, concrete integrity of our being (fulfilment is the intensification of particularity, what we have been made and made of ourselves in actual, historical lives with all the contingencies that involves). Hence, to encounter God through the mediation of the material is to encounter this movement to and for us.

This does not mean a prohibition on speaking of the presence of God in the material, and neither should it make us cautious in so doing; only careful (excessive caution bedevils too much theology, preventing its being properly positive, especially about the world). If we speak of presence, we can only do so as active and dynamic (through the agency of the Spirit); similarly, if we speak of action, we can only do so in the context of the dynamic of ongoing relationship; if we speak of relationship, we have to bear in mind that that involves concrete, historical and material action and interaction (relation). This is as true of the Church's

sacraments as it is of any extension of the term. Sacrament refers to the active and dynamic presence of God in movement through matter. It is not a property of the material itself.

When we use the language of sacrament in relation to art, we must self-consciously keep the active, dynamic and relational firmly in mind. It is therefore more satisfactory to speak of a work of art as *acting* in a sacramental manner than to talk of it *being* a sacrament, but even then we must take care to keep in mind that action is a relational (interactive and continuing) dynamic, not a one-off event. For art to act sacramentally, there must be a three-way interaction involving God, the work of art, and the observer. This is because 'there is not an objective world, unaffected by subjectivity, which one can call sacrament. Only divine action and human reaction in a concrete situation can form the basis for possible sacramentality.'[7] In other words, a work of art will only be transparent to the numinous if God communicates through it *and* the observer responds when new people make for a new performative space and there is the possibility of sacramental gracing. To speak in this way is to make clear the importance of relationality when speaking of sacrament as much as in talking of creation, for 'in a sacrament God has not only to reveal himself, but to give us the grace to perceive him'.[8]

Art that is (more or less consciously) created in response to being gripped by the movement of God may be a peculiarly apt vehicle for the double-mediation that all this involves (of God to human beings and vice versa). We may be moved by or captivated by a work of art that so speaks to us in the depths of our being that we respond from those same depths and, in that response, are empowered to see that we are caught up in and addressed by the movement of God, and enabled to make a response.

Such an approach also makes it clear that it is unwise to attempt to define exactly where 'the sacrament' actually is. Similarly, questions about where music is to be located are redundant. Is it with the composer, the performer, or the listener? Benjamin Britten referred to these three as a 'holy triangle' and the answer must surely be that the music is in the

making *and* response to that making. Here again, the music is in the action rather than simply in the material. This approach also, incidentally, cuts through redundant discussions about 'real presence' in sacrament since if that real presence is not recognized then it will not have significance to a person. To take an analogy, I can be physically very close to someone in a crowded tube train but if I have no relationship with that person it will be of no consequence to me whatsoever. As far as a particular work of art is concerned, there will be some for whom it will remain entirely opaque. For others, the numinous will break through. In the familiar words of George Herbert,

A man that looks on glass,
on it may stay his eye,
or, if he pleaseth, through it pass, And then the heav'n espy.

This approach is consonant with George Pattison's assertion that

a theology of art which is to be of service in the context of the present relationship between art and religion will need to affirm that the processes of *seeing* are of irreducible value in human life and that they must on this account continue to be characteristic of the human subject when he or she is caught up in the processes of redemption.[9]

We have spoken of the relation of the work of art to Christian notions of creation and sacrament, but this mention of redemption reminds us that the work of art not only affirms God's ongoing creative power and gracing presence but speaks, too, of salvation. There is an eschatological aspect to sacrament. The Fathers were fond of describing the eucharist as a foretaste of the heavenly banquet prepared for all humankind. The medievals who built Ely Cathedral intended it to be a vision of heaven, and thus to act sacramentally as a foretaste of heaven upon all who enter it.

At the heart of Ely Cathedral lies the glorious fourteenth-century octagon. From the roof of the octagon looks down the

risen Christ, *Christus Pantocrator*, Christ in majesty. Below him, angels pay him homage and yet lower still we see the saints and martyrs. In the fourteenth century pilgrims would have entered the Cathedral by a door in the north transept. They would have been confronted by the backs of the choir stalls underneath the octagon, which would have been painted to show the saints. The tombs of some of the earliest Ely saints were placed here too. So the Church in Ely – local saints in their tombs, present visitors on pilgrimage and resident monks singing the office, would come into contact not only with the apostles and saints of the universal Church above them, but with the whole company of heaven at the top of the octagon, with Christ at their centre. It is no mere coincidence that this scene has resonances with the vision of the heavenly Jerusalem coming down out of heaven adorned as a bride for her husband as articulated in the Book of Revelation. The Cathedral is intended to be a point of departure for the heavenly realm[10] as the architecture pulls one's gaze upwards, towards heaven and the redemption of the whole of the created order in Christ. So, too, *The Way of Life* acting sacramentally will, God willing, speak of the consummation of all things in Christ and lead the person who encounters it on the way of the cross towards redemption. This is the reality of creation *and* redemption with which we are put in touch and invited to be stretched towards in response. Thus we are caught up in the worship which is the Cathedral and of which *The Way of Life* is a part.

The hand of the fourteenth-century boss of Christ in majesty at the heart of the Cathedral is extended in blessing over all that he surveys. It is this blessing in which *The Way of Life* will partake, God willing, for generations to come.

Notes

1 We have borrowed this phrase from Eberhard Jüngel.
2 This may be the most helpful way of understanding *how* it is a work of art; certainly, no understanding of it as a work of art would be complete

were it to neglect the being of the Cathedral as worship.

3 There was some opposition to this plan from those who felt that the money would be better spent on refurbishing side chapels and other small projects. One correspondent suggested that the country is littered with 'works of art' which have been installed in cathedrals and bear no relation to their setting. It is instructive that the phrase 'work of art' is used here in a pejorative manner.

4 S. Platten and C. Lewis, *Flagships of the Spirit: Cathedrals in Society*, London: Darton, Longman & Todd, 1998, p.110.

5 The resonances, of course, need to be aesthetic and artistic as well as theological. Sadly, it is sometimes the case in cathedral commissioning that installed pieces are in argument rather than conversation with each other. For example, the fine *Prisoners of Conscience* window at Salisbury Cathedral does not sit easily with the Pearson window above and to the west of it. Both are visible from the west end.

6 Dorothy Sayers' work, *The Mind of the Maker*, London: Methuen, 1941, offers an analogy between trinitarian creation and the work of the literary artist.

7 Keenan Osborne, *Christian Sacraments in a Postmodern World: A Theology for the Third Millennium*, New York: Paulist Press, 1999, p. 143.

8 John Macquarrie, *A Guide to the Sacraments*, New York: Continuum, 1997, p. 10.

9 George Pattison, *Art, Modernity and Faith*, London: SCM Press, 1991 and 1998, p. 135.

10 We owe this terminology to the Revd Lynn Broughton.

Interview with Jonathan Clarke

VANESSA HERRICK

VH – *Jonathan, is this the first time you've been commissioned to produce a piece of art for a cathedral?*
JC – Ely was the second major piece. Before that was a set of stations for Southwell Minster, which is quite different. This is the biggest piece I've ever done.

Would you call yourself a 'Christian' artist?
No, I'm an artist who is a Christian.

And what's the difference?
The difference is: I don't exclusively make Christian art, I make all sorts of art. But I particularly enjoy the opportunity to make something that's going to be respected. You can make pieces to go outside Tescos, or whatever, but it isn't the same; it's just street furniture, looked at if people happen to look up from their shopping trolleys. In a church or cathedral, it's treated (hopefully) with the reverence its deserves.

How conscious are you, as you work in your foundry, that your Christian faith is or isn't contributing to what you do?
I'm not conscious of it as I work – it's much more instinctive. I don't analyse it – I use my eyes to see how I feel, rather than thinking how I feel. Often, I have no idea what I'm going to make until I start making it. Sometimes I don't have any themes at all. Maybe I'll 'title it' afterwards because it's turned out looking like something.

Would you say that there are any risks attached to producing a work of art for a religious place?
Yes. There are huge risks, unfortunately. For good or bad you get labelled as a Christian artist, and that isn't always good for doing other things. For instance, I've done a job for a housing estate – a piece for a central roundabout. It used to be the site of a monastery, so I suggested we might have a big religious piece, and they said 'O we can't have that!' – even though I would have liked to have a done a forty-foot-high crucifixion or something. Also, the trouble is that a lot of religious art, currently, isn't that good, and that's another reason why I don't want to get too associated with it. It has a sort of over-jolly quality to it which I don't like.

What interested you initially about the TTA project, and why?
To be honest, the project was secondary to the fact that some-body said 'you could be in the shortlist to make a piece for Ely Cathedral'. That was the carrot, and then the process of doing it turned out to be a bonus. I think the interesting thing about the 'pod' group idea was the fact that we all equally helped each other. I think Alistair came at it not knowing anything about art; I came at it not knowing anything about theology, and we both ended up gaining something. If that was all that came out of it we were doing well, but we actually ended up with a piece of art that is successful and works very well. We needed that discussion to work out what I was doing right.
I initially did the design before day one, before I even got the commission, when I was at the interview for the shortlist. I did this doodle which was in the back of my CV which I'd done the night before – just a squiggle of a cross with a path leading to it – which the Dean and John Inge took an immediate shine to. (Fig. 2, p. 138.)

Were you surprised about people's reactions to the doodle?
Yes, I was. I'd thought, 'that's the sort of thing that would look good on a wall', but nothing more. I almost didn't include it because it didn't seem very original – it's the sort of thing you see

on the front of every parish magazine in the country! But the Dean 'cooed' over it in the interview, so I realized before we started working in the 'pod' group that this was the sort of thing they were after. We came up with over twenty designs. These ranged from the idea of a path made up of tiny six-inch-high aluminium figures, which would have formed the whole cross and which would have been a mammoth undertaking, through to pieces with strands of black 'chaos' being divided by a gilt cross suspended upside down from the top (to illustrate 'divine intervention') and other variations of the 'path' theme. We also had an idea of having seven gilt figures on the top, one of which was a central Christ-figure with intertwining paths (a sort of serpentine quality), the path representing our lives crossing paths with Jesus, and then leading to salvation. It linked back to medieval ideas of 'dooms', with all the sinners at the bottom, and all the good people (including the local dignitaries) all up there with the Bishop and God at the top. We had virtually got the go-ahead and I started working on it, when I had a phone call to say they preferred the one I did first. So I went back to the drawing board, and did twenty more designs based on the squiggle. They still thought the squiggle was better than anything else I'd done.

What did that do to you in terms of your artistic judgement?
It was a double-edged sword: I'd been honing this design for six months, and they liked what I did first! But it also gave me great satisfaction that I instinctively did the right thing – or whether it was that they as the group *recognized* that I instinctively did the right thing (which was very astute of them), I don't know . . .

As you reflect back on all of that – the going from simplicity to complexity and back to simplicity – what part do you think God played in it?
I suppose you could say he was telling us to make sure we'd covered everything before we made any rash decisions! We went from A to B and back to A again because we needed to know we were doing it right. It was a sort of reassurance.

Can you say something about some of the challenges the wall presented as well as the opportunities?

The main challenges I had arose because I'm a sculptor, not a painter – so there are lots of practical things to think about, such as how you're going to hang half a ton of aluminium on a wall. I had to get that over to the others in the group all the way through – about the design, about the logistics. I was slightly blinkered some of the time, because of two display boards already fixed at the bottom. My original idea was for the sculpture's path to start at the ground – literally fixed to the floor. But in retrospect, I don't know whether it would have been as effective without the sort of 'leap' between the bottom of it and the ground. And the shadow of the door worked quite well as a sort of pointer, because of the top of the arch springing to a point.

The other big hurdle was the Fabric Advisory Committee (FAC). When we had a big meeting with the FAC, interesting things came up. There was the fact that they didn't want the new sculpture to detract from the view up the nave. I'd never thought of that – it never crossed my mind, because I'm in the business of making the biggest statement I can. So to take a step down and to be a bit more modest about it is something I've learnt to do as well. Big and brash is not everything. The piece harmonizes with the wall so beautifully now that I think it's a complete success.

Do you think it would 'fit' anywhere else?

It wouldn't unless it was an almost identical wall. The other thing it *has* got which it wouldn't have anywhere else is the link with the labyrinth. That was in my subconscious all the time, even though had I done the design to the ground, it would literally have linked with the labyrinth. In an ideal world, it would have started to spread across the floor as well! But you have these practical considerations . . .

So, it wouldn't fit in a supermarket?

Not at all, no. It couldn't be in anything but a cathedral.

You worked with a theologian, a canon in a cathedral and some-
body who worships regularly in the Cathedral. Each had a dis-
tinctive contribution to make, each spoke a different 'language'.
You speak with your creativity, a theologian speaks primarily in
words, a canon of a cathedral is concerned with the worshipping
life of a community of people as well. How did you manage to
communicate and understand each other?

I think a common cause was definitely there between us. A lot of
the theological vocabulary was completely beyond me, to be
honest, and I was using art vocabulary which was completely
beyond Alistair. So there was that certain 'trip barrier', which
was probably a good thing. I'd even say it was helpful to keep a
sort of distance of 'non-understanding'. That way we didn't
make wrong assumptions.

How did you then draw those different strands together to
produce a collaborative piece? What made it possible?

I think the title *The Way of Life* had a lot to do with it. Alistair
thought of it quite early on, and we referred to it with that name
the whole time. It became a sort of anchor, and it was very good
as a way of thinking along the same lines, once we'd got that
'buzz phrase', as it were.

I think the people I was working with on it drew my attention to
the fact that the simpler the scupture was, the more possibilities
it had. Less is more. Not everything was 'spelt out' and so it
affects different people in different ways. It has much wider
scope than I'd realized. If it hadn't been for John taking me to
one side, I probably would have gone in with this notion that
these people high up in the Church expected a lot of me – some-
thing complicated – which turned out to be wrong in that
respect. Now I know!

Working with the group, I found there were lots of things I'd
never really thought about – things I've never treated with such
reverence as they did, because I was operating mechanically,
bashing this thing out and making sure it didn't fall off the wall.
Doing that, you sort of distance yourself from its *meaning*.

As you look back over the process, what would you say was the biggest 'plus' about working with the 'pod' group?
The biggest plus was making friends. We had a really tight-knit group of people – all tuned in.

There must have been a lot of trust?
Yes, I was amazed how much trust they gave me – I was really 'unproved' at that sort of scale, doing that sort of thing. It was quite an undertaking, because there had been two hundred years of nothing on that wall, and everyone was backing me up.

Would you do it again?
Without a doubt. It was very stimulating. I think the method could benefit a lot of sculptors and painters who work for the Church. In fact, I think TTA should start up a system of a service with an appointed theologian for every major commission. It's very important that the right decisions are made – nothing too brash – it just needs constant nurturing from 'day one' through to the finished item. It can be a sounding board, a stimulation. Artists and theologians are very similar; I think they're like two lines of a railway track – going in the same direction but not necessarily in the same way. The more points you can put in where they cross over, the better. A 'pod' group is like having 'Mum and Dad' involved – sitting there like a family. It was excellent, and I think all major commissions should be done in this way.

I guess, within the 'pod' group, 'conversation' played an impor-tant part. Does the conversation continue, as it were, with the people who now walk into Ely Cathedral?
The piece seems almost too simple – that's why I probably didn't 'go with it' the first time. It seems *so* obvious to me that it's *too* obvious. But perhaps people have to stop and think about it, in which case, if it's made them think for five seconds longer than they would have done otherwise, then it's doing the job isn't it? Perhaps years of sculpting has tuned me in to something which is not as obvious as I thought it was.

How did you react to the dedication service?
It was a high point in my life, I have to say. When it all appeared 'in full regalia' I found it all quite emotional. But that's the only time I've got emotional over it – before or since, really. I thought: this is such an accolade as far as I'm concerned.

You were saying a few moments ago that you'd really like to go back to Ely to have another look at it. Do you think you will look at it as a pilgrim or as a sculptor?
Ask me again in ten years! At the moment, I'd look to see who *else* is standing at the bottom looking at it, because I'm so proud of it.

Did the whole thing change or deepen or affect your understanding of God at all?
It's made me think about God a lot more than I did. But my understanding of God is still very basic, subliminal. The journey's still there, I'm still searching, the path's still going up. I'm somewhere at the bottom. It's as simple as that.

13

The Way of Life in Three Dimensions

VANESSA HERRICK

Almighty God, whose most dear Son went not up to joy but first he suffered pain, and entered not into glory before he was crucified: mercifully grant that we, walking in the way of the cross, may find it none other than the way of life and peace.

The Collect for the Third Sunday of Lent encapsulates much of the dynamic and meaning of Jonathan Clarke's sculpture, *The Way of Life*, which now graces the blank north-west wall at the entrance to Ely Cathedral. In its few words, it conveys both the sense of 'journey' which *is* the Christian life, and also an awareness that that journey, that 'way', is one that has already been uniquely travelled by the Father's 'most dear Son'. It bears witness to the elements of joy and pain, glory and crucifixion which, in both real and metaphorical terms, characterize the journey, and it affirms the paradoxical possibility that life and peace may co-exist with – indeed, may be fully apprehended through – walking in the way of the cross.

The Way of Life came into being out of a radical and innovative collaboration, sponsored by *Theology Through the Arts*, involving two theologians, the sculptor and a representative of the Friends of Ely Cathedral. Each member of the group brought their own particular insights to bear on the project – practical, theological and artistic – issuing in a joint wisdom which would otherwise have been impossible. For through such a collaborative project, the artist is urged to think deeply about what his work conveys, and the theologian discovers new potential for 'speaking' of God by non-verbal means, thus going far beyond the limits of more conventional ways of 'doing theology'.

The dedication

Originally, the sculpture had been due for completion in time for the 'Sounding the Depths' festival in Cambridge in September 2000. Unavoidable delays – not least the fact that the wall upon which the sculpture was to hang needed to be strengthened to take the weight of half a ton of aluminium – meant that the dedication was delayed six months, until the Feast of St Patrick, 17 March 2001. The liturgical context for the dedication was Choral Evensong, sung ably and sensitively by the Cathedral Choir, and attended by some two hundred people – including Friends of the Cathedral (who had commissioned the work), the artist's family and friends, and members and supporters of *Theology Through the Arts*.

Incorporating such a special event into the regular cycle of worship (whether in a cathedral or elsewhere), is not always easy; the two elements *can* feel disjointed, the 'special' simply an 'add-on' to the 'normal'. Not so, in this particular act of worship. Here, the one was skilfully interwoven with the other, music and word, movement and reflection combining in such a way that the dedication neither dominated the seasonal aspect of a Lenten evensong, nor was lost inappropriately in an act of worship which paid no heed to the particular focus of the work of art to be dedicated. On the contrary, each enhanced the other.

For example, one of the most powerful themes running through the liturgy was that of 'walking in the company of Christ', himself the Way, the Truth and the Life.[1] Already cited in the Collect and present in each of the hymns, in the Psalm,[2] the Prayers and the Responses at the Dedication,[3] this theme was perhaps most poignantly illustrated in the gentle choir solo verse of St Patrick's Breastplate – *Christ be with me, Christ within me* – a verse which prays for the presence and comfort of Christ in the lives of all who follow him[4] – both friend and stranger.

There were processions too – into the nave sanctuary by choir and clergy, and from the crossing to the sculpture at the west end by the whole congregation. Each emphasized, in an embodied

way, that we are a pilgrim people, moving from place to place, following (quite literally) the cross of Christ and walking not only in his company but in the company of each other. The experience may have been lost on those who struggled to sing the words of a hymn as they moved from one end of the Cathedral to the other, but perhaps for some, there was a renewed awareness of walking *together*, of being part of a corporate journey with the whole people of God.

This 'corporate walk' in procession found its natural terminus as people gathered around the font to look upward to *The Way of Life* suspended on the north-west wall. When all had gathered, the choir sang (from high above in the triforium), the Vaughan Williams anthem, *The Call*, – a setting of words by George Herbert.[5] It was a moment of balance, both physical and spiritual: physical in the sheer demand of standing and looking upwards at the sculpture for a period of time; spiritual, in the awareness of being surrounded by many others and yet also being personally engaged in contemplation of a work of art which seems to invite each *individual* to step on to the pathway. The invitation to follow in the way of the cross is both corporate and personal,[6] an emphasis which was clear in the context of the liturgy, but which may go unnoticed for those who view the sculpture outside a liturgical setting.

'Head up' and 'head down'

Whether personal or corporate, there is no doubt that *The Way of Life* invites a response. It stands as a three-dimensional point of entry, not only into a glorious Norman cathedral building, but also into an inner world of reflection on life itself. Its very scale, as well as its position high above ground level, demands both a looking upwards and outwards. It is a 'head up' experience. The sculpture is expansive, in every sense of the word, leading the eye from ground to the cross and back again, out into the wider space beneath the cathedral west tower and beyond into the nave. Herbert's words 'Such a Way, as gives us breath', seem remarkably apt. The sharp turns and corners of the pathway,

sometimes rising, sometimes more level, becoming more angular the closer they are to the cross itself, speak of the harshness and difficulty of the way. Indeed, even the texture of the pathway appears smoother at the bottom, more pitted and cracked towards the top.

Yet despite the harshness, the swinging to and fro, two things are particularly striking. First, the path and the cross are one. They are 'of the same stuff'; the visual (and physical) movement to and from the cross is unbroken. There is no separation, no 'unassailable leap', even though the cross remains, clearly, a cross. The 'leap' – if there is one – is from the door at the foot of the sculpture *on to* the path. Once on the path it leads, unbroken, to the cross. Second, the way the sculpture is lit conveys a movement from darkness to light as the eye rises upwards. Paradoxically, the place of greatest darkness and pain (the cross) becomes the place of greatest light, drawing the eye inexorably to itself.[7] Indeed, it is as if the cross becomes both the focus and the source of the light in which the sculpture is bathed.

In sharp contrast, a labyrinth – made of black 'Winton' and white 'Mansfield' tiles and embedded into the floor of the Cathedral west entrance, between the font and the north-west wall – speaks of a more constrained, more 'inward' understanding of the Christian journey (Plate 18). To walk the labyrinth is very different to looking at the sculpture. It is a 'head down' experience. It demands a focus downward and inward, with intense concentration on the backward and forward, almost mechanical and predictable pattern of the path. There may be others walking the labyrinth, but it is a particularly 'singular' journey, for there is room for only one person on the narrow stone pathway. Others may be present, but they cannot be described as companions. People brush past each other, seemingly moving in opposite directions, even though they are ultimately walking exactly the *same* path towards the centre!

How then do these two very different 'paths' speak to us of God in his relationship with the world? Two particular areas of reflection seem to emerge. First, *The Way of Life* gives us certain insights into the meaning of the cross of Christ. Second, in their

new proximity, the sculpture and the labyrinth raise issues concerning the nature of God as one who frees or controls, 'opens out' towards creation or 'closes down' and binds creation.

The cross that crowns the pathway of *The Way of Life* is integral to the whole sculpture: it is 'of the same stuff'. The cross of Calvary was, of course, unique – the 'once and for all' salvific act.[8] Yet this material continuity of cross and pathway seems to underline two things: first, the complete and utter identification of Jesus Christ with the human condition, (incarnation and redemption are inseparable); and second, the invitation and encouragement to take up *our* cross in the knowledge that he has already walked the path which led to his. In this way, his cross becomes both the source and end of each pilgrim's journey,[9] a truth emphasized by the lighting that constantly draws the eye upwards.

We walk the path only because of Christ's death and resurrection; we take up our own cross only because we know that he has assumed and already redeemed our humanity – with all its sin and shame – and taken it into the Godhead. The previously 'unassailable leap' was made at Golgotha; he himself *becomes* the Way,[10] invites us through the door into relationship with himself, and we receive and respond to a gift of faith grounded solely in God's graceful initiative.

But what of the labyrinth? It would be wrong to overstate the contrast with *The Way of Life*. For many years, the labyrinth has offered a 'way in' to understanding the demanding, lengthy and intricate nature of the Christian journey, 'speaking' of the importance of perseverance, of obedience and single-mindedness, of the need to stay within bounds, of the awareness that sometimes the pilgrim is walking towards the centre, and sometimes appears to be wandering in the opposite direction. All of these are important insights.

Next to the new sculpture, however, two things become noticeable. First, the labyrinth ends at the centre – four blank, white tiles of (apparently) no symbolic significance, seemingly taking the pilgrim nowhere – other than further into himself or herself. Perhaps that is the intention? Perhaps the labyrinth

is designed as an exercise in self-discovery or spiritual self-exploration? Perhaps not. Whatever the intention, it seems unfortunate that (unlike *The Way of Life*) there is no apparently God-focused end to the journey.

Second, the labyrinth speaks of constraint rather than expansiveness, of looking inward rather than looking outward. *This* path seems to point to a God who keeps us tightly bound, who demands that we (almost literally) 'keep our heads down' and get on with life, rather than one who of his very nature is outwardly dynamic, open, seeking the good of the other, offering new freedom. Here again, it is possible to overstate the contrast: true freedom does, of course, lie within the bounds of constraint. It is a myth to assume that an absence of boundaries will bring freedom; rather, it brings isolation, insecurity and inward-focus. Nevertheless, there seems to be little in the path of the labyrinth to encourage the pilgrim to find that freedom which comes through relationship with God, with others and with the created order. The pilgrim's is a solitary journey that seems to take no account of the outward-looking dimension of the God whose Spirit opens us up (together with the whole of creation) to the love of the Father and the Son.

At the extreme, the labyrinth may be construed to point to a God who 'controls' the path of every pilgrim, reflecting a theological determinism that has no grounds in Scripture. By contrast, *The Way of Life* seems to point to a Father who is utterly committed to what he has made, redeeming it through the cross of his Son, nurturing and sustaining it through the work of his Spirit.

His way, my way

The Way of Life will evoke as many different responses as there are visitors and pilgrims to the Cathedral. It is a public work of art, yet at the same time, intensely personal and engaging. Some will simply see a large and imposing modern sculpture, depicting something of the unpredictability and variously-fated nature of life's journey. Others will reflect on their own Christian journey,

leading to – and in their life experience, intimately connected with – the cross of Christ. Yet others will be taken into the passion of Christ himself, the *Via Dolorosa*, the Way of the Cross. For many, taking time to reflect on the sculpture will evoke a combination of all of these elements (and more), drawing together that mixture of joy and pain, glory and crucifixion to which the Collect for the Third Sunday of Lent so succinctly points.

More than anything, *The Way of Life* is an invitation – and a dual invitation at that. Theology will *indeed* speak through art. For as Herbert's words, 'Come, my Way, my Truth, my Life' floated across from the triforium of the Cathedral, they became not only a calling out to Christ to meet us in the way, but (strangely perhaps) an invitation *from* Christ to walk in *his* Way. Jonathan Clarke's sculpture will articulate this invitation without words, calling visitor and pilgrim alike to respond with integrity to the simplicity of art, and to recognize afresh the God in whose company they travel.

Notes

1 John 14.6 – used as the opening sentence.
2 Psalm 31.4 – 'For thou art my strong rock, and my castle; be thou also my guide, and lead me for thy name's sake.'
3 Dean: Jesus Christ is the Way, the way to God
 All: Christ is the Path of Life we must follow
 Dean: The path is narrow
 All: Christ is the Path of Life we must follow.
4 Christ be with me, Christ within me,
 Christ behind me, Christ before me,
 Christ beside me, Christ to win me,
 Christ to comfort and restore me,
 Christ beneath me, Christ above me,
 Christ in quiet, Christ in danger,
 Christ in hearts of all who love me,
 Christ in mouth of friend and stranger.

5 (Verse 1)
 Come my Way, my Truth, my Life: Such a Way, as gives us breath:
 Such a Truth as ends all strife: Such a Life as killeth death.
6 Matt. 16.24; Mark 8.34; Luke 9.23.
7 Cf. John 3.14; 12.32.
8 Rom. 6.10.
9 Heb. 12.2.
10 Heb. 10.20.

EASTER ORATORIO

Easter Oratorio

This 'pod' group differed from the others in that its two key members were already collaborating before being approached by Theology Through the Arts. The composer Paul Spicer had been commissioned to write a major oratorio for the Lichfield International Arts Festival in 2000, with libretto by the New Testament scholar Tom Wright (until recently Dean of Lichfield, now Canon Theologian at Westminster Abbey, London). The Easter Oratorio, based on the resurrection narratives from John's Gospel (chapters 20 and 21), turned out to be a piece on a vast scale, for soloists and a massive choir and orchestra. Premiered at the Lichfield Festival under the composer's direction, it formed the closing event of the 'Sounding the Depths' festival in Ely Cathedral, on 16 September, 2000. Jo Bailey Wells, then Dean of Clare College, Cambridge, records her impressions of that occasion.

I joined Paul and Tom to form a 'pod' group after they had been meeting for about a year. I found one of those rare partnerships in which complete trust and respect meant not only that they could work together with extraordinary synergy, but that they could also disagree openly, even to the point of leaving some things unresolved (a matter which both Tom and Paul write about here). Most memorable for me were discussions about the ending of the Oratorio: how does one 'finish' a work about the resurrection, by its very nature an 'end without an end', indeed, an end which opens out for humankind a life of expansive, ever richer abundance (not simply 'on-and-on' but 'more-and-more')? Moreover, how does one do this in music, in which notes

ceaselessly die, eventually into silence? Wrestling with these matters pushed us deep into theology, in a way in which none of us had been pushed before.

Paul recounts in detail the agonies and ecstasies of composition, and the questions he was made to face through working with Tom. Tom himself, a leading international biblical scholar, expands on the ramifications of this kind of exercise for the future of theology: the way in which collaboration with a musician compelled not only a closer but a different kind of reading of John's text, the way in which some of his own words which he regarded as weak were transformed by music, and how he discovered afresh 'the non-reducible, and not merely decorative, function of imagination within historical work . . . and also theological endeavour'.

It was a rare privilege to be part of a process which, while seeking to honour a biblical text meticulously, allowed music and poetry to do their own work in their own way, so that – as Tom puts it – we (and, we trust, the audiences) 'learned and grew and grasped afresh some of the central matters of Christian faith'.

Substantial excerpts from the Easter Oratorio *are available on CD which can be obtained from:* jennifer@the-abnalls.freeserve.co.uk

14

Easter Oratorio:
The Composer's Perspective

PAUL SPICER

The *Easter Oratorio* came into existence in October 1998 when I was formally commissioned by the Lichfield Cathedral Special Choir to write a major Oratorio to have its first performance at the Lichfield International Arts Festival in 2000. It had a slightly quirky genesis which is interesting. I was looking to commission a new setting of the Passion to mark the three anniversaries being celebrated in the 2000 Festival: the Millennium (the 2,000th anniversary of the birth of Christ), the 250th anniversary of the death of J. S. Bach, and the 1,300th anniversary of the founding of Lichfield Cathedral. However, having discussed the project with the Dean of Lichfield, Dr Tom Wright, Canon Charles Taylor, the Cathedral's Precentor, and Dr Jim Berrow (from the Board of the Lichfield Festival), it was decided that it would be more valuable (and less open to impossible comparisons with Bach's incomparable settings) to set the resurrection story. Tom Wright immediately suggested chapters 20 and 21 of St John's Gospel and set to work at once on a new translation. At that stage I was still anticipating commissioning another composer, but after talking to London publishers about the project I soon discovered that the scale of what I had in mind would simply cost too much money to contemplate.

On my return to Lichfield, and after considerable reflection, I wrote to Tom Wright, who was then Dean, with the suggestion that we should consider composing the work between us. Tom (who shortly afterwards left Lichfield for Westminster Abbey) was highly enthusiastic about the prospect and produced a draft

libretto of Part One almost at once. It was an exciting moment.

I began work on Tom's text in December 1998, wrote the final double bar of the short score (piano and voices) on 25 October 1999 and finished the full score on 12 March 2000.

The Oratorio begins where the Passions end, with Christ's body in the tomb. It is structured, as are Bach's Passions, by telling the gospel story interwoven with choruses, arias, chorales and hymns which reflect the story from different angles. Whilst it is designed as two large paragraphs of music either side of an interval it is thus comprised of a large number of movements of varying scales from very short to quite extended. The work is divided into two parts. Part One: *The New Day* is some 60 minutes in duration, and Part Two: *The New Calling* about 50 minutes. The forces involved are SATB choir, boys' choir, four soloists: Soprano (Mary and arias), Tenor (Evangelist), Tenor (Thomas, Simon Peter and arias), Bass (Jesus and arias), orchestra, and the whole audience who sing some of the big Easter hymns at key points.

By any standards this is a major work and completely outside my experience in terms of scale. There were therefore many unknowns as I set to work. In the first place, my questions were all self-centred: had I the technical equipment and 'inspiration' (enough musical ideas) to make a large-scale work hang together and keep the listener's interest? Had I sufficient colour in my 'ears' to make an orchestrally accompanied work of this size interesting and varied? Would my musical style, based on a language which drew its inspiration from English practitioners of over half a century ago, be taken seriously and have any kind of impact at the start of a new century? Would I be able to write the kind of choral music I wanted to and yet write it at a level which would be straightforward enough to be performed by competent amateur choirs? Much of my previous choral music has tended towards the challenging. All these questions crowded in on me as I began to put pencil to paper.

The extraordinary thing which I found, however, right from the first movement, was that the music simply flowed. At no time, once I had started, did I feel that I was short of ideas. I

certainly discarded quite a lot of pages along the way and made very heavy use of my eraser, but the interesting thing to me was that I worked from Tom's first word to his last in that order and that the shape of the work simply came to me. Ideas for recurrent themes (particularly the motif which binds almost all the Evangelist's recitative passages together) were quickly articulated and therefore the question of style was also answered. I took courage in this (as I have on many occasions) in writings either about or by Herbert Howells, my composition teacher, whose biography I had recently finished writing before I began work on this Oratorio. Hugh Ottaway, a distinguished commentator on music, writing in 1951 about Howells's great choral work *Hymnus Paradisi* said:

> The strength of the music derives from its impeccable style, from the mode and quality of thought within the idiom. That's what tells in any work of art. Idioms come and go and history finds little to choose between them; the enduring factor is the quality of thought, which alone makes the idiom a living and vital thing.[1]

In a letter to Arthur Hutchins (Professor of Music at Durham University) after the first performance of his *Missa Sabrinensis* at Worcester Cathedral, Howells wrote:

> In my comparative old age I feel strangely freer to express myself in music – free of the thousand and one fears and fashions, comparisons and estimates being interminably made by one's contemporaries. There is, in so many of us, a crippling concern with the public reaction and the critical opinions of Tom, Dick and Harry. The four walls of one's study cannot shut these out: or is it that one fails to learn how to shut them out till one has one foot in the grave?[2]

This articulates so well how I felt in the early stages of writing this work. But yet it was also important for me to remember that the style with which I feel I can best express myself was in itself

part of the reason for feeling that I *could* undertake the writing of the work.

I have been involved in church music all my life. From my very earliest days I sat with my grandfather at the organ of Manchester College, Oxford. I then went to New College aged seven as a chorister and was inspired by the great corpus of music either written for or sung within the services of the Anglican Church. This led me not only into choral conducting but into organ playing and composing. My love of Howells's music was planted at that very young age when we sang his carol anthem *Here is the little door*. What moved me then (although I was too young to either recognize or articulate it) as it does now was the mystical quality of this and so much other church music. Here was a music which was ecstatic in the sense of that word which comes from its Greek derivation *ekstasis* 'to stand outside oneself'. Here was a music which, at its best, put one on another plane 'outside oneself' and drew one to God through the power of this creation which made the words and images vivid and metamorphosed them into a living and unforgettable experience through the genius of a composer's imagination and skill.

The essence of this experience was analysed for me by the Rt Revd Keith Sutton, Bishop of Lichfield, as a 'vertical' rather than 'horizontal' experience: God in his heaven and his people on earth rather than 'Jesus, friend and brother'. I hadn't been properly aware of this distinction, but was immediately taken with the potency of the image. In this valuable debate, as in many such discussions whether over religion, poetry or music, Bishop Keith has been a very close and valued friend to me as I know he has also been to Tom.

Howells set a typically visionary translation by Helen Waddell of a poem by the eighth-century poet Alcuin in a motet he called *A Sequence for St Michael* in 1961. In her translation Waddell creates an image from Alcuin's original which has always somehow epitomized for me the mystical element which so appeals to my own imagination: 'Thou with strong hand didst smite the cruel dragon, and many souls didst rescue from his jaws. Then there was a great silence in heav'n, and a thousand thousand

saying 'Glory to the Lord King'. For me the idea – even the visual image – of the totality of that silence, and the gradual murmur of these countless souls uttering their near-silent prayer of praise is quite overwhelming.

Thus, to return to the discussion of musical style, the language which I have used seems to me to be a perfect vehicle for expressing the *ekstasis* which so much of Tom's libretto summons up. I would cite various images as speaking powerfully to me in this way: 'Now the word had fallen silent and the water had run dry, the bread had all been scattered and the light had left the sky' (No. 1); 'Rest you well, beloved Jesus . . . In the brooding of the Spirit, in the darkness of the spring' (No. 1); 'Like a day new dawned there rises in me now /The wild delight of God's creative power./One glance upon the bed where Jesus lay /Has quite undone my cold and aching fear' (No. 5); 'Where have they laid my Jesus? . . . The spices rich and rare /Are worthless; and I stand here /In shame and in despair' (No. 7). (I found the setting of Mary's distress in finding Jesus's body missing in the early part of the work particularly moving.) And later: 'The price of peace is carved upon his hands /And in his side. The wounds that love has borne /Are strange, familiar, signs of passion spent' (No.20); and finally in this rather invidious extracting 'The peace so dearly won is dearly shared. We glimpse the glory of the Word again /Made flesh – our flesh, our hands, our side, our love . . .' (No. 22).

There is another element in the compositional palette which was enormously important to me and which I think of as being as much a connecting thread throughout the work as the motif for the Evangelist's recitatives, and that is counterpoint. If there is something which has moved me in music more than anything else it is marvelling at a great composer writing outstanding counterpoint. Counterpoint makes music flow. It is the writing of individual musical lines which together combine to make harmony. There is something utterly timeless about counterpoint which transcends fashion. Interestingly, when Schoenberg took music down the path to atonality and was joined by his pupils Berg and Webern (who collectively were known as the Second

Viennese School) it was the triadic system based on keys which he was seeking to break. Thus 'one particularly prevalent feature is the uncompromisingly linear and contrapuntal character. In the absence of any given referential harmonic norm such as a triad, even harmony is conceived as a kind of vertical melody.'[3] So, even as music was breaking up and moving away into a new world of sound and technique, the interaction of a number of musical lines sounding together and often related to each other remained.

To me, the technique of counterpoint has a 'mystical' quality which reflects what I see as the mystical elements in the text. However, it is not this alone which made me want to pursue this style of writing. I have found that the interplay of musical lines when carefully handled brings the music a passionate intensity which is not possible by merely homophonic (chordal) writing. Thus, I often see the choral movements as central to the development of dramatic (and emotional) intensity throughout the work and are thus particularly well suited to this treatment – as well, of course, as being well suited because of the individual voice parts which divide naturally into separate musical lines. Good examples are No. 7, where there is a feeling of rumour-like questioning amongst the participants 'Where have they laid my Jesus?', and No. 20 where everyone is elated in their singing of 'Jesus is risen from the dead'. Just before this Tom has written 'Now, hands and side declare a double theme' at which point I mirror this with two-part counterpoint between the four voices. In Part Two, the opening chorus is almost entirely contrapuntal taking its cue from the 'strange, unmapped new land' image which Tom conjures up so beautifully. I try to mirror this 'strangeness' with a Tippett-like four-part fugue for winds which is picked up after a lengthy exposition by the voices who carry it forward, eventually transforming it into a chordal dance as the Lord is invited to show 'our explorers' eyes your new found land'. There are many other examples including the 'treading' figure in No. 60 'The path he trod . . .' which leads to an ecstatic five-part contrapuntal texture which takes us through 'feasting, healing, shame and grave', and the one movement, No. 64

'The unnamed, special friend whom Jesus loved', which was originally intended as an unaccompanied choral movement and is written in a motet style entirely contrapuntally. There are many other examples including the very final Alleluia with which the work ends which provides a kind of mystical 'winding down' as the parts taper away to leave the lone sound of a tolling bell.

Another special challenge was found in the two different kinds of hymn which Tom wrote into the text. Like Bach's Passions this work includes 'chorales' for the choir to sing. The difference in this work is that whereas Bach's chorales were well-known Lutheran hymns, these chorales are newly composed and are thus for choir only. The equivalent, in the present work, of the congregational participation Bach achieved through the chorales is thus the great Easter hymns. There is one exception: the final hymn of Part One which is intended to be a big set-piece Easter Hymn but which is entirely new and which is therefore sung by the choir without audience. This was, quite unashamedly, an attempt to write a memorable tune which could be lifted out of this context and used in general church services. It gave me great pleasure to be asked straight away if it could be used for the installation service of a vicar in a local parish who was present at the first performance.

When it was first suggested that our project might form part of Jeremy Begbie's *Theology Through the Arts* project I was both excited and alarmed. I was excited because it ultimately meant the possibility of a second performance (a real luxury for many new works – especially of this scale), and also because it would have an opportunity of reaching a wider audience. However, I was alarmed because I was not sure whether I really wanted the level of scrutiny which the 'pod' (or discussion) group which forms a central part of the workings of the project would entail. My mind was put at rest at my first meeting with Jeremy (who, with Tom and myself formed our 'pod'). He was intensely sensitive, made me feel that my layman's feelings about theology and my struggles with faith were all part of the rich tapestry of the human condition and he promised fascinating debate. And fascinating and creative it has been. I have valued the interaction

between the three of us more highly than anything I have experienced in recent years with the single exception of the wonderfully fulfilling and enjoyable hours I regularly spend with Bishop Keith (who joined one of our 'pod' meetings in my house for a brief while). Similarly, the privilege of working with someone like Tom Wright has been a life-changing experience and it is wonderful for me that Tom, whose scholarship is a beacon of light around the world, professes this project to be one of the most exciting he has undertaken.

I have carried by far the greater burden. That is certainly true in terms of physical and time terms, but that is not what I mean. The greatest burden in some senses has been that of interpretation. Music, as we all know, is the most expressive and powerful of all the arts. It has the greatest power to move, to describe, to lift and to drop, to instil passion and whip up a crowd. And this is where I felt my responsibility most keenly because my music has to demonstrate that I understand the full import of all these words. Words, as we all know, are dependent on their context for their full meaning to be revealed. However, there is the additional problem here of my 'unbelief'. That is not *dis*belief, nor is it a lack of faith. It is quite simply that there are points in this work where I don't *feel* the certainty which Tom's words seem to convey. There are two notable points in the work where this became an issue, one of which was very happily resolved between us, the other was not.

The first of these is No. 28 in Part One 'The sea has parted'.

> The sea has parted. Pharaoh's hosts –
> Despair, and doubt, and fear, and pride –
> No longer frighten us. We must
> Cross over to the other side.
>
> The heaven bows down. With wounded hands
> Our exiled God, our Lord of shame
> Before us, living, breathing, stands;
> The Word is near, and calls our name.

New knowing for the doubting mind,
New seeing out of blindness grows;
New trusting may the sceptic find,
New hope through that which faith now knows.

I have set this as a nerve-racked, slightly neurotic aria for tenor.
The strings buzz with tremolandi and the whole piece is miles
from the image which Tom felt he had created. The certainty, the
celebration of Pharaoh's hosts in being able to cross the Red Sea,
the heaven bowing down, the word being near, and new hope
and trust abounding. And yet I feel that this aria is one of the
most successful in the whole work and one which I believe in
passionately precisely because of its intense humanism. Think of
those walls of water – the crushing walls of your doubt being
held back. Would you, as a fallible human being not be a tiny
bit worried as you started walking between them for all your
bravado – how strong really *is* your faith? The image Tom
beautifully creates '. . . with wounded hands /Our exiled God,
our Lord of shame /Before us, living, breathing stands . . .' is that
not a cause for mixed emotions? The very wounds, that shame,
that exile – don't they count for anything in all this sea of
certainty? The point for me is in Tom's third verse where he
admits to the *growth* of certainty. Thus: 'New knowing for the
doubting mind, / New seeing out of *blindness* grows, / New trust-
ing may the *sceptic* find / New *hope* through that which faith now
knows.' The knowing is the final word of the aria and that leads
directly into the most affirmative music of the whole work where
Thomas's doubts are finally put aside in the revelation of recog-
nition. To me, this treatment of No. 28 makes that moment of
revelation and recognition so much more powerful because I
have invested the process of coming to faith, recognition and
revelation with human doubts and uncertainties. Let me see the
process by which we achieve faith not the wax-polished finished
product!

The other point by which both Jeremy and Tom were very
surprised was the very end of the whole work. The great Easter
Hymn with which it finishes 'Ye choirs of new Jerusalem' is

surely one of the most joyful of all and is arranged for maximum effect and to encourage the most sonorous audience participation. Surely then, a triumphant end to send everyone away inflamed? No. I felt very strongly that if I had learned nothing else during this very long, arduous journey it was that everything worthwhile is achieved by struggle. The resurrection of Jesus Christ is a matter for universal celebration. The problem is that the ongoing present and future of the Word is more of a constant crucifixion which, thank God, is often followed by individual resurrections. During this work there are a number of opportunities which were taken to be triumphalist (think of No.12 'the horse and his rider he has thrown into the sea' etc., or No. 20 'Jesus is risen from the dead'). The message I wanted to leave ringing (literally) in people's ears was that whatever point we have reached in our faith is still only a start. We may declare undying devotion, but every day of our lives brings new tests. Faith is a living, breathing thing (how interesting that I have quoted words from the contested ground of No. 28 there!). It is not a showroom commodity for sale. We as human beings are entirely fallible and as such it is given to very few to be certain and to be comfortable in their certainty. This is not a problem (to me), rather, another of life's challenges which properly nurtured can be a wellspring for good throughout one's life. It was these feelings which led me to end the work with a long winding down after the final hymn and to the contrapuntal farewell 'alleluia' which is led away by a single tolling bell ringing on the flattened seventh of the tonic chord with which the choir has ended (the whole work begins and ends in C major). This feeling of incompleteness is in some senses a metaphor for picking up where the piece finishes. In other words, here is the crucifixion and resurrection of Jesus Christ. Now, think on these things and go and act upon them in your lives. That feeling would not have been engendered by ending with a big bang and in soaring triumph. It should be added that once Tom and Jeremy had registered their surprise at the work ending in this way (and I had gone away to reflect further on it) they came to not only accept, but very firmly endorse it.

In these 'post-modern' days people seem ready to accept musical style as it comes provided that it has something within the style which is worth saying. This has both advantages and disadvantages. We have lost some of the cutting edge new music by which the 1960s–1980s were characterized. But good new music in advanced new languages is still being written by forward-looking composers (think of James MacMillan who has also been a part of the *Theology Through the Arts* project) but who are now perhaps more aware of their audience and who want to give them new experiences to which they can relate rather than deploying the shock tactics which characterized the late twentieth century. This must go on. It is vital to the health of our artistic diet that we take music on further, and in different ways from before. However, those of us who are not original composers in that way but who still believe that we have something worthwhile to say can now have a reasonable expectation of also being taken seriously which is an equally good thing. The reviews which followed the first performance of the *Easter Oratorio* showed how broad minded the critics were and how they were listening with intelligent ears not for fashion but for content. The *Church Times* proclaimed 'Resurrection, English-style' which might well have been a prelude to a review of the mediocre, but in fact wrote of 'a vital new oratorio' which was '(a) splendid undertaking, rich in colour, to cheer any large choral society with a fondness for traditional Three Choirs repertoire'. It also wrote of the wind writing as being like 'Tippett inspired, transmuting the rapt paganism of *The Midsummer Marriage* into sacred-oratorio form'. The *Birmingham Post* critic singled out the hymns 'which we all sang with the hairs on the back of our necks tingling'. The *Independent* wrote of the work as 'almost operatic in its inherent drama and memorable tunes' and as being 'a major contribution to the choral society repertoire' and 'a viable and rewarding alternative to the Bach Passions for choirs equal to realising its diversity of mood and wide expressive range'.

In some senses the inclusion of the hymns and chorales were central to the successful deployment of the English style in this

Oratorio. These great moments of reflection, corporate celebra-
tion or statement of faith are so wedded to the Anglican tradition
that, out of context, they can appear almost jingoistic. The
stylistic jolt occasioned by the inclusion of a Victorian hymn into
a contemporary choral work can make it sound ridiculous –
embarrassing even. I have to admit to feeling quite worked up at
the thought of the orchestral rehearsal the day before the
premiere. This rehearsal was without chorus and I had visions of
all the raised eyebrows and tired looks between players as we
'sawed' our way through the various hymns. I had to keep hold
of the thought that all would be different when the choirs, organ
and audience were all at singing their hearts out – some 1,200
singers makes an impressive sound! In the end the orchestra were
polite at the prior rehearsal and were amazed at how the whole
thing turned out in its finished form the following day. The brass
section even admitted to the organist that they were enjoying
themselves! Stylistic integrity is a key factor in the writing of this
work and that, to me, is why the hymns work so well in context
as they all 'grow out' of what has gone before. In many cases this
is literally the case where the introduction to a hymn is incorpo-
rated into the end of the previous movement. This, to my mind,
is one of the most successful elements in the compositional
process. In this way, the chorales and hymns feel completely
natural in their context.

There was an appalling crisis over the completion of the
orchestral parts just prior to the first performance on top of
managing the ongoing Lichfield Festival which gave the premiere
a particular frisson. Some reflections are perhaps relevant to this
'debrief'. First, that the work is perhaps a little over long. Not a
single person complained of this from the audience or from
amongst the performers. In fact a number of people wrote to me
expressing their surprise at not feeling this. My feelings are
occasioned more by the practical realities of performance given
the appalling constraints of rehearsal we face in the UK through
lack of funds. A two and three quarter hour rehearsal (three
hours minus the statutory break) to rehearse a work whose
duration is over 130 minutes does not give much leeway for

rehearsal as opposed to simple 'playing through'. Of course it is unlikely that future performances will field the three hundred or so performers who gathered for the Lichfield premiere. That brought its own problems – space and distance in particular. A smaller group with a more intimate string section would make many of the problems of ensemble much less acute and therefore more likely to work first time for a conductor who knows the score and is therefore clear in his directions.

The orchestral forces are sizeable, but are only what is necessary to my mind for the variety of colour needed to sustain aural interest for a two-hour period in such a major work. They do not constitute a full 'symphony' orchestra, but do include separate players for celesta and organ, together with two percussion players in addition to a timpanist.

Second, and this is the only reflective comment I have post first performance in relation to Tom's text, and that is that I feel that there is too much of a concentration of hymnody at the end of Part One. I felt it as I was composing it, but also felt that it would probably feel like a crescendo towards the end. In fact, I feel that the Chorale (No. 30) followed immediately by 'The day of resurrection' and almost straight away by 'You shall go out with joy' is one hymn too many at this point. I honestly don't know how I would deal with it (and, frankly, it is probably best left alone), but it might have been best to leave No. 31 out and teach the audience No. 33. It is a small point and I do not think that I would want to deprive the audience of a good sing at any point!

In conclusion, I feel that all elements of this project have been remarkable, and a success beyond my wildest imaginings. The image of Tom sitting with me in the hall of the Adult Education Centre at Twickenham listening to the marvellous singing of the Twickenham Choral Society being rehearsed by Christopher Herrick and being quite overwhelmed by their enthusiasm for the piece was extremely moving. It is difficult to describe what it felt like (I think for both of us) when we finally heard the music being sung by real voices (as opposed to computer simulated ones) singing Tom's words and my music and being obviously moved by both elements. That, surely, is the overriding

justification for all this work. To have produced a major new choral work which touched people is all that a composer or librettist can hope for. I know that some of the music I wrote moved me as I was writing it, and I know, too, just how much of an effect it had on some of that first audience. The number of people who told me (or wrote to say) that they had been moved to tears by parts of it was extraordinary. To that extent this work was memorable. But the critic in the *Church Times* had it right when he wrote 'Courageously, it runs to a full-length evening. Yet it sustains the interest, in large part thanks to the distinguished biblical scholar Tom Wright's sensitive and generally uncloying text.' Amen to that. 'In the beginning was the Word'. If Tom's words had not moved me to writing music which connected with people it would not have achieved its proper end which should be to make people think about the resurrection of our Lord Jesus Christ and to reflect on its implications for our own lives. That is why the bell tolled at the end of the work in a musical representation of the writer's three dots . . .

Laus Deo

Notes

1 Hugh Ottaway, '*Hymnus Paradisi*: an appreciation', London: Musical Opinion, 1951.
2 Christopher Palmer, *Herbert Howells A Celebration*, London: Thames Publishing, 1991, p. 426.
3 Robert P. Morgan, *Twentieth Century Music*, New York and London: W. W. Norton, 1991, p. 69.

15

Resurrection: From Theology to Music and Back Again

N. T. WRIGHT

Beginnings

The second week of May 1998 was a typical week in the life of Lichfield Cathedral. Worship, preaching, meetings, visits and more meetings. And one of those meetings, on Wednesday 13 May, had effects more far-reaching than we could have imagined.

The meeting was called by Paul Spicer to plan the Lichfield Festival for July 2000. Paul was keen to commission a large-scale work that would simultaneously commemorate the Millennium (so-called; I have made my views on that subject well enough known[1]), the 1,300th anniversary of the first founding of Lichfield Cathedral, and the 250th anniversary of the death of Johann Sebastian Bach. We brainstormed the subject for a while with two colleagues (Canon Charles Taylor, the Precentor of Lichfield Cathedral, and Jim Berrow, a member of the Festival Board). As we talked through various options, we soon rejected the idea of a Passion on the lines of Bach's own Matthew and John Passions. They are too well known; the comparison would be too obvious; anyway, the theme hardly fitted a summer festival. For similar reasons a setting of the Christmas story, or a large-scale Mass, seemed inappropriate. But – an Easter Oratorio?

Bach wrote a small piece with that name (BWV 249), but interestingly it wasn't on the scale of his Passions. But there was certainly a potential project in that area, provided we chose

the right Gospel. Mark's resurrection narrative (16.1–8) is notoriously curtailed, with the longer ending (vv. 9–20) being almost certainly a later addition, and in any case not providing much to gladden the heart of either a librettist or a composer. Matthew's story (ch. 28) is a bit fuller, but still without the dramatic potential necessary for a musical setting. Luke's narrative (ch. 24) is fuller again, and contains the incomparable Emmaus Road story (24.13–35). But that story itself poses a problem: its very length, and extraordinary power, overshadow the rest of the chapter. Thus all the signs pointed in one direction: John's Gospel. It is John who provides not only the most Easter material but also a succession of vivid personal encounters with sharp characterization and dialogue. John was not only the one possible contender; his two Easter chapters offered splendid possibilities.

The meeting broke up in some excitement as Paul Spicer agreed to search for a composer and librettist to take on the task. I myself, as a *jeu d'esprit*, roughed out that afternoon a fresh translation of John 20 and 21 divided into the relevant parts: Evangelist, Christ, Peter, Mary and so on, with suggestions of where one might add choruses, arias, and so on – for which we would of course need fresh text, that is, a libretto to go with the material from John's Gospel.

We were then overtaken by the summer's events, including that year's Festival itself, and such things (not unconnected in my mind at least) as the Jubilee 2000 meetings which the Cathedral hosted in the run-up to the 1998 Lambeth Conference. Then, in September, Paul wrote to me. He had been unable to find a composer or librettist who was both available and affordable on the Festival's limited budget. He proposed that the two of us do it together: he, of course, to write the music, I the libretto.

I was shocked and excited, realizing both that I was in uncharted territory (scholars and preachers may write poems in private, but they aren't usually invited to make them public and have them set to music), and that if I declined I would kick myself for the rest of my life. But I had the germ of an idea. I had long been fascinated (not least through reading Hans Urs von

Balthasar's book on Holy Saturday[2]) by the idea that God's Sabbath rest after creation (Gen. 2.2–3) somehow foreshadows Jesus' rest in the tomb on Holy Saturday. The final great chorus of Bach's St John Passion is 'Ruht Wohl', laying the dead Saviour to rest after his work has been completed. That, I thought, was where an Easter Oratorio based on St John ought to begin, picking up the theme where Bach had left it.

So: how to do it? That evening, during Choral Evensong in Lichfield Cathedral, there flashed into my mind a new twist on an old hymn:

> O sabbath rest by Calvary
> O calm of tomb below. . .

And before I knew it I had the whole first chorus in my head, then on paper and through Paul's front door. From that point there was no turning back. I took the project with me on a couple of foreign trips and scribbled lines and verses on aeroplanes and in hotel rooms. By early December I had a draft to discuss with friends – and, rather to my alarm, Paul had already begun setting it to music. By the time I came back to him with textual revisions, some of the words I had contemplated changing were already set to music that was gathering pace and power. Paul and I were both nervous of our huge undertaking, but the backing of some generous sponsors and the enthusiasm of friends and colleagues sustained us at every step. I happily record our gratitude to them all, not least *Theology Through the Arts*.[3]

Words, music and ideas

From then on it was a matter of creative dialogues: between Paul and myself on several matters of detail; between the two of us and Dr Jeremy Begbie, the other member of our 'pod' group; and, most importantly, between the subject-matter of both St John, and the theme of resurrection itself, on the one hand, and the form and substance of the musical work on the other. That, it seems to me, is where the real creativity of such a project

lies, and hence also its huge potential for further theological reflection.

I had determined early on that if we were going to write about Easter, it would truly be Easter we would write about – the empty tomb, the astonishing risen body of Jesus, the puzzles of new creation bursting in upon the old – rather than some etiolated version of the Easter message having to do only with the promise of a disembodied heaven after death. The question of how to express that not only in the words of individual poems but in the structure and flow of the whole work was one of my principal concerns. Paul, to my delight, was giving that aim musical substance not least in his through-composing of large sections. He was catching the excitement and drama of John's text and turning it into notes, but also much more than notes: a mood, a response to the mystery of the text, which in turn made me think, and still makes me think, about the underlying theme and the questions it continues to raise.

At the structural level, the obvious division of the two halves, covering John 20 and 21 respectively, lent itself to the over-arching themes: 'The New Day' for Part One, and 'The New Calling' for Part Two. John himself tells the story of Easter in such a way that, though the themes overlap both chapters, chapter 20 highlights the new creation as particularly significant (John repeats 'the first day of the week' in verses 1, 19, and when John does something like that we should take it seriously), and chapter 21 focuses on the puzzlement of the disciples about their new vocation, which is resolved by Jesus' forgiving and recommissioning of Peter.

Paul Spicer has, I think, brought this out not least by the choruses which open both parts. Reflecting on his settings has helped me to see more of what was there in the text itself.

Part One begins with 'On the seventh day God rested', starting low and mysterious in the darkness of the tomb, rising to its climax with 'the brooding of the Spirit' (lovers of Gerard Manley Hopkins will know where that came from) and preparing the way for Mary's visit to the tomb. The 'running' motif in the Evangelist's description of Mary (which Paul marks 'urgently,

breathless' – the latter presumably not a literal instruction to the singer!) says it all: the excitement of the new day, the new creation, bursting out, troubling at first, then challenging, then all-embracing as the beloved disciple 'saw and believed'. In listening to Paul's settings here (and only space prevents further appreciative exposition) I find myself not only confirmed in my reading but sensing the mood of John 20 in more dimensions than before.

Part Two begins with the chorus 'Into that strange, unmapped new land'. The marvellous woodwind scoring of the opening, and the haunting theme of the sung entry, set the tone and reinforce John's text: the disciples don't know what to do next, and are stumbling forwards into the new world without under-standing God's plan, or the meaning of the strange events they have witnessed. The comedy of the fishing scene ('All night we worked') blends with the music's strange sense of serenity which clothes Jesus' reappearance on the shore and his invitation to breakfast. Breakfast itself, cooked on the charcoal fire which reminds us of the previous fire in the High Priest's hall, where Peter denied Jesus, sets the scene for the almost unbearably dramatic reconciliation between Peter and Jesus, and Jesus' calm but challenging orders to his wayward lieutenant: feed my lambs, look after my sheep, tend my sheep. All of this, as I now come back to the text two years later, is bathed in new light by Paul's music. He has not only caught the mood I hoped to create with my words, but has enhanced it and given it wings.

One question of content was a concern of mine all through. I wanted to keep the poems tightly Johannine, to prevent them from sprawling into too many wider theological ideas. Hence, in the first twelve lines of the opening chorus, the major themes of the Gospel (word, water, bread, and so on) come together in describing Jesus' death. Where I have departed from John, it has been, so to speak, with his permission: thus, for instance, in the duet and chorus 'I will sing to the Lord', I pick up the parallel between Jesus and Mary in the garden and Moses and Miriam (the Hebrew for 'Mary') by the Red Sea after the Exodus and the defeat of the Egyptians. This is of course a regular Easter motif,

highlighted in the hymn which follows. Then, by way of the Exodus, we move to the Thomas scene, where Thomas first expresses his doubts in terms of the children of Israel being afraid to cross the sea (No. 26):

> The sea is too deep,
> The heaven's too high,
> I cannot swim,
> I cannot fly;
> I must stay here,
> I must stay here,
> Here where I know
> How I can know,
> Here where I know
> What I can know.

and then moves towards faith in 'The sea has parted' (No. 28):

> The sea has parted. Pharaoh's hosts –
> Despair, and doubt, and fear, and pride –
> No longer frighten us. We must
> Cross over to the other side.
>
> The heaven bows down. With wounded hands
> Our exiled God, our Lord of shame
> Before us, living, breathing, stands;
> The Word is near, and calls our name.
>
> New knowing for the doubting mind,
> New seeing out of blindness grows;
> New trusting may the sceptic find,
> New hope through that which faith now knows.

This draws together two other biblical contexts. In Rom. 10.6–9, Paul quotes Deut. 30.12–14: the promise of 'the Word being near you', neither high in heaven nor far away across the abyss, has been fulfilled in Jesus Christ. This, obviously, ties back into John's controlling theme of the Word made flesh, which, though

not explicit in chapters 20 and 21, is clearly intended by the Prologue (1.1–18) to be in mind throughout. Another example of a related point is where, in the new hymn at the end of the first Part, I have used Isaiah's picture of the Word of God coming down like rain or snow, producing new creation, as a controlling image for celebrating the resurrection itself. In all this, the thematic tightness I was striving for is more than matched, of course, by the same quality in the music.

From doubt to faith – and beyond

This leads me to reflect on the two passages which prompted the most dialogue, one of which still engages us, the other of which was completely resolved. The first is the aria just mentioned, No. 28, 'The sea has parted'. When I wrote this I intended it as a statement of Thomas having already come to faith. In No. 26 (see above) Thomas not only cannot believe that Jesus is risen, but intends to remain *epistemologically* in the same place: he wants to stay where he knows both *what* he can know (e.g., that resurrection is impossible) and *how* he can now (i.e., through ordinary sense-perception). But when Jesus stands before him, and invites him to touch and see, he finds a new mode of knowing, as well knowledge itself: 'New knowing for the doubting mind,/ New seeing out of blindness grows;/ New trusting may the sceptic find,/ New hope through that which faith now knows.' This then leads in to Thomas' actual confession of faith (No. 29).

Paul Spicer, however, read No. 28 (see above) as referring to Thomas still groping *towards* faith, rather than his arrival. The piece stays in the minor, with an agonized tone that awaits the resolution which now comes in the confession of faith which follows: 'My Lord and my God!', one of the most dramatic musical moments in the whole first half. This is so effective that I can hardly grumble; yet – and here is the creative tension of a collaboration like this – I find myself still torn between what I had had in mind and Paul's very different reading not only of the process whereby Thomas struggles through darkness towards

faith but also of my words about it! This has, inevitably, caused
me to reflect further on my own understanding of doubt and
faith and their respective epistemologies, a process of reflection
which continues to this day as I work elsewhere on the theme of
the resurrection. It has also caused me to think a bit more about
the whole dialogue, which is of course central to cultural studies
today, between authorial intent and reader-response.[4]

The second question that occupied us for some while was how
to end the whole work. I shall comment presently on the hymns
we had decided to employ at strategic points. We had thought,
from early on, that the work should finish with one of the great
Easter hymns, and we had more or less chosen 'Ye choirs of new
Jerusalem' for this role. But, as completion and performance
drew nearer, Paul raised a question which, though generated (as
far as I know) by his thinking through the situation of a live per-
formance, worked backwards from there into the theological
understanding of the entire piece. Paul felt – and the two perfor-
mances so far have surely borne this out – that it would be quite
wrong to end the piece simply with that great hymn, with the
audience standing up as a congregation, and with a great bang on
the final 'Alleluia! Amen!'. Quite apart from the artificiality of
contriving a 'standing ovation' at the end of the work,[5] Paul's
musical instinct led him to the theological insight that such an
ending would be deeply untrue to the strange, open-ended nature
of John 20 and particularly John 21, with the call of Jesus to
Peter to follow him into the unknown. John 21 doesn't offer a
triumphant closure with all the loose ends tied up. It points into
God's future, from (to be sure) the secure base of Jesus' resurrec-
tion and God's new day, but without specifying how precisely
everything will be worked out.

I took this point completely, and we discussed various ways of
solving it. I remember at one point suggesting a parallel with
Dvorak's New World symphony, whose final chord lingers on,
pointing into the future. We didn't want to add another chorus
or equivalent after the final hymn; but 'Ye choirs of new
Jerusalem', fortunately, gave Paul a clue. Since it ends with
'Alleluia, Amen', he requests the audience to sit down again as

soon as the hymn is over, while the choir continues with Alleluias, getting fainter and fainter, like the angels disappearing at the end of 'Glory to God' in Handel's *Messiah* (except that, there, they are going back into heaven, whereas here the Alleluias are disappearing into the still-unknown future; perhaps those are two ways of saying the same thing?). The work finally settles back on the great pedal C where it had begun two hours earlier. Only now with this difference, which catches and expresses the sense of waiting and expectancy with which John's Gospel does indeed close: as the pedal C dies away, the tubular bells play a B flat, resonating against it with an unresolved seventh, pointing into the future. The solid achievement of the cross and resurrection now gives rise, not to the feeling of 'Well, that's all right then', which many of us theologians, left to ourselves, might have been tempted to offer, but to new questions, new opportunities, to a future as yet unknown but beckoning. The whole process of discussion, with Paul's brilliant solution, was for me a matter of rich theological learning as well as musical excitement.

I might highlight one other point which was instructive to me as a collaborator. The climax of No. 20, 'The Price of Peace', had bothered me for a while, because the penultimate line was weaker poetically than I intended ('Jesus is risen from the dead', which doesn't tell us anything new at this point). I actually altered it to 'The master craftsman's costly work is done', which was printed in the programme for the first performance. But by the time I made the alteration Paul had already taken the weakest point of my poem and turned it into its strongest musical moment: the number starts quietly and meditatively, but then builds up to a terrific climax precisely on the 'Jesus'. No question of changing the words after that! That was a lesson about grace – the transformation of the weak point into the moment of glory – which it was good for a theologian to learn by such means.

In each of these different instances a point emerges which may be of interest to the wider project of *Theology Through the Arts*. I shall return to it below but want to flag it up now. Paul Spicer, as the artist in this project, had quite simply a keen sense for what would work. The music must carry its own integrity. But this

integrity is not something removed from the theological integrity of a sustained meditation on the gospel story. As Dorothy Sayers argued in *The Mind of the Maker*,[6] there is a God-given resonance between the different levels – artistic and theological – because (to put it at its most basic) humans are made in God's image. Though I am not so confident as Sayers that one can argue a kind of natural theology by starting with artistic integrity and going right the way up to the Christian doctrine of God, I am certainly prepared – and the whole experience of working with Paul has enabled me to articulate this – to think in terms of the revelation of God in Jesus and the Spirit moving towards us *and meeting artistic integrity coming the other way*. Without the first, the artist is in danger of producing form without substance, a classic problem of both modernity and post-modernity. But without the second the theologian and preacher, struggling to hear what the Spirit is saying to the churches, might easily fail to speak the full truth.

The Easter hymns

This leads me to some reflections about the hymns in the work. We decided early on that, as J. S. Bach got his audiences to participate by singing chorales which they already knew, we would do the same with some of the great Easter hymns. (The 'chorales' in Spicer's work, which are all new, and may go on to become small hymns in their own right, are at the moment designed for choir alone.) But when I set about selecting the hymns, I was surprised, and somewhat depressed, to discover how comparatively few of the well-known Easter hymns really express the subject-matter of the resurrection narratives, not least of John 20 and 21 – in other words, God's new creation, the new day, the new calling. Many of them are content to go along with the view that Easter is simply about 'life after death', the opening of heaven, and so on, rather than the robust new-creation theology of the New Testament. However, we found five which fitted the bill. They are: No. 13, 'Come ye faithful, raise the strain/ Of triumphant gladness'; No. 18, 'Now

the green blade riseth / From the buried grain', which at the first performance was sung by choir alone; No. 31, 'The day of resurrection! / Earth, tell it out abroad'; No. 50, 'Alleluya! Alleluya! Hearts to heaven and voices raise', and No. 67, 'Ye choirs of new Jerusalem'.[7] We also wrote a completely new hymn to close the first half, based on the triumphant song of new creation in Isaiah 55: 'You shall go out with joy'. This too, being new, was sung by the choir alone.

These, obviously, provide a chance for the audience to become a congregation for a few minutes, responding in praise and delight to what they have heard. But the way Paul has set the hymns enables them to do two other things as well. In each case, the hymn is introduced without a break from the previous number. Like a traveller turning a corner in the road and suddenly coming upon a beautiful vista, the listeners are swept forward, caught up in the drama, and find themselves on their feet and singing, all in one unbroken sweep of music. Or, to change the image, it is like someone sea-bathing who, while watching waves break at a distance, finds that one comes sweeping towards him and carries him off. The hymns are not bolted on to the outside of the piece. They rise up, like the swelling of the sea, from the great drama, the great turning of the tide, that the story itself and its musical setting is all about. The sense of excitement each time the audience rose to its feet had something of that power.

Once singing, though, Paul again enhanced the experience with added colour, inviting fresh understanding. The spine-tingling descants in Nos. 13 and 50, the winding meditation of No. 18, the final-verse harmonies of No. 33, and the sheer magic and power of No. 67, all leave worshipper and theologian more aware of the words and their many-layered meaning than we were before. These things may seem obvious, but should not be overlooked. In a Church which values music and loves to sing, the composer may have as much theological influence as the preacher. Not many eighteenth-century preachers taught the Church as much as Johann Sebastian Bach.

From Bach to Howells to Spicer

And yet even J. S. Bach himself did not write an Easter piece of this kind. This leads me to some reflections on the theological significance of Paul Spicer composing such a work at this time. Paul clearly stands in (one strand at least of) the great traditions of English church music, whose roots go back both to sixteenth-century English choral writing, which itself grew out of its mediaeval and plainchant roots; and, via Bach, Handel and others, to seventeenth- and eighteenth-century Germany, and its Lutheran, pietist and mystical elements. Though I am even more out of my depth here than elsewhere, I would like to suggest that Paul's work represents a turn in a new direction (not, of course, without parallel, but significant in itself for all that) from within these traditions.

Bach's own 'Easter Oratorio' (BWV 249), which I mentioned before, is a short work, without biblical narratives or quotations, and is hardly known today.[8] It may even be the case that Bach himself was not very interested by the message of Easter seen in robust New Testament terms as bodily resurrection, new creation, God's renewal of the whole world. If Albert Schweitzer is to be believed, the centre of Bach's own faith was neither dogmatic Lutheranism (though he possessed a complete edition of Luther's works) nor the fashionable pietism of the day (though many of the poems which he used as librettos in the Cantatas and the Passions were of pietist origin), but 'mysticism'. What precisely Schweitzer meant by this term is itself controversial, not least through his development of it in his classic book on Paul.[9] But in the present case he had this to say:

> This robust man . . . was inwardly dead to the world. His whole thought was transfigured by a wonderful, serene, longing for death. Again and again, whenever the text affords the least pretext for it, he gives voice to this longing in his music; and nowhere is his speech so moving as in the cantatas in which he discourses on the release from the body of this death.[10]

If this is indeed the case – and no doubt many would want to contest it – it goes some way to explaining what could be seen as a remarkable lacuna in Bach's work. Perhaps Bach was simply not interested in the possibility of a life *beyond* 'life after death', a resurrection of the body at some future date, to share in the kind of new creation that St John seemed to have in mind. And, if this is the case, the writing of an Easter Oratorio which shares the form of his great Passions may in fact represent a large step towards a filling out, a rounding out, of his theological vision.

But if the fact of Paul Spicer writing this Oratorio is a step beyond the Bach whom we were aiming to commemorate, something more remarkable again is happening in Spicer's own development from within the tradition represented by his teacher, Herbert Howells, whose biography, written by Paul, was published in 1998, around the time the Oratorio was starting to germinate in our minds.[11] Though Howells could and did write some wonderfully uplifting music in various genres, those who have come to know and love his church music will be aware, over and over again, of a melancholy strain (think, for instance, of the wonderful anthem 'Like as the hart', and some of the famous Magnificats where the glory only really emerges in the Gloria at the end). Howells, of course, spent a fair amount of his life grieving for his beloved son Michael, who died of polio in 1935 at the age of 9. Howells himself seems not to have had a religious faith, certainly nothing in the way of a robust Christian belief in either life after death or an eventual resurrection. That is not to deny the celestial wonders of, for instance, his *Hymnus Paradisi* and other pieces; only to draw attention to his abiding lack of comfort in the face of the loss of one so dear.[12]

Paul Spicer's *Easter Oratorio* achieves, I believe, something approaching the redemption of this tradition. Of course, Howells is by no means the only influence on him; like most good students, he has long outgrown his teacher. But – insofar as I understand these things – I think he has sown a new seed in the soil where Howells grew some of his plants. The seed has sprouted, blossomed and borne fruit in something Howells never imagined: the rich and hard-won affirmation that God is

sovereign over death itself. Though comfort is not cheap, or necessarily quick (think of our debates about Thomas!), and though questions remain (think of the ending of the piece), it is real and solid, and bursts through the wall of doubt in a blaze of faith and hope. Indeed, the Thomas sequence may after all reflect precisely this: the long struggle from within a musical tradition to turn despair into faith, inconsolable grief into newborn hope.

All this leads to some further and wider questions about the resurrection and epistemology.

Resurrection and how we know things

I have spent the last few years, on and off, thinking, praying, reading, lecturing, preaching and writing about the resurrection.[13] Within my own field one of the major questions to be faced here is not just *what* we can know but, as with Thomas' question in No. 26, *how* we can know it. Christian thinkers have been divided for some time on this question. Some have moved, with more or less caution, towards saying that the bodily resurrection is, in some sense, historically verifiable.[14] Others have denied this *a priori* for two reasons: either because, they say, it is not in that sense a 'historical' event (i.e., it was an event only in the minds of the disciples);[15] or because, they say, to assess the truth of the resurrection on the basis of post-Enlightenment historical method is to grant the latter a supreme position – *over* the resurrection, whereas the resurrection itself must be the starting-point, epistemologically as well as onto-logically, for everything else.[16]

Let me be cautious but clear at this point. I have become convinced that we can and must argue a historical case, to be defended on grounds that people of any faith and none might legitimately recognize, that (a) the tomb of Jesus was empty on Easter morning, and (b) the disciples really did see Jesus alive again in what gave every appearance of being a physical, though transformed, body. Only this will make sense of the fact that the early Christians really did believe Jesus was bodily raised (a point which, though sometimes challenged, is in my view absolutely

secure historically). If they had only found an empty tomb, they would have concluded that the body had been stolen; if they had seen Jesus a few times, especially with him coming and going through locked doors and not always being instantly recognized, they would have concluded that they were hallucinating. It was the two together – empty tomb plus appearances – that convinced them that he was truly alive, that he had gone through the valley of death and, after a brief 'rest', was fully and bodily alive again, indeed even more so than before, since now death could never touch him again.

Can we move further than that, and if so how? Christian apologists can legitimately challenge their critics to explain how these two things happened on any other supposition except that the early Christians were speaking the truth. It is remarkable how thin, and full of special pleading, are all the alternative explanations that have been offered over the last two centuries by ingenious apologists for a post-Enlightenment world-view, often masquerading as 'neutral' or 'objective' observers or historians.[17] Can a Christian apologetic do any better? Can it, on 'historical' grounds alone, compel someone to take the final step and declare that they too now believe Jesus was truly raised from the dead on Easter day? I think not. We can point, like an archaeologist, to two pillars which look, by their shaping at the top, as though they were designed to support a now-missing arch. We can show that, despite years of energetic attempts to suggest an alternative, nothing else explains those pillars nearly as well as an arch; that is, that nothing else explains both the empty tomb and the appearances (which themselves explain early Christian belief) nearly as well as the bodily resurrection. For some that has been sufficient; for instance, the well-known Frank Morison, who wrote *Who Moved the Stone* as a result.[18] But to this extent I think Frei and others may have at least a grain of truth: the story and fact of the resurrection itself, rather than a post-Enlightenment positivism, carries the power to lead doubting Thomases to declare that they believe the arch really existed.

I thus cautiously agree with those theologians who have

insisted that the resurrection, if true, must become not only the corner-stone of *what* we now know but also the key to *how* we know things, the foundation of all our knowing, the starting-point for a Christian epistemology. This is not to say that all other epistemologies are rendered null and void. Precisely because it is the resurrection of the crucified Jesus that might now form the starting-point for our thinking and knowing, it will affirm the proper place and power of other epistemologies, as the resurrection affirms the goodness not only of Jesus but of God's present creation – however much that present creation is subject to corruption, decay and death. A resurrection-based epistemo-logy, in other words, while being significantly new, might never-theless affirm the goodness of non-resurrection-based historical knowledge, even while recognizing, as such knowledge itself sometimes insists, that it cannot reach beyond a naturalistic and even reductionistic account such as we find in Troeltsch. This argument is thus parallel to that offered by Oliver O'Donovan, in his famous book, in relation to moral order.[19] To put it quite sharply: History raises the question, 'Granted that only an empty tomb and appearances of Jesus will explain the rise of Christian faith, what will in turn explain these two satisfactorily?' When Christian faith, arising from the whole gospel story, says, 'the bodily resurrection of Jesus from the dead,' history may reply, 'Well, I couldn't have come up with that myself; but now that you say it, it makes a lot of sense.' And perhaps at that point his-tory itself – the mode of our knowing – undergoes some kind of redemptive transformation.

Working with Paul Spicer on the Oratorio has caused me to reflect on this from several angles, of which one in particular contributes, I think, to the ongoing discussion. I have said a little, above, of *what* I have learnt from this work; but *how* have I learnt it? Was the source of my new learning Scripture, tradition, reason, or what?

The basis of the project was Scripture; but my reading, trans-lation of and meditation on Scripture had not shown me all that I now think I see there. The work stands in a tradition, but, as I have suggested, it challenges and changes it as it goes forward.

Only by a considerable stretch could 'reason' be said to have contributed materially to the work, or, through it, to my fresh understanding. Of course we thought through what we were doing, but what mattered was aesthetic, not (in the eighteenth-century sense) rational, judgement. (A false antithesis, most likely, but I am here deliberately using traditional and over-wooden categories.) At this point some might want to invoke 'experience' as our guide, or even 'feeling'; but neither of those notoriously slippery terms will do justice to what I think was going on. My memory of the process suggests that at the centre of it was the meeting, and dialogue, between the revelation in Scripture on the one hand (telling the story of the ultimate revelation, that of the Word made flesh, in history) and the demands of artistic and aesthetic integrity on the other. There might, of course, be a sense of 'reason' which would happily include those, but that isn't, I think, what most people mean by the word.[20]

This is by no means a matter of integrating left-brain and right-brain activity, as it is sometimes simplistically put. In terms of the older and somewhat outdated distinction, reading and understanding Scripture is an art, not just a science; and anyone who has seen a composer at work knows that there is a huge amount of science and technology required, not just inspiration, if the work is to come to birth! Nor was it a simple matter of Wright bringing scripture to the mixture and Spicer bringing art; far from it. Paul's own faith, and my own feeble struggles after art, were both important as well, and I honour Paul's particular spiritual insights as he has been gracious enough to honour my poetry. Yet he as the professional musician, and I as the professional exegete, met most naturally along the lines where those two disciplines confront one another, as they have done throughout much of church history, certainly in the Western Church for the last half-millennium.

Is this then a reinforcement, from a musical point of view, for Dorothy L. Sayers' thesis in *The Mind of the Maker*, to which I referred earlier? Is there indeed a trinitarian pattern to the work of the artist or writer which, reflected back, provides some kind

of evidence of who God may be? I am not sure that this thesis can be sustained by itself, or that a natural theology built up by that means without help from elsewhere would arrive at anything approximating to the God and Father of Jesus, the giver of the Spirit. But when the creative and aesthetic project meets the scriptural revelation – mediated, of course, through the thinking of the household of faith – then the two can perhaps at least be complementary. I have explored elsewhere what I have called 'an epistemology of love', in which the sterile opposition between 'objective' and 'subjective' reductions of 'knowing' are transcended.[21] I think, and hope, that what Paul Spicer and I discovered in our work on the Oratorio was something like that: a love for the subject-matter, a love worked out in art and scholarship, through which we both learned and grew and grasped afresh some of the central matters of Christian faith. And if this is true it may be a pointer to something else – something which the whole *Theology Through the Arts* project is all about: the non-reducible, and not merely decorative, function of *imagination* within historical work (as Collingwood insisted) and also theological endeavour, as well as in musical composition and performance.

I realize that I have thus arrived, as a non-specialist, at more or less what Aquinas says in his famous formulation: 'As grace does not destroy but perfects nature, it is right that natural reason should serve faith just as the natural loving tendency of the will serves charity.'[22] There is of course a dangerous circularity about reaching *that* conclusion about method precisely by engaging in what, I hope, might be an instance of it happening in practice. But I think I have said enough to show that this is a fruitful area for further enquiry and experiment, especially if – though this would be a matter for specialists to enlighten me further – what Aquinas meant by 'natural reason' is a large enough category to embrace aesthetic and artistic integrity, the composer's and conductor's sense of 'what works'. Certainly in this case the composer's – and conductor's – aesthetic and artistic integrity 'served faith' in a way that makes the ordinary jobbing theologian and preacher jealous. If all theology, all sermons, had to

be set to music, our teaching and preaching would not only be more mellifluous; it might also approximate more closely to God's truth, the truth revealed in and as the Word made flesh, crucified and risen.

Notes

1 See my *The Myth of the Millennium*, London: SPCK, 1999.
2 Hans Urs von Balthasar, *Mysterium Paschale: The Mystery of Easter*, Edinburgh: T&T Clark, 1990 [1970].
3 I also note my gratitude to my son Julian for his shrewd comments on an early draft of this chapter, particularly its final section, though he should not be held responsible for the use I have made of his advice.
4 For a recent stimulating treatment of this whole area, see Mark Allan Powell, *Chasing the Eastern Star: Adventures in Biblical Reader-Response Criticism*, Louisville: Westminster/John Knox Press, 2001.
5 American readers may like to know that British audiences are far more sparing with such things than their generous-hearted American cousins.
6 Dorothy Sayers, *The Mind of the Maker*, London: Methuen, 1941.
7 'Come ye faithful' and 'The day of resurrection' are J. M. Neale's translations of eighth-century poems by St John of Damascus; 'Now the green blade' is by J. M. C. Crum (1872–1958); 'Alleluya! Alleluya!' is by Bishop Christopher Wordsworth (1807–85); 'Ye choirs of new Jerusalem' is Roy Campbell's translation of a poem of St Fulbert of Chartres (d. 1028). There is food for thought in the comparative lack of robust new-creation Easter hymns, Wordsworth excepted, in the eighteenth, nineteenth and twentieth centuries; and Wordsworth was, of course, a great biblical and patristic scholar.
8 It is briefly described, along with the little-known resurrection oratorios of Schütz and Handel, by John Bowden, 'Resurrection in Music', in Stephen Barton and Graham Stanton, (eds), *Resurrection: Essays in Honour of Leslie Houlden*, London: SPCK, 1994, pp. 188–97. Bowden wisely concentrates, for his main material, on settings of the resurrection material in the Creeds of some of the great Masses, and on Mahler's Second ('Resurrection') Symphony.
9 Albert Schweitzer, *The Mysticism of Paul the Apostle*, New York: Seabury Press, 1968; German orig., 1931. On 'mysticism' see, e.g., Richard Woods, (ed.), *Understanding Mysticism*, London: Athlone Press, 1981; Philip Sheldrake, *Spaces for the Sacred*, London: SCM Press, 2001, ch. 5; and the classic studies of, e.g., E. Underhill, *Mysticism: The Nature and Development of Spiritual Consciousness*,

1911 (repr. Oxford: One World Publications, 1993); F. von Hügel, *The Mystical Element in Religion*, 1923 (repr. London: James Clarke, 1927).

10 Albert Schweitzer, *J. S. Bach*, London: Black, 1923 (French orig., 1905).

11 Paul Spicer, *Herbert Howells*, Bridgend: Seren, 1998.

12 See esp. Spicer, *Herbert Howells*, p. 98, pp. 109–10.

13 My major work *The Resurrection of the Son of God* is still in preparation at the time of writing. Advance statements of some parts of the argument may be found in *The Meaning of Jesus: Two Visions* (with Marcus J. Borg), London: SPCK, 1999, ch. 7, and *The Challenge of Jesus*, London: SPCK, 2000, chs. 6–8.

14 The most impressive case is that of W. Pannenberg, e.g., *Systematic Theology*, Vol. 2, Grand Rapids: Eerdmans, Edinburgh: T&T Clark, 1994 (German orig., 1991), pp. 343–63, with reference to earlier discussions. There is of course a more enthusiastic (in both senses) and almost positivist case regularly made by evangelical apologists.

15 The best known example is Rudolf Bultmann: e.g., 'The New Testament and Mythology', in H. W. Bartsch (ed.), *Kerygma and Myth: A Theological Debate*, New York: Harper, 1961 [1953], pp.1–44; cf. p. 42: 'The real Easter faith is faith in the word of preaching which brings illumination. If the event of Easter Day is in any sense an historical event additional to the event of the cross, it is nothing else than the rise of faith in the risen Lord . . . The resurrection itself is not an event of past history.'

16 I think here particularly of the work of Hans W. Frei, *The Identity of Jesus Christ: The Hermeneutical Bases of Dogmatic Theology*, Philadelphia: Fortress Press, 1975.

17 E.g. G. Lüdemann, *The Resurrection of Jesus: History, Experience, Theology*, London: SCM Press, 1994.

18 London: Faber & Faber, 1930.

19 Oliver O'Donovan, *Resurrection and Moral Order: An Outline for Evangelical Ethics*, Leicester: Inter-Varsity Press, 1986.

20 See the discussion of Aquinas, below.

21 Wright, *The Challenge of Jesus*, pp.150–2.

22 *Summa Theologica*, 1q.Ia. 8 ad.2.

16

Why do we Shrink from Joy?

JO BAILEY WELLS

You have to admire the courage of Wright and Spicer: they begin where Bach left off. I heard the *Easter Oratorio* at Ely Cathedral just a few weeks after I had been to hear the *St John Passion* at the London Proms. I was particularly struck by the continuity between them. The *Passion* finishes at the end of John 19 with Joseph of Arimathea burying Jesus' body on the eve of the Sabbath. The *Easter Oratorio* follows this directly, according to the Johannine account, beginning very early on the first day of the week with the discovery of an empty tomb (John 20).

How often I have been told, 'You can't truly celebrate Easter unless you've been through Holy Week first.' The Bach *Passion* was perfect preparation: and I was not disappointed by Easter. It was a feast for the heart and mind: for over two hours, brief hours, we dwelt on the events of Christ's resurrection. I do not remember doing that before. Churches more usually squeeze the Easter celebration into a service lasting an efficient hour.

I write this piece by way of appreciation. I was one among many who felt tingles down the spine as we sat in Ely Cathedral, who caught a glimpse of Christ's resurrection as if for the first time. The heart and the imagination met each other and met God, through the events of the last two chapters of John. In the first half, we experienced 'the new day' in Jerusalem (ch. 20): the disciples' search for the body, Mary's encounter with 'the gardener', Jesus' appearance to his disciples and Thomas' declaration of doubt and faith. And in the second half we followed 'the new call' in Galilee (ch. 21): the miraculous catch of fish, breakfast on the beach, Jesus' restoration of Peter and his instruction to John.

The most striking feature about the Oratorio was its apparent simplicity. It does not take a musician or poet to recognize the extent to which Spicer and Wright have borrowed from tradition for this new composition. The borrowing is self-conscious and purposeful; it is without apology. Most obviously, they have borrowed the form from Bach, and the composition com-memorates the 250th anniversary of his death. As with the Bach Passions, the core is the text of the Gospel itself, sung in recita-tive by a tenor representing the Evangelist, with Christ's words sung by a baritone. In addition, the smaller roles of certain other characters (Mary and Thomas, for instance) are taken by solo voices, while the utterances and exclamations of the disciples are voiced (as with the crowd, in Bach), succinctly but sometimes with great intensity, by the chorus.

But there are other kinds of borrowing which are evident. Wright's script is based closely on John 20 and 21. The text – translated afresh – is sung by the Evangelist, and this is inter-spersed with poetry, arias and hymns. The hymns are obviously borrowed from tradition: that is their strength and their purpose. The rest of the libretto is Wright's own – but the ideas and the expression have evolved from a variety of places. There is evidence of Gerard Manley Hopkins, of Shakespeare, and of the metaphysical poets, John Donne and George Herbert. There are Old Testament texts; there are Pauline references; above all, there is Johannine theology.

Aside from any music, the libretto is inspirational. Wright is an artist with words; he is also an outstanding theologian. This libretto proves him not just a good writer and good preacher. He has the skill to paint poetry also, poetry which communicates deeply and simply. The most brilliant of all scholars are those whose work is accessible as well as sophisticated.

For myself, I shall return to this text for meditation year after year. I find here not just a resource for ideas or a thesaurus of phrasing. It rings of authentic experience, of someone who understands faith and doubt, love and fear, even despair. And it draws me in. Close to the end, the intimate interplay between Jesus and Simon Peter stands out especially. The conversation is

punctuated with short reflective arias and choruses. Consider,
for example, this one (No. 58):

> The sharpest pain
> In love's bright armoury:
> The probing, wounding,
> Healing question. Why
> Do we shrink from joy?

It is hard to communicate the power of this stunning section
without hearing the music also. Spicer's composition is comple-
mentary: it raises the text to life. The listener can have no doubt
that Spicer and Wright have worked closely together: they know
each other and talk to each other and respect each other. Indeed,
they belong to the same community: they share the same
approach to 'borrowing tradition'.

Spicer states that his music 'breaks no new ground'. Whether
or not this is true, the point is that new ground is not his aim. His
borrowing is acknowledged. I was struck by the ease with which
he draws on the English pastoral tradition. I could hear touches
of Elgar and Vaughan Williams, as well as Walton and Finzi and
Howells. Perhaps it is this that enables the first-time listener to
feel 'at home', to travel comfortably through the ups and downs
of story and mood.

I did not find myself humming memorable tunes; the music,
rather, is more functional. It serves the text, by creating a mood
and conveying the words. It does this with great effect.
Admirably, Spicer achieves what he sets out to achieve, to
'capture some of the drama of the story-lines'. He enables the
music to stand behind the text and serve it, rather than vice versa.
It would be important to hear the words to appreciate fully the
music.

Because of this, I found the music to have a sincerity; and such
sincerity allows for worship. It did not beg to impress; there was
no superficial drama. Rather, it was modest. Grandeur was
reserved for the hymns – but then, don't the Victorian classics cry
out for *big* arrangements? The readiness with which the audience

leapt to their feet to join in bore witness to the success and appro-
priacy of the drama here. A couple of thousand voices do make a
big noise.

In similar vein to the scholarship of Wright, I also found the
music both sophisticated (in the sense of being well-written and
clear) and accessible. Many musicians consider it impossible to
bridge this gap; but I think Spicer succeeds. The process of
receiving the music was, of course, aided by three choirs, four
soloists and the Britten Sinfonia, disciplined and inspired by the
composer himself as conductor. Spicer's choral expertise shone
through in the performance as well as in the composition.

In the aftermath, I found myself wondering why I find such
need for this Oratorio – indeed, why the Church has so little
Easter music in its repertoire. There are plenty of Passions; there
are not many Easter Oratorios. Is it that the arts are found to
flourish in circumstances of struggle and depression – and thus
they reflect such experience best? The convention of musical
composition relies on various forms of tension moving towards
resolution. Much of the power of music lies in the irresolution, in
the cry for a final answer. It is hard to depict resolution itself.

It seems no coincidence that it was over matters of resolution
in this oratorio that Spicer and Wright had their most heated
engagement. The crucial resolution, the very end of the Oratorio,
includes rumours of a minor key – hints of unfinished business,
of the implications of resurrection which are yet to be complete.

Perhaps the popularity of the passion is that it makes a good
story: it lends itself well to narrative rendition, according to at
least four different accounts; whereas the resurrection tends too
readily to express a *concept* as much as an *event*. In the lives of
many Christians 'the resurrection' becomes an abstract noun.
The gift of Spicer and Wright is that of enabling one to enter into
the narrative of the resurrection, as presented by the Gospel of
John. Easter Sunday becomes a story that is every bit as involv-
ing as Good Friday. Here is no piece of liberal apologetic, but the
proclamation of the decisive interpretative event of history.

Yet, our habit is to hurry through the most crucial moment of
the Church year. Could we not, instead, savour the occasion

with an Easter Oratorio in church on Easter Sunday? Bach originally composed his Passions for performance in church on Good Friday, with sermon interposed at what has now become the interval break, the congregation joining in for the well-known chorales. I hope this may be the future for the *Easter Oratorio*.

Bach's position in Leipzig – carrying responsibility for organizing the music at all four of the city's main churches – demanded that the music he arranged 'be of such a nature as not to make an operatic impression, but rather to incite the listener to devotion'. Of course, the Passions fulfil both aspects. But, perhaps, it was the requirement of the latter which enabled the fulfilment of the former.

This *Easter Oratorio* is composed with the same presupposition. Not only did it incite this listener to devotion; it also made a profound and lasting operatic impression.

AFTERWORD

17

Afterword

NICHOLAS WOLTERSTORFF

The first response of anyone involved in the arts to reading the preceding discussions will surely be astonishment: astonishment that these so-called 'pod' groups worked, and not only worked, but flourished. Getting artists and theologians to talk together about artistic and theological matters is difficult. Putting them together in a small group whose goal is that the members will together contribute to the emergence of a finished work of art is a recipe for disaster. That none of the four groups collapsed into the grieved nursing of bruised feelings is extraordinary. That all who write about their experience in a 'pod' group testify to its having been one of the most meaningful experiences of their lives is astonishing.

The 'pod' groups flamboyantly contradict the Romantic ideology of artistic creation that we have all imbibed. The point is well stated by John Inge and Alistair McFadyen in their essay, 'Art in a Cathedral':

You can't produce a work of art by committee' say the sceptics . . . Though it would be inaccurate to describe the working group which surrounded Jonathan Clarke as a committee, our experience proves that the sentiment behind such a remark is very mistaken. It implies that a work of art can only be the result of the inspiration of an artist working alone and that no other person can have any constructive role in the process. Indeed, perhaps it suggests also that others can only contribute by hemming in or constraining the inspired creativity of the artist. Inspiration and the freedom of artistic creativity tend here to be understood as individual and internal to the artist.

Creative inspiration is therefore free in the sense of being free *from* external influence . . . What we discovered through the 'pod' group process was that artistic creativity may be freed by and through conversation because, in the end, it is freedom *for* responsiveness to a reality that is neither individual nor internal.

The point made parenthetically here by Inge and McFadyen, that the sculpture, *The Way of Life*, was not a committee product, is important. In the case of the composition of *Easter Oratorio*, Tom Wright, one of the two theologians in the 'pod' group, composed the text that was set to music by Paul Spicer; *Easter Oratorio* was in that way the product of a collaboration between theologian and composer. But not so in the other cases; the artists produced the works.

So what were the theologians doing there? And what, at bottom, were the artists and theologians talking about? An important clue is to be found in the following words of David Ford, from his reflections on the workings of his 'pod' group:

In interpreting Scripture . . . we are involved in a multiple performance. There is first the performance to which the text witnesses . . . The biblical text itself is a new communicative performance which embraces fresh elements but still can only act as an indicator of the full richness to which it testifies. This very underdetermination of the text opens the way for generation after generation of interpretation in many modes, from commentary and liturgy to drama, ethics and systematic theology. These are new performances. *Wrestling with Angels* is now part of the tradition of interpretation surrounding Genesis 32—33 and 2 Corinthians – and its composition was fed by intensive discussion of those texts, with the participation of theologians who knew something of the history of their interpretation.

Note the recurrence of the word 'interpretation' in this passage. Scripture is an interpretation of the reality of which it speaks;

and of Scripture we in turn have interpretations, of various sorts. Ethics and systematic theology are interpretations of Scripture, so too are biblical commentaries, so too is liturgy, and – to come to the point – so too is the dramatic work, *Wrestling with Angels*, along with a good many other dramatic works. Ben Quash makes essentially the same point using the concept of *meaning*. Ford (and Quash too) would of course add paintings, sculptures, musical compositions, poems, fiction, and films to the list: in all of these genres we find interpretations of the biblical text and of the reality of which the biblical text is itself an interpretation.

In short, there's this deep affinity between systematic theology, on the one hand, and a great many works of art, on the other; they are all interpretations of the biblical text and of the reality of which the biblical text itself is an interpretation. More specifically, they are *theological* interpretations of those, the point being that there are other sorts of interpretations of those than theological interpretations: Freudian, Marxist, secular feminist, liberal progressivist, and so forth.

Systematic theologians do not only interpret the biblical text and the reality of which that text is an interpretation. In their capacity of theologians they interpret other things as well – that is, they *theologically* interpret other things. David Ford's own theological writings are a testimony to this. So too for some of these 'pod' groups. David Ford's and Ben Quash's group worked with two dramatic productions. The one to which Ford refers in the passage quoted, *Wrestling with Angels*, is, as he says, an example of biblical interpretation; but the other, *Till Kingdom Come*, is not. It deals with a person and an episode in the Cromwellian revolution. Nonetheless, it too is an interpretation – in the genre, once again, of drama; and more specifically, a theological interpretation – not a Freudian interpretation, nor a Marxist, nor a secular feminist, but a theological interpretation. Which brings us to the musical composition that emerged from the 'pod' group whose work is presented first. *Parthenogenesis* is a musical interpretation – there's the word again! – of that strange story from the Second World War of a woman in Hanover, in 1944, becoming pregnant as a result of the Allied

bombardment rather than sexual intercourse. It too is a theological interpretation.

I submit that what brought these artists and theologians together, and made it not only possible but profitable for them to talk together, was the realization that they were jointly engaged in theological interpretation. Admittedly it's odd to describe theologians as engaged in theological interpretation; what other sort of interpretation *could* they be engaged in while remaining theologians? To diminish the oddity we could say that these artists and theologians saw themselves as engaged jointly in *religious* interpretation; but I will brave the oddity, and follow these writers themselves in continuing to speak of 'theological' interpretation.

Many of the readers of this book and of this Afterword will know that over the past fifty or so years there has been something of a cottage industry in discussions about art and religion, the main centres being Berkeley, Yale, and now Cambridge and St Andrews. What has often struck me, as a sometime-auditor to these discussions, is how difficult the participants make it seem to uncover the relation of religion to art – it takes really hard work! – and how unsatisfying the results often prove to be. My own view is that this self-perceived difficulty and this unsatisfactoriness are due in good measure to the constraints that the participants have placed on themselves, these constraints going unnoticed and hence never defended. It is only high art meant for perceptual contemplation that the participants are willing to pay any attention to; and within that body of high art, they resolve to ignore all that which has Christian content, on the ground that the connection between art and religion in such art is, as they often say, 'merely external'.

I find both of these exclusions exceedingly odd. As to the first, one would have thought that the icons of Eastern Orthodoxy represent one of the most obvious and rich interactions between art and religion. But this gets excluded, since the Orthodox do not contemplate their icons, they *kiss* them. It is my view that the discussions on art and religion have been seriously impoverished by this failure or refusal – I'm not sure which – to reflect on this

practice of kissing icons, and other such non-contemplative engagements with art. Secondly, one would have thought that whatever the attitudes one may have absorbed from the high Romantics about the superiority of so-called 'intrinsic' connections between art and religion to 'merely external' connections, if one wants to understand how art and religion engage each other, it's bizarre to exclude all art with religious content – whether Christian, Buddhist or Islamic.

The discussions in these four 'pod' groups were all focused on works of art meant for perceptual contemplation – with the exception that some of the chorales incorporated into *Easter Oratorio* were meant to be sung by the audience, or 'congregation', if you will. It's my impression that this was pure happenstance, however; all the works in question just happen to have been meant either for performance or visual contemplation. Where these discussions do depart strikingly and gratifyingly from those other discussions is that here there is no resistance – none at all – to dealing with art that has Christian content. With the exception, arguably, of *Parthenogenesis*, all of them do in fact have Christian content. The discussions also depart strikingly and gratifyingly from those other discussions in that there appears to have been nothing of *the laboured* about them. My guess is that that is because, wittingly or unwittingly, the participants in these discussions had hit on the category of *theological interpretation* as that which unites them in their endeavours. The artists, in these particular works, see themselves as engaged in theological interpretation; the theologians have it as their profession to engage in theological interpretation. So they talk together: fruitfully, insightfully, easily.

Of course the realization that they are together engaged in theological interpretation is not sufficient by itself to guarantee a fruitful discussion between artists and theologians. For the *mode* of interpretation by artists on the one hand, and by theologians on the other, is very different. Theological interpretation by artists is wrought in colours, shapes-in-space, musical sounds, stories and the like; that by theologians is wrought (with the rarest of exceptions) in non-fictional prose discourse. It would

have been easy, in the formation of these 'pod' groups, to wind up with theologians who regard anything other than assertoric prose as an inferior medium for achieving theological interpretation, and with artists who regard assertoric prose as an inferior medium for achieving theological interpretation. What was remarkable about these 'pod' groups is that there was none of that – or at least, none that emerged in these ruminative essays. There was, rather, a recognition of difference without hierarchy: music has different powers from assertoric prose, both of those have different powers from sculpture; and so forth.

I wrote in the preceding paragraph of theological interpretation as 'wrought in' colours, shapes-in-space, musical sounds, stories, assertoric prose, and the like; I deliberately refrained from describing theological interpretation as *presented by means of* colours and the like. In writing as I did, I meant to allude to a theme that runs throughout these reflections.

The theme is sounded by Rowan Williams when he says:

> art, whether Christian or not, can't properly begin with a message and then seek for a vehicle. Its roots lie, rather, in the single story or metaphor or configuration of sound or shape which *requires* attention and development from the artist. In the process of that development, we find meaning we had not suspected; but if we try to begin with the meanings, they will shrink to the scale of what we already understand whereas the creative activity opens up what we did not understand and perhaps will not fully understand even when the actual work of creation is done . . . Artistic work is always discovery, not illustration.

The theme is sounded again by Nigel Forde:

> Like most writers, I don't know what I know until I start to write about it. The very process of writing becomes the process of revelation. I write not *because* I see but *in order* to see. I don't have a vision of the world which must with missionary fervour be passed on. The imagination . . . offers treasures,

mysteries, gifts. The writer must unwrap them and greet them
with the time-honoured cry of 'Just what I wanted!'

The artist doesn't *first* have an interpretation and *then* compose
something that will present his or her interpretation to the rest of
us; the interpretation is wrought in the course of composing.

 The arts, for those of us who engage them as recipients, are a
medium of discovery. Tom Wright, in his reminiscences, remarks
that 'Reflecting on [Paul Spicer's] settings has helped me to see
more of what was there in the text itself.' And just a bit later he
says that 'in listening to Paul's settings here . . . I find myself not
only confirmed in my reading but sensing the mood of John 20 in
more dimensions than before'. The same point is made by Jeremy
Begbie in his Introduction when he says that it is the ability of the
arts 'to "open up" and disclose reality in unique ways which is
the main interest of the essays which follow. In particular, we are
concerned with their capacity to open up what Tom Wright calls
"God's truth", and thus to contribute to *theology*.'

 What Rowan Williams and Nigel Forde hint at is that the arts
are a means of discovery *for the artist* as well as for recipients.
That is because artistic media have a life of their own. Interpre-
tations are not only wrought and achieved in the course of work-
ing with the artistic medium rather than being imposed on the
medium after being first worked out; what has to be added is that
the artist is not fully aware of the interpretation wrought until he
or she stands back to reflect on what they have achieved. Thus it
is that artists themselves learn things from their art – and not just
things about their art but about reality. For what they achieve,
remember, is an interpretation of what lies outside the work:
reality.

 These points, about the arts as a means of discovery, seem to
me both correct and profoundly important. But I want to append
two comments. In the first place, I think it would be a mistake to
see a deep fissure between the medium of assertoric prose which
the theologian typically employs – and which is, incidentally,
almost entirely the medium of this present book – and the
various artistic media. It is so obvious as to scarcely need saying

that the medium of assertoric prose has the power to disclose truth; my guess as to the reason none of the writers made a point of this is that they were assuming, rightly, that everybody takes this for granted, so that what needs arguing is not that point, but the point that artistic media are *also* media of disclosure. So let me go beyond the obvious point, that assertoric prose is a medium of disclosure for readers, to say that it has been my experience, as one who works in the medium of assertoric prose, that I too in good measure do not know in advance what I want to say but achieve what I want to say in the course of writing; here too meaning and interpretation are achieved in the course of working with the medium rather than being something achieved in advance and dropped onto the medium. And furthermore, that it has also been my experience that the medium of assertoric prose too has a life of its own, so that I sometimes discover what it is I am saying only sometime after I have said it. It is not something I had in mind to say, not even something that came to mind in the course of working with the medium. Sometimes to my delight, sometimes to my dismay.

That last sentence, 'sometimes to my delight, sometimes to my dismay', leads on to my second comment. I think the point that actually emerges from these discussions is more subtle than that art is a means of disclosure, to the artist as well as to recipients. That more subtle point emerges in the discussions between Tom Wright and Paul Spicer as to how *Easter Oratorio* should end; it emerges most forcefully, however, in the discussions of the 'pod' group that co-operated in the genesis of *The Way of Life*. That more subtle point is this: a theological (or other) interpretation wrought in some artistic medium may prove *unacceptable* in one way or another; rather than being a means of disclosure, it may be a means of distortion if we allow ourselves to be led on by it. Paul Spicer was convinced that ending the Oratorio with a musical bang would be theologically unacceptable, though perhaps musically effective; eventually Tom Wright came around to this view as well. And the participants in the discussions concerning *The Way of Life* repeatedly discovered that, after mulling over design suggestions they offered to the artist,

those suggestions, if accepted, would have yielded an unaccept-
able interpretation of Christ's cross and of the Christian life.

The conclusion to be drawn is that the arts confront us with
the need for *critical discernment*. The assumption that the inter-
pretation wrought by the medium is true, insightful, and all the
rest, is yet one more of the planks in the house of Romanticism
that we have to discard. The interpretation achieved may instead
be unacceptable, in one way or another. What I myself find, in
working with my own medium of assertoric prose, is that some-
times what the medium has led me into saying has to be
scratched out; I have to begin again.

Some of the theologians in these discussions appear to me to
have a larger agenda in mind than what could be surmised from
anything I have yet written. It is my impression that this larger
agenda did not surface much, if at all, in the 'pod' groups; it
appears to have remained in the background. My guess is that
the discussions in the 'pod' groups were the better for that.

We catch a glimpse of this larger agenda in Begbie's statement,
in his Introduction, of the primary aim of the research project,
Theology Through the Arts (the sponsor of the 'pod' groups).
The primary aim of the project, he says, is 'to discover and to
demonstrate ways in which the arts can contribute towards the
renewal of Christian theology in the contemporary world'.

It remains unclear to me what is meant by 'Christian theology'
in this formulation. Sometimes it appears that it means what
Begbie, in his Introduction, describes as 'Christian faith seeking
deeper wisdom'. It is the disciplined thinking and re-thinking of
the 'gospel' from which Christian faith arises. From the dis-
cussion about wisdom which then follows, it becomes clear that,
on this understanding of 'theology', all the works of art that
emerged from the 'pod' groups are specimens of theology. If this
is what is meant by 'theology', then there is no larger agenda.
The agenda is accomplished by what the 'pod' groups did: con-
tribute to the creation of new works of art which are theological
interpretations and reflect on the process. On this understanding
of 'theology', these artists are theologians.

Clearly this is by no means always what is meant by 'theology',

however; indeed, it is my impression that in the essays in this book it is *usually not* what is meant by 'theology'. For the project was to bring artists and theologians together in 'pod' groups. But if the artists are theologians – well, then there is no 'bringing together' to be done. When the talk is about bringing artists and theologians together to discuss the theological interpretation being achieved in some artistic medium, what is meant by 'theologians' is, surely, those who practise the discipline, the *Wissenschaft*, of theology. The primary aim of the research project of *Theology Through the Arts* becomes, on this understanding, discovering and demonstrating ways in which the arts can contribute to the renewal of the discipline of theology. That, clearly, is a larger agenda than any which these 'pod' groups explicitly undertook; it's an agenda I find hinted at here and there in Begbie's Introduction, and which I find surfacing especially in David Ford's essay.

These essays, and the projects on which they report, do not contribute to that larger agenda; they do not pretend to, they make no attempt to. That is not a deficiency, in my judgement. The larger agenda, hinted at but not dealt with, raises questions in my mind. It is my conviction that just as the arts have their own integrity, so too does the discipline of theology. The medium of assertoric prose should be honoured for the powers it has – different powers, neither better nor worse, than those of the artistic media. I heartily agree that the discipline of theology needs renewal in the contemporary world. But on my analysis of the situation, what mainly ails theology is its inability to find an appropriate voice on the contemporary scene, along with a peculiar tendency toward self-laceration, that is, lack of courage. Possibly the arts can in some way contribute to cure the former ailment, I do not know; I cannot see that more or better attention to the arts will do anything at all to cure the latter. This is by no means to suggest that the discipline of theology should not engage the arts; most definitely it should. But an understanding of what those modes of engagement should be remains on the unfinished agenda. The work of the *Theology Through the Arts* project is not finished!

Or may it be that the day is over when the medium of asser-
toric prose is an effective means of theological interpretation? It
could be; but I doubt it. In any case, the evidence is not in yet.

I want to close by taking note of one place where there was, in
my judgement, a breakthrough in these discussions. It occurs in
the reflections by Inge and McFadyen on the 'pod' group out of
which emerged the sculpture for Ely Cathedral, *The Way of Life*.
They note that among certain Christians it's been customary for
some time to speak of art as a *sacrament*; *sacrament* has been
their main category for working out a Christian understanding
of art. The has been true especially, but not only, for Anglo-
Catholics. Those who know my own writings on art and the
aesthetic will know of my discomfort with this way of thinking.
For one thing, one discovers, when scrutinizing the writings of
those who go beyond merely talking of art as sacrament to work-
ing out the thought, that to get the concept of sacrament to fit
works of art they truncate it so severely that it no longer catches
what is distinctive in the Christian sacraments.[1] And secondly, I
find unacceptable the static way of understanding sacraments
that lies behind this way of thinking and speaking. On this point
I betray – I will not deny this – my Calvinist sympathies! At the
centre of the sacraments, in Calvin's way of understanding them,
was not *God's presence* in material things but *Christ's action
among us* by way of *our actions with* material things: our action
of sprinkling water on a person, our actions of eating bread and
drinking wine.[2]

In their essay Inge and McFadyen eloquently express the same
dissatisfaction with a static understanding of sacrament and with
the tradition of art-as-sacrament which makes use of that static
understanding; they too argue for a 'dynamic' understanding, as
they call it. And then they go on to show how this can illuminate
the interaction among God, us, and art.

They lead off this part of their discussion by asking what
happens to the 'people visiting Ely [Cathedral] and encountering
The Way of Life'? What happens, they suggest, is that viewers –
some viewers, anyway – are caught up in the dynamic of faith out
of which both works of art were created:

We have deliberately spoken of a *dynamic* of faith in order to steer away from the suggestion that all the work is done on the human side; that what is involved is an independent movement of the human spirit. It is, rather, the work of the human spirit *responding to, set in motion by, and incorporated into God's movement towards us.* What may be encountered in and through the material of the Cathedral and of the statue is the movement of God: the God of Jesus Christ in movement towards and for us.

Then, after stating their reservations about the traditional art-as-sacrament line of thought and the static understanding of sacrament that lies behind it, they say that though they 'are sensitive to those reservations', they are convinced that

> sacrament is nonetheless potentially illuminating for speaking of what may happen through the art of a cathedral and of a statue. Indeed, we would risk saying more: at least some of the suspicions that restrict use of the term for 'the Church's sacraments' . . . can be assuaged if we avoid slipping into a static view and adopt a self-consciously dynamic one . . . [The] movement of God is to and for the whole world . . . [To] encounter God through the mediation of the material is to encounter this movement to and for us.

Exactly! This is a way of using the concept of *sacrament* to understand the relation among God, us, and art, that I can live with. More than live with: embrace!

Notes

1 See especially my 'Evangelicalism and the Arts', in *Christian Scholar's Review*, XVII: 4, June 1988.
2 See my 'Sacrament as Action, not Presence', in David Brown and Ann Loades, (eds), *Christ: The Sacramental Word*, London: SPCK, 1996 pp. 103–22.

Further Reading

The following is suggested reading for those who want to follow up the lines of thinking found in this book. For a much larger reading list, see: *http://www.st-and.ac.uk/~itia/resource.html*

Books by the contributors on the arts or art-related themes

Rowan Williams, *After Silent Centuries: Poems by Rowan Williams*, London: Perpetua Press, 1994.

Michael Symmons Roberts, *Soft Keys*, London: Cape, 1993; *Raising Sparks*, London: Cape, 1999; *Burning Babylon*, London: Cape, 2001.

Nigel Forde, *The Lantern and the Looking-Glass*, London: SPCK, 1997.

Nicholas Wolterstorff, *Works and Worlds of Art*, Oxford: Clarendon Press, 1980; *Art in Action*, Grand Rapids: Eerdmans, 1980.

'Theology through the arts': introductory

Jeremy Begbie, (ed.), *Beholding the Glory: Incarnation through the Arts*, London: Darton, Longman & Todd/Grand Rapids: Baker Book House, 2000.
 The miracle of Christmas explored through seven different art forms.

John Drury, *Painting the Word: Christian Pictures and Their Meaning*, New Haven: Yale University Press, 1999.
 Paintings from London's National Gallery open up various theological themes.

Gabriele Finaldi, (ed.), *The Image of Christ*, London: National Gallery/New Haven: Yale University Press, 2000.

Neil MacGregor and Erika Langmuir, *Seeing Salvation: Images of Christ in Art*, London: BBC, 2000.

Both are associated with the millennium exhibition, 'Seeing Salvation', at the National Gallery in London.

Henri Nouwen, *The Return of the Prodigal Son: A Story of Homecoming*, London: Darton, Longman & Todd, 1994.

Now a spiritual classic; a meditation on Rembrandt's 'The Return of the Prodigal Son'.

'Theology through the arts': more advanced

Jeremy Begbie, *Theology, Music and Time*, Cambridge: Cambridge University Press, 2000.

Music is given room to do its own kind of theological work, in relation to issues of time and history.

David Brown, 'The Trinity in Art', in Stephen T. Davis et al (eds.), *The Trinity: An Interdisciplinary Symposium on the Trinity*, Oxford: Oxford University Press, 1999, pp. 329–56.

A study of treatments of the Trinity in painting.

Paul Fiddes, *Freedom and Limit: A Dialogue between Literature and Christian Doctrine*, Basingstoke: Macmillan, 1991.

A conversation between themes in Christian theology and some key writers.

Paul Fiddes, *The Promised End: Eschatology in Theology and Literature*, Oxford: Blackwell, 2000.

A dialogue between the theological and literary treatments of the future.

Robert Jewett, *Saint Paul at the Movies: The Apostle's Dialogue with American Culture*, Louisville: Westminster John Knox, 1993; *Saint Paul Returns to the Movies*, Grand Rapids: Eerdmans, 1999.

Biblical studies through film.

Roger Lundin, *The Culture of Interpretation*, Grand Rapids: Eerdmans, 1993.

A sensitive discussion of the theological dimensions of

contemporary culture, especially as they become apparent in modern (especially North American) literature.

Kathleen Powers Erickson, *At Eternity's Gate: The Spiritual Vision of Vincent Van Gogh*, Grand Rapids: Eerdmans,1998. An unveiling of Van Gogh's changing theological vision, gleaned through his art and writings.

Leonid Ouspensky and Vladimir Lossky, *The Meaning of Icons*, Crestwood, NY: Saint Vladimir's Seminary Press, 1982. Icons as mediations in theology.

Index

Index of Scriptures